JAPANESE DRAWINGS
OF THE
18TH AND 19TH CENTURIES

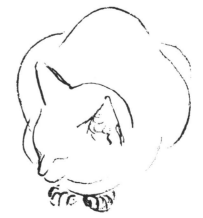

Japanese Drawings
OF THE 18TH AND 19TH CENTURIES

Catalogue by
JACK R. HILLIER

Organized and Circulated by the
International Exhibitions Foundation

This project is supported by a grant from the National Endowment for the Arts, Washington, D.C. (a Federal agency) and sponsored by:

▲ MITSUBISHI

Mitsubishi Heavy Industries, Ltd.
 Mitsubishi Motors Corporation
 Mitsubishi Corporation

The catalogue is underwritten in part by The Andrew W. Mellon Foundation.

Cover illustration: Hayashi Jikkō, *Dragonfly* (Cat. No. 83)

Contents

Acknowledgments

The International Exhibitions Foundation is proud to present this exhibition of "Japanese Drawings of the 18th and 19th Centuries," which brings together for the first time more than 140 rare and important works from 43 public and private collections throughout the world.

The exhibiton is the result of our close collaboration with Jack Hillier, whose expertise in the field of Japanese paintings, prints and drawings brought him instantly to mind when we first entertained the idea of organizing this show. Happily, he agreed to serve as Guest Director for the project, bringing to the task a scholarly dedication and cheerful enthusiasm that are reflected in both his selection of the works and in his catalogue text. We have thoroughly enjoyed this opportunity to work with him, and extend to him our warmest appreciation.

A project of this scope and complexity necessarily requires the cooperation of numerous other individuals and institutions, all of whom deserve our sincere thanks. First and foremost, we wish to express our appreciation to the many lenders who have so generously agreed to share these treasures. In addition to their willingness to lend to the exhibition, they have responded patiently and thoughtfully to our requests for information, and we are deeply in their debt. We are likewise grateful to His Excellency Fumihiko Togo, the Ambassador of Japan, for agreeing to serve as honorary patron of the exhibition during its tour.

In Tokyo a very special measure of thanks is owed our friend and colleague Haruo Igaki, who has given unstintingly of his time and expertise at every stage of the project. We are also grateful to Jack M. Dinken for his assistance with the Japanese loans, and to the Agency for Cultural Affairs (Bunka-Cho) for their cooperation and advice.

It is always a pleasure to acknowledge those organizations which have rendered financial assistance to the project. The National Endowment for the Arts, Washington, D.C., a Federal agency, has provided generous grants toward both the planning and the implementation of the project. The International Exhibitions Foundation would like to express its sincere appreciation for their generous support of "Japanese Drawings of the 18th and 19th Centuries" to Mitsubishi Heavy Industries Ltd., Mitsubishi Motors Corporation, and Mitsubishi Corporation. Mitsubishi's sponsorship of this exhibition is an important step towards strengthening the cultural understanding between the United States and Japan. Our thanks go also to Mabel H. Brandon for her efforts on our behalf. And we are once again most grateful to The Andrew W. Mellon Foundation for underwriting a portion of the cost of catalogue production.

The exhibition catalogue, beautifully printed by Schneidereith & Sons, was produced with the capable assistance of Thomas R. Phillips of that firm. Dana Levy's considerable design talents have once again resulted in a most handsome publication, and we have enjoyed this opportunity to renew our association.

Throughout the planning of the exhibition we have received the full cooperation of the museums participating in the tour, and to the directors and staffs of these institutions —and in particular our colleagues at Japan House Gallery— we extend sincere thanks. Finally, I wish to express my gratitude to the Foundation staff, notably Crystal Sammons and Taffy Swandby, for attending to the many complex practical details involved in preparing the exhibition and catalogue.

Annemarie H. Pope
President
International Exhibitions Foundation

Author's Acknowledgments

I would like to add my personal thanks to private collectors and to directors, curators and staffs of the various museums and institutes for their generosity and kind cooperation. In addition, I have special obligations to the many who have helped me in the quest for drawings, or who have contributed to the Catalogue, by translation, by elucidation of obscure subjects, or in other ways, and particularly, I wish to express my gratitude to Stephen Addiss, James Cahill, Willem van Gulik, Michael Harari, Roger Keyes, Eikō Kondō, Susumu Matsudaira, Hugh Moss, Robert Ravicz, B.W. Robinson, Johei Sasaki, Felix Tikotin, David Waterhouse and Hugh Weiser.

<div align="right">Jack Hillier</div>

Lenders to the Exhibition

Dr. Walter Amstutz
Anonymous Lenders
The Art Institute of Chicago
The Ashmolean Museum, Oxford
Collection Baines, Antwerp
Huguette Berès, Paris
Dr. and Mrs. Lawrence R. Bickford
E. Biedermann, Bern
K. G. Boon
The British Museum, London
Nathan Chaïkin
The Cleveland Museum of Art
James DeLong, Los Angeles
Dr. Eugene Gaenslen, Jr., MD, Burlingame, California
John R. Gaines, Lexington, Kentucky
Kurt and Millie Gitter Collection
Kōsuke Hanawa, Mito City, Ibaragi Prefecture, Japan
Ralph Harari Collection, London
Mr. and Mrs. Jack R. Hillier, Redhill, Surrey, England
Daisaku Hosoya, Yamagato Prefecture, Japan
Keigensai Collection, Berkeley
Richard Lane , Kyoto
Manyoan Collection
The University of Michigan Museum of Art, Ann Arbor
Mr. and Mrs. John Milne-Henderson, London
The Minneapolis Institute of Arts
Takanari Mitsui, Tokyo
Musée Guimet, Paris
Museum für Ostasiatische Kunst Berlin,
 Staatliche Museen Preussischer Kulturbesitz
Museum Rietberg Zurich
Collection of Betsy and Karel Reisz, London
Rijksmuseum voor Volkenkunde, Leiden
Robert G. Sawers, London
Gerhard Schack
Shin'enKan Collection
Shōka Collection
Felix Tikotin, Mont Pélerin, Switzerland
The Tikotin Museum of Japanese Art, Haifa
Victoria and Albert Museum, London
L. L. Weill
Prof. Dr. Franz Winzinger, Regensburg,
 Federal Republic of Germany
Mr. and Mrs. Dennis Wiseman
Takashi Yanagi, Kyoto

Introduction

*I*n the West, there is a clear distinction between a drawing and a painting: drawings may be small or large (the largest sometimes described as "cartoons"), but provided they are in certain media—pencil, silver-point, chalk, sanguine or pastel, pen, quill or brush with ink bistre or sepia—there is no mistaking what they are, or what they should be called. Only when watercolors are used does any doubt arise, for although some writers invariably use the expression "watercolor drawing" for any work in the medium, there are some watercolors of a size, elaborateness and finish that seem to designate them "paintings." It is exactly this difficulty we have in drawing a line between Western drawings and paintings in watercolor that besets us in any attempt to make the same distinction in respect to Japanese works, for they are invariably in *sumi* (translated loosely as "ink") or watercolor, always applied with a brush.

To the Japanese, during the period covered by the exhibition, all their paintings were drawings, all drawings, paintings. Indeed, the concept of a drawing as something distinct from a painting was practically unknown to them. They recognized the *shita-e*, the "under-drawing," either as a guide that an artist provided for a final, fully worked out version painted over, and obliterating, the *shita-e*; or as an outline for the woodblock cutter, who destroyed the *shita-e*, pasted to the block, with his knife: but the Japanese language has no native equivalent to the word "drawing" in the sense we use it, and thus foreign terms like *dessan* (デッサン) and *suketchi* (スケッチ) have been pressed into service in modern art-literature. Any question as to what constitutes a Japanese drawing tends to become a matter of semantics, and those who wish to pursue that aspect should refer to Theodore Bowie's analysis in depth in his stimulating *Japanese Drawing*, a book which accompanied an exhibition at The Indiana University Art Museum in 1975.

At best, any conclusions are bound to be arbitrary and subjective. Often the intention, the act itself, coupled with scale, is decisive. Entirely without premeditation, the brush may be seized to project, or capture in pictorial terms where a poet would scribble key words, an inner compulsion that has urgently to be expressed. So prompted, an artist

may conceive the germ of what might be developed into a painting, but, abandoned before that stage is reached, still in embryo or incomplete, it may remain a drawing, something taken only so far towards a possible goal, yet perfect at whatever point the goal is forsaken. Or the brush may be picked up casually, to jot something down from the simple pleasure of exercising a gift, without an audience or any thought of an ultimate outcome, like a dancer pirouetting offstage from sheer joy in the physical accomplishment; or again, with a distant, perhaps half-conceived objective, the brush can be used to transcribe "from life," or "from memory," making preliminary soundings, testing what outlines will be most effective, planning a composition and revealing in successive amendments the working of the artist's sensitive response to the demands of his own creation, during the very act of creation. For us, the gleaners of sheets the artist may have discarded as worthless because without purpose or else superseded by later developments from them, many such drawings have so high an aesthetic import that they have been mounted as *kakemono* and given a presence and a setting that is usually reserved for full-scale paintings; but their essentially "drawing" character is not diminished and a number so mounted have been included in the exhibition.

Yet not all drawings are of the impromptu or exploratory nature: many are the outcome of intense prior consideration and even drawn with slow deliberation. Where an artist was working within certain self-imposed limits of size or format (a fan, for instance, comes to mind), such works may come close to the detailed, small-scale portrayals of animals by Dürer and many others, which are universally accepted as drawings. Quite often, this kind of Japanese drawing puts us in mind of Western "presentation drawings." It was once said of the letters of Lady Mary Wortley Montague that "her expressions were choice, but not chosen": that might describe the lines of a good drawing of this type — "choice, but not chosen" — naturally expressive but effortless from an innate mastery.

Again, as the brush is the sole implement, we do not have to restrict the term "drawing" to works produced with a fine line from the tip: the brushes themselves ranged from those of a few hairs brought to a fine point to the wide, flat-topped *hake* inches in width, and in washes made with a full brush, the broad sweeping strokes (like those in the Nanrei landscape, No. 100) are as integral and as stunning as they are in sepia drawings by Claude or Guercino. Nor, obviously, does the use of color disqualify a work from being described as a drawing: indeed, color is one of the principal delights of almost every Shijō drawing.

However unavoidably arbitrary and equivocal the qualifications for their selection may be, the works shown here are unified by being universally the outcome of mastery with the brush. Through all the immense range resulting from varied occasion, period, school mannerism, personal idiosyncracy or mood, we are conscious of this flair for expressive brushwork, and it is to this quality that we respond above all. It is a gift native to the Oriental artist, who, in mastering the letters of his ABC's, learns a repertoire of brush strokes, a control and a dexterity that make possible the dazzling spontaneity we marvel at in his drawings.

There are certain artists in whom these powers reach exceptional intensity. They have the gift that some singers have, of performing effortlessly what others struggle to achieve, producing their top notes with an ease and indifference that is almost casual. Drawings by Itchō, Hokusai, Nanrei, Kuniyoshi and Kyōsai, to name five of those who were both inspired draftsmen and prolific in output, naturally figure very prominently in the exhibition.

Four of those five artists belong to the 19th century (Hokusai was working from 1778 onwards but none of his drawings in the exhibition dates before 1800), only Itchō representing the 18th century. The time span — 18th and 19th centuries — was adopted partly to make it feasible to show a body of works of each of the outstanding draftsmen sufficient to demonstrate his prowess and versatility, which could not have been done in covering a longer span of centuries and the increased number of artists; and partly because the 18th and 19th centuries were a time of ferment and innovation in the arts in Japan, when new attitudes, new demands, led artists to throw off more random drawings than the masters of more formal and academic styles of previous centuries would have deemed it necessary or proper to make, or certainly to preserve. The new movements — particularly Nanga, which stemmed from literati who exploited the virtues of the elliptic, the fragmentary and a harsh frugality of line; and Shijō, representing a new wave of naturalism, a "return to nature," inspiring far more "sketching from nature" than had been known previously — did not make their impact until the second half of the 18th century onwards, and little is included here that dates to the first half of that century. But there has been no underlying purpose of a strictly chronological coverage: the drawings have selected themselves, they have not been chosen by artist, by school, or by decade. This is, then, manifestly in no sense a didactic, and only indirectly an educational, exhibition: but the drawings will, it is believed, have a manifold appeal, arising from the Japanese artists' mastery with the brush; from the sense of compelling decor and pattern, innate to the race from earliest times; from the subtle understatement, the intriguing suggestion that provokes an imaginative response; from a brand of humor that has the bouquet and bite of a dry wine; and from the projection not merely of a philosophy and way of life, but of an aesthetic concept profoundly different from our own at the same period, yet challenging even today in the alternatives offered (and actually still not without their influence upon modern Western art).

It is the virtue of such Japanese drawings that, like our own, they are more intimately revealing than the more considered work, they bring us closer to the artist in the first flush of his inspiration and its unpremeditated expression. Sometimes they accompanied letters and are now part of precious autobiographical documents, like the marvelous self-portrait of Hokusai at the end of one such letter (No. 73); and the rather pathetic recollection of a family gathering by Watanabe Kazan in another (No. 90). Others are the overspill of poetry, the written characters of the verse seeming to constrain the artist, who bursts into pictorial accompaniment (as in the various *haiga* exhibited). Fans, too, were often a vehicle for spontaneous drawings, either as autographic gifts, or as mementos of convivial gatherings, when it was not unusual for several artists to adorn a fan, invariably with surprising empathy. Other drawings are the very first stirrings in an unfathomable sequence that led to famous paintings or prints. Hokusai's first thoughts for some of the "One Hundred Views of Fuji" (Nos. 71 and 72) are among the most remarkable: they bring us into an artist's studio at the moment the brush gives shape to the "forms of things unknown," existing until then only as imaginative visions in the artist's mind.

Most drawings, certainly those of the "sketch" kind, were left unsigned, and although the hands of some masters are immediately recognizable, our expertise is not so far advanced that we can put a name to every unsigned drawing: many have to be left in the limbo of one or other of the schools—the Shijō or Nanga, say—or, in a more sharply focused location, in the entourage of one or other of the well-known masters. An exhibition of drawings offers wall space to comparative unknowns, men whose names are never likely to figure in the "Who's Who" of the arts. Many a minor artist or happy

amateur at some time makes a perfect drawing — the hand performs a single, slight, unconscious miracle, although it could never sustain the effort, nor call upon the profounder skills, needed to bring a fully deliberated painting to fruition. And so here, alongside the truly great names, are those of Nonoyama Kōzan, with his exquisite arrangements of crayfish (No. 109); and Kagawa Hōen, whose affectionate study of a chimpanzee falls just short of sentimentality (No. 110); and others for whom no name can be given, who yet have left small tokens of their personalities in drawings like the provocative *Standing Woman* (No. 137).

There is another kind of drawing that particularly defies identification of the artist because it is so slight: as if we were to be faced not with a line of verse, by which an author reveals himself, but by a single evocative word. Quite often, such drawings are indeed counterpointing verses that themselves rely on half-hints: *haiga*, like the Sōchō (No. 82) are the supreme examples of this kind of a double obscurity dissolving in light. But there was also, quite apart from *haiga*, an actual cultivation of the insignificant for its own sake. Drawings equally trifling have been left by Western artists, but more often than not, at least until modern times and the unconscious borrowing of ideas from the Japanese, they were tentative beginnings, or brief notes, or aimless jottings: with the Japanese, there was deliberate intention, a conscious search for the minimal, in which touch and placement were critical. A drawing such as the Hōitsu (No. 85) may be thought of as the apotheosis of the slight: and note that he has signed and sealed it in a manner which asserts that the drawing is meant to be taken seriously. Yet, unsigned, it would have needed a clairvoyant to have named the artist. Such unsubstantial drawings do not rely on a technique, a brush stroke, which one might recognize, but on the quirk of a sophisticated intelligence, communicated almost without the volition of the artist.

Some artists, especially those of the Shijō persuasion, enjoyed exercising their mastery in a succession of not necessarily connected drawings, using either a scroll unfolding laterally (a *makimono*) where each drawing, as in the delightful Nanrei and Chinnen scrolls exhibited (Nos. 96, 97, 101 and 104), forms a separate entity, to be viewed separately; or an album of bound paper, to which the artist could turn when the fit was upon him, as a diarist to his notebook. The subjects were chosen, one feels, not for any intrinsic interest they might have but simply as vehicles for the parading of a positively flamboyant virtuosity in brushwork (as in the *Ferret* by Nanrei, No. 99). Whatever the ostensible "subject," the *real* subject is the play of the brushlines by which it is depicted, the dissolving washes, the partial veiling of one color by another, the crucial accents, the revelation of the texture of the paper by the sunk pools of ink or color, and the ridges and pits evoked by a dry brush.

The appreciation of Nanga, especially in its more extreme form as *bunjinga*, is of comparatively recent date in the West, and it astonishes us now to read the Japanophile Fenollosa's calumny of what he calls the "bunjinga fanatics," accusing them of an art that was "hardly more than an awkward joke." Taiga and Buson, whom Fenollosa specifically condemns, are now seen as masters of a kind of art that almost certainly we have come to accept by the enlargement of our capacity for aesthetic experiences brought about by our own modern Western artists. We can follow the historical development of Nanga from the *wenjênhua* of China, but we are conditioned to receive it and enjoy it by the lessons of the artists of l'École de Paris. Among all the Nanga practitioners none has risen more spectacularly in esteem than Uragami Gyokudō — not only among us but among the Japanese themselves, thus possibly reflecting the way a knowledge of Western concepts and practice has influenced *them*. It is significant that perhaps the only counterpart in

Western painting to Gyokudō's restless, thrusting peaks and rocks are the vortical cypresses of van Gogh's paintings: trees that we sense respond to and externalize the commotion of a tortured mind and spirit. With brush in hand, Gyokudō was literally "possessed," and if not actually intoxicated with wine, as on some paintings he expressly stated he was, then under the influence of some overmastering emotion. We are swept on by landscapes that are passionate to a degree very few other artists attain, the world is in a state of flux and Gyokudō endeavors to keep track of it with a brush that swoops and darts as if tracking seismological movement.

Followers of the Zen sect produced their own curiously brusque, offhand tracts, using a scriptural shorthand as obscure as the *kōan* (or riddle-me-rees) propounded by the monks to the acolytes. A distorted Daruma (like that in the Hakuin drawing, No. 7) is to them an anti-art emblem of their anti-religion, but we reinterpret it in our own purely graphic terms. The Sengai drawing of Tao Chi taking an axe to his zither (No. 95) may have been full of profound syllogisms for those who could read the inscription, and the still fewer who could interpret it; but for most of us outsiders—before it is explained, and even afterwards — it conveys a zany impetuosity to which both rough calligraphy and drunken brushline contribute.

Perhaps these two drawings, more than others, pose the warning that most of us simply convert Japanese drawings into Western drawings, the instantaneous coordination of eye to brain — bypassing whatever knowledge we may have of Japanese life, mores, religion and art — setting in motion exactly those complex subconscious assessments that come into play when we view any Western drawing: unwittingly, we rob the foreign drawing of its nationality and "naturalize" it for our understanding. Certain Hokusai drawings were acclaimed on their first introduction to the West because they had qualities that appealed to the connoisseurs of European Old Master drawings. Two in particular exemplify this proclivity: *The Rape* (No. 69), and the *Warrior on a Rearing Horse* (No. 70). In both, the vigorous action, the embroglio of clashing lines and tones, graphically express the artist's feverish search for the solution to a problem he has created, and which only he can resolve. The lines fly in every direction, improvisations are repeatedly discarded and overlaid by afterthoughts, and when at last finality is achieved, it can only be established by a bolder superimposed line that cancels everything earlier, or, as in the case of the mounted warrior's head, by a complete redrawing on a fresh piece of paper that is pasted in position, the collage effect of the shape of contrasting paper adding a further dimension quite beyond the calculation of the artist. Goncourt and Focillon both recorded the deep impression made upon them by these drawings, but Gauguin, referring either to the *Warrior on a Rearing Horse* or another drawing very like it, makes it obvious that his admiration stems from the fact that the Japanese drawing falls naturally into place beside the European. He wrote in his *Journal*: "In this warrior of Hokusai, Raphael's Saint Michael has become Japanese. In another drawing of his, he and Michel Angelo meet. Hokusai draws freely. To draw freely is not to lie to oneself."[1]

Gauguin is explicit, but the initial favorable response of others in the West has been due to a quite unconscious alignment of the Japanese drawings on the same plane as Western drawings with which they are familiar and in which they find points of resemblance. "First reactions" do not have to be dismissed out-of-hand: indeed, we cannot deny instincts that are ours by birthright and reinforced by upbringing; nor, in fact, is it without value to the Japanese themselves that we should give free rein to our inclinations — occasionally our attitudes have led them to look more closely at their own art, to experience what they have missed or undervalued until admired by us (one could cite

Ukiyo-e in general, and Sharaku in particular, as cogent examples). But it is also worthwhile for us to endeavor to come closer to an understanding of the Japanese response to their drawings, and to that end the catalogue notes that follow attempt to situate the drawings, where possible, in their native context, not as isolated phenomena but as chance survivals that may bespeak a period, a school, a movement, a known artist, an individual style, particular commissions. Such facts and suppositions can only be peripheral to the appreciation of the drawings as drawings, but they help to restore them to their original settings, where they may perhaps be seen to better advantage and convey more significance.

[1]From *The Intimate Journals of Paul Gauguin* (translated by van Wyck Brook, 1952).

Color Plates

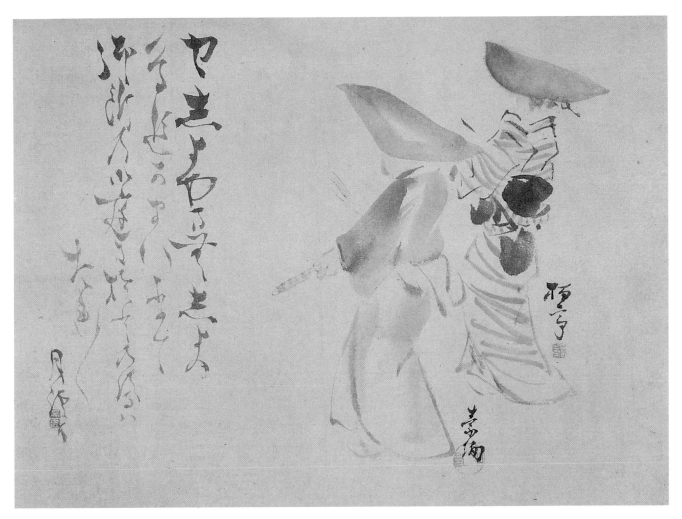

24. *Strolling entertainers*. Yamaguchi Soken (1759-1818) and Nishimura Nantei (1755-1834)

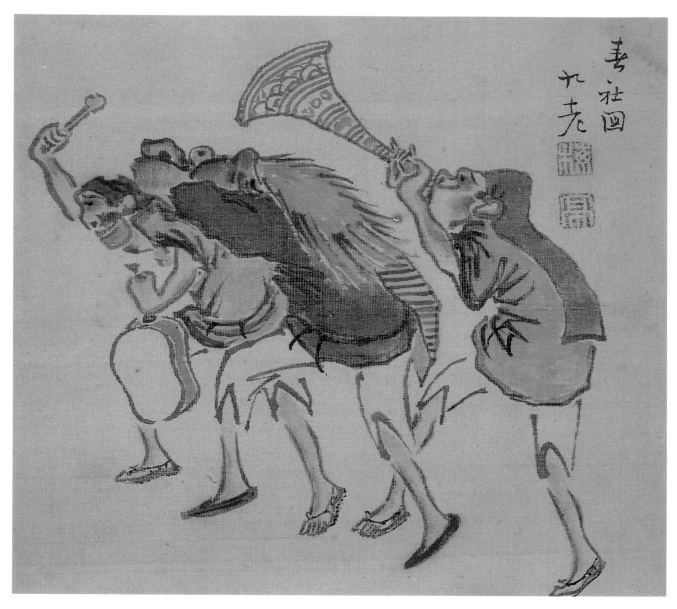

26. *Festival musicians and dancer.* Ki Baitei (1734-1810)

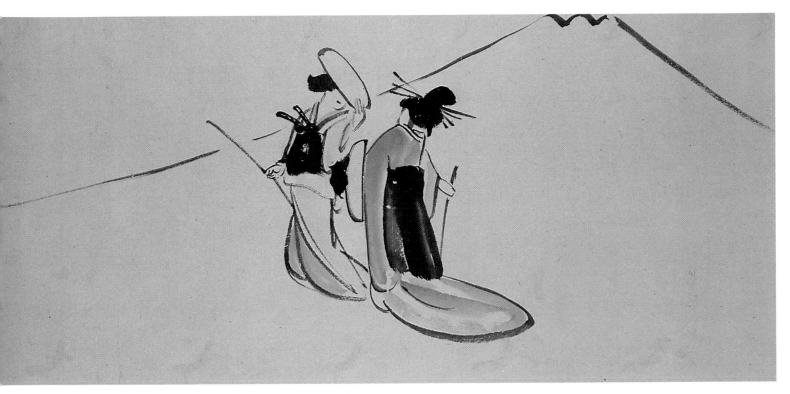

28. *The Bridal Journey.* Jichōsai (Last Qtr. 18th century)

41. *A sheet of figures in the "abbreviated style."* Keisai Masayoshi (1761-1824)

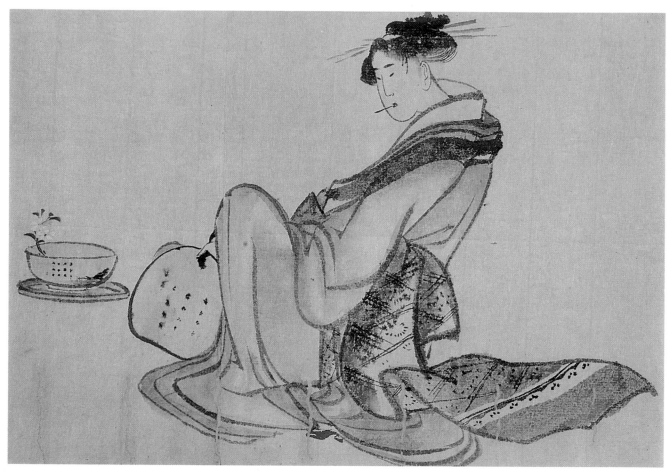

56. *Seated beauty with a fan*. Katsushika Hokusai (1760-1849)

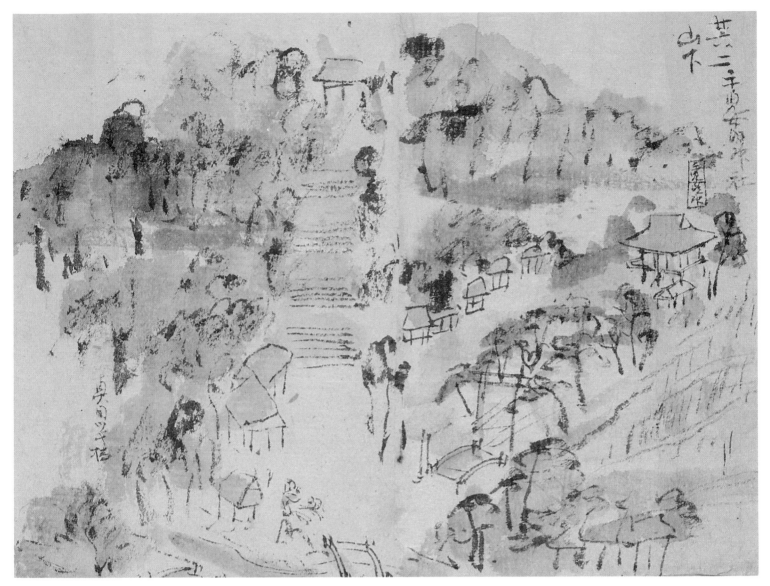

81. *Travel sketches of Kōnodai.* Tani Bunchō (1763-1840)

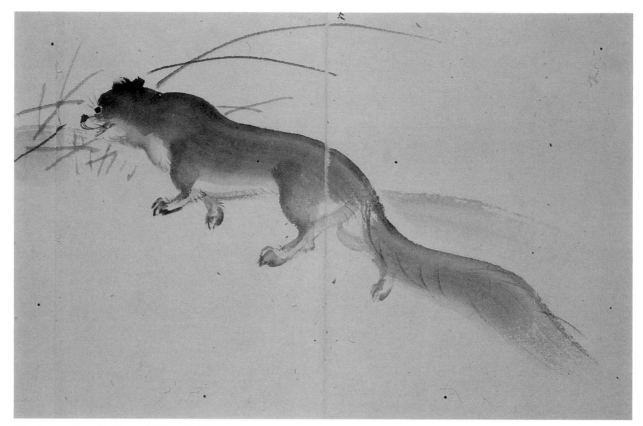

99. *Ferret.* Suzuki Nanrei (1775-1844)

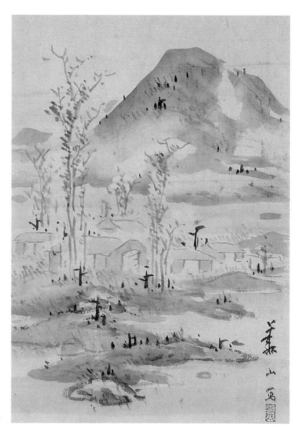

107. *Autumn landscape with a village below a mountain.* Yokoyama Kazan (1784-1837)

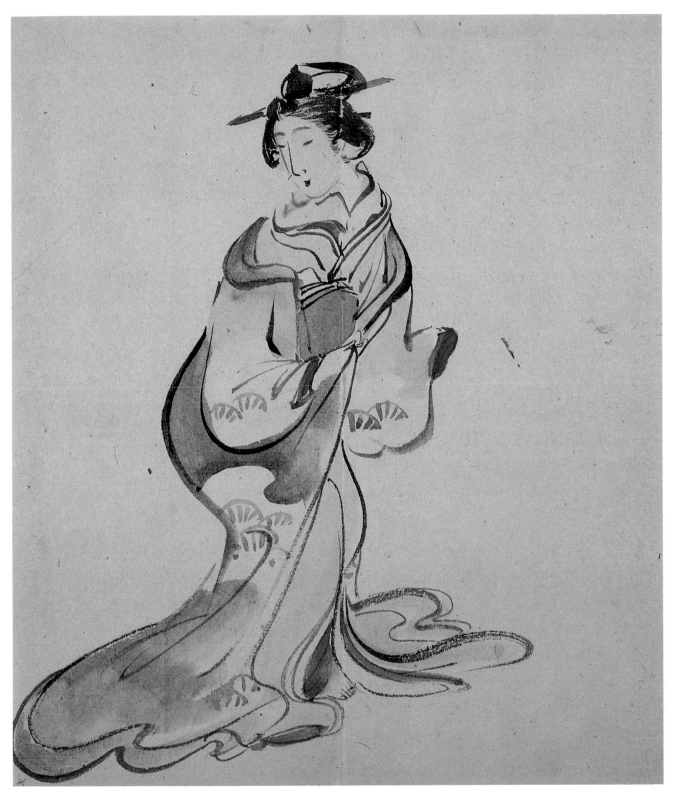

108. *Standing figure of a young woman.* Attributed to Katsura Seiyō (1786-1860)

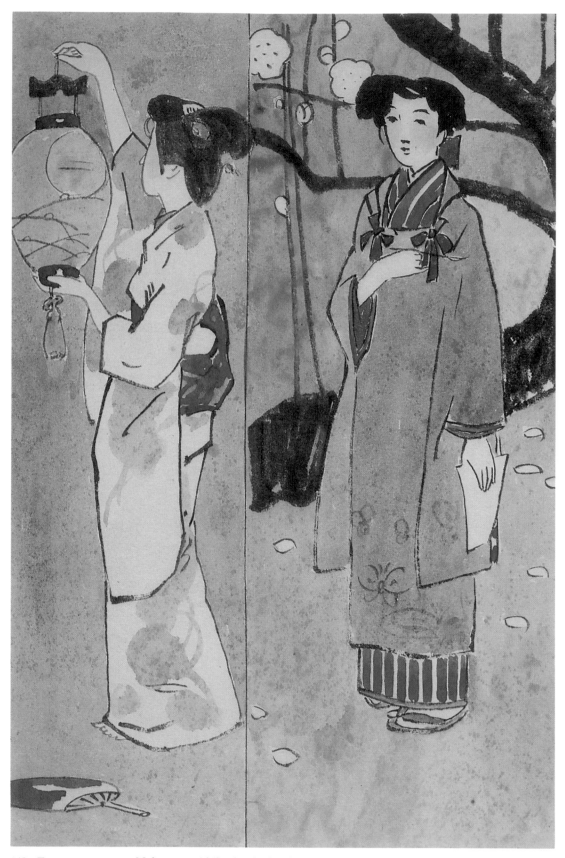

142. *Two young women.* Nakamura Akika (end of 19th century)

JAPANESE DRAWINGS
OF THE
18TH AND 19TH CENTURIES

SUMIYOSHI GUKEI
(1631-1705)

Gukei is a convenient starting point for this selection of drawings of the 18th and 19th centuries, since he had his roots in the native Japanese tradition of a much earlier period and represents that "old world" with which so much of the art of the post-17th century is strongly contrasted. The Sumiyoshi family stemmed from Jokei, Gukei's father, who was a pupil of a Tosa master and so had distant ancestors in the medieval Yamato-e. But Gukei, while painting frequently in the tight, detailed Tosa manner, occasionally showed greater freedom in a more Kanō-type brush-work, and in his best-known work, *Life in the Capital and Suburbs* (in the Tokyo National Museum), can be seen as a pioneer of Ukiyo-e.

The preliminary drawings for an *Ise Monogatari* scroll, exhibited, show a deftness of touch and line that would have been lost in the final version. The scroll is thought to be-long to the latter part of the artist's career, and although its actual date cannot be established, it is near enough to 1700 to make a fitting opening to the two centuries of drawings that follow.

1. Narihira on a Journey. The *norimon* (carriage) and the retinue of followers suggest that the scene represents a halt on Narihira's return from exile, when he visits an old flame. No finished work based on this sketch-scroll has been recorded.

Signed (at end of scroll): *Hōgen Gukei shita-e; Sumiyoshi Naiki.*
Ink on paper.
From a *makimono*; height 19.2 cm.
Literature: R. Lane, "A Gallery of Ukiyo-e Paintings (XX)," in *Ukiyo-e*, No. 76, illustrating two other sections, including the signed end section.
Collection: Richard Lane, Kyoto.

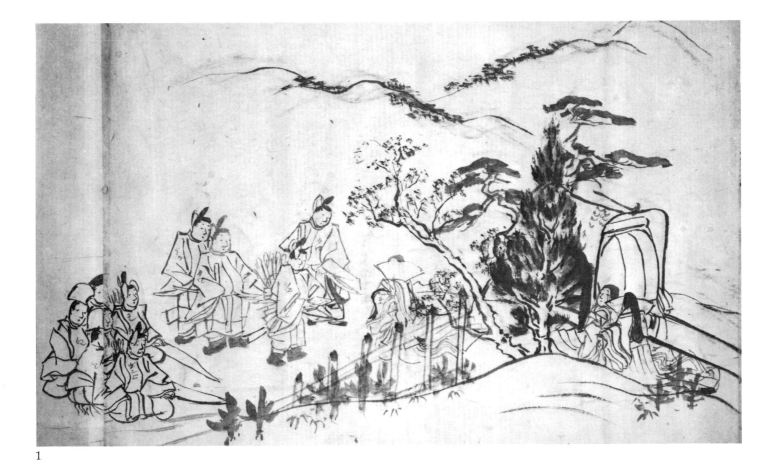

1

HANABUSA ITCHŌ
(1652-1724)

Itchō is one of those artists who resist classification. Coming as a youth of fifteen to Edo from his birthplace near Osaka, he was enrolled as a student of that paradigm of Kanō virtues, Yasunobu, but soon left, or was expelled by, his master. He was attracted more by the color of Tosa and the license of Ukiyo-e, and his mature work is often undisguised genre, imbued with such gaiety and verve that the academic tradition underlying his brushwork is easily overlooked.

His adult life was stormy and he gained a reputation for bohemianism and nonconformity. He was, nonetheless, at the center of Edo intellectual life, studying *haiku* composition with Bashō and calligraphy with Sasaki Genryū. He fell afoul of the establishment on a number of occasions, suffering a term of imprisonment and, from 1698 to 1709, a period of exile on the island of Miyake.

Itchō's humorous and vivacious sketches were extremely popular in the 18th century, and several picture-books based on his drawings, prepared for the block cutters by Ippō or Rinshō, were published, including *Ehon Zuhen* (1751) and *Eihitsu Hyakuga* (1773).

2. Young woman trampling clothes in a stream. She is no ordinary laundress, but must be intended for the girl whose bared limbs so distracted the holy Kume that he lost his power of flight and plummeted ignominiously from the sky whence he had been ogling her.

This drawing of marvelously fluid line comes from a remarkable repository of Itchō drawings that were mounted in scroll form. In 1813 the author Nampō wrote a colophon to

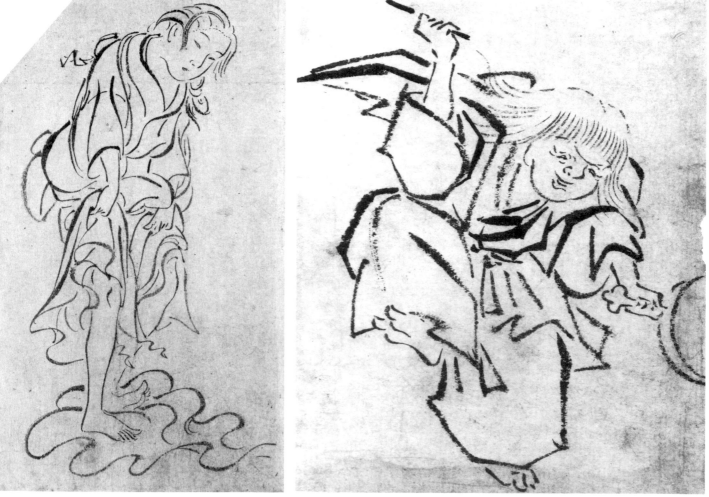

2

3

the scroll, stating that it had belonged to the artist's wife, the presumption being that it passed to her on Itchō's death and that the drawings were made in the last years of the artist's life, after his return from exile.

The slightly scandalous subject became a fairly common one for Ukiyo-e artists, who always enjoyed portraying the discomfiture of holy men. It is unlikely that Sukenobu could ever have seen this drawing, but the winsomeness of the girl and the system of rippling curves both reappear in his work some decades later.

Unsigned.
Ink on paper.
14.5 x 15.4 cm.
Literature: Ostier, No. 3, illustrated; Schack, No. 2, illustrated; *Japanske Hadtegninger.*
Collection: Gerhard Schack.

3. New Year dancer. He is whirling on one leg, holding a tambourine, or drum, in one hand and a stick with which to beat it in the other.

Unsigned.
Ink on paper.
14.5 x 11.5 cm.
Literature: Ostier, No. 95; Schack, No. 15.
Collection: Gerhard Schack .

4. Street performer. Holding a fan behind his back, he is balancing a stick on the end of his nose; a young urchin points excitedly to some object above the man's head, perhaps a ring that had to be caught on the stick. Quite often, *ame-uri* (jelly-sweet vendors) attracted children by juggling, or by performing with puppets or *karakuri* (mechanical toys), though in this drawing the man is not shown with a stand for any wares.

This seems to be a drawing of roughly the same period as those described in Nos. 2 and 3—that is, between 1709 and 1724.

Unsigned.
Ink on paper.
34.4 x 23.4 cm.
Collection: E. Biedermann, Bern.

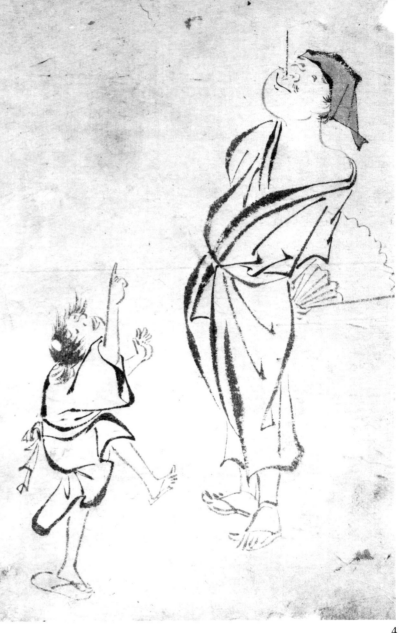

4

ŌGATA KŌRIN
(1658-1716)

We think of Kōrin as the great decorator, the creator of screens patterned with wilfully manipulated natural forms in gorgeous, arbitrary color: it is such works that make him a key figure in the great efflorescence of native art called "Genroku," after the name of the era (lasting from 1688 to 1703) central to the cultural explosion. The screens are among the most deliberate and calculated of all Japanese paintings and the furthest from our concept of a drawing, but there are other sides to Kōrin's art. First, there is a very personal handling of *sumi* in paintings that demand a completely extempore freshness, a reliance on *premier coup* that is the very opposite to the highly-wrought screen paintings, and of which the *Hotei* in the exhibition is a fine example; and second, an aptitude in drawing from nature that anticipates Ōkyo's neo-naturalism, and which resulted in such fine studies as the *Album of Birds and Animals* in the Yamato Bunka-kan (unfortunately not available for exhibition).

5. Hotei seated in front of his bag, his gnarled staff beside him. *Uchiwa*, non-folding fans, were often decorated for friends at convivial gatherings. This genial drawing, where the sweeping curves perfectly describe the rotundity of both Hotei and his bag and where the accents of the upper garment and the staff are so effectively placed, is in the spirit of such an occasion. The gold ground gives a hint of the extravagant *de luxe* for which Kōrin was censured by the authorities during his lifetime.

Signed: *Kōrin*; seal: *Kanse*.
Ink and slight color on gold.
Uchiwa; 21.3 x 22.5 cm.
The University of Michigan Museum of Art,
　　Margaret Watson Parker Art Collection.

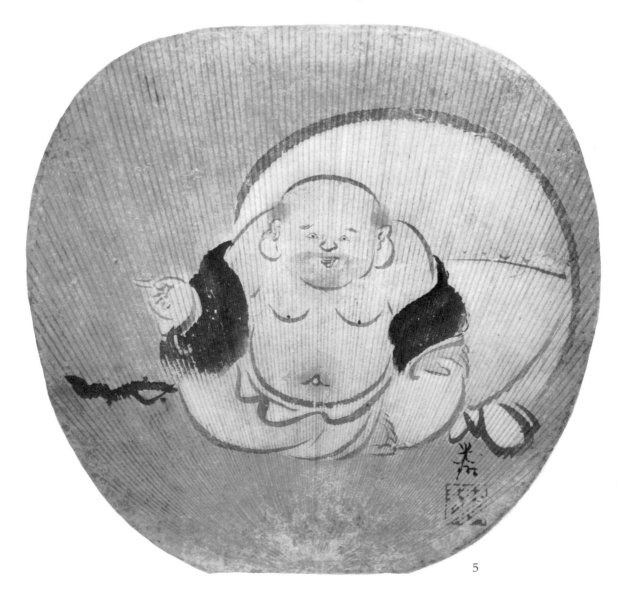

5

WATANABE SHIKŌ
(1684-1755)

Like most artists of the *samurai* class, Shikō studied first under a Kanō master, but eventually followed Kōrin, whose style he found more congenial. There are a number of screen paintings that demonstrate Shikō's individuality as a decorative artist in the Rimpa mould, even when he directly challenges Kōrin in such works as the "Iris" screens in The Cleveland Museum of Art. Like Kōrin, Shikō made numerous drawings from nature and the *makimono* of plovers, finches and other birds exhibited makes it easy to understand why Ōkyo found him such a great source of inspiration.

6. Studies of wild birds. The practice of making drawings from nature, especially of birds, was more widespread in Japan than we are led to expect. Tanyū and Kōrin are among the more illustrious who left drawings of this kind, and Ōkyo's famous *shasei*, realistic or naturalistic studies, seem to have owed a great deal to Shikō. Shikō shows an evident interest in lifelike realism, even down to ornithological detail, and although such drawings were the basis of the convincing structure and buoyancy of birds even when they formed part of daringly artificial compositions, there seems to have been a pleasure in the "drawings from nature" for their own sake.

In the section of the scroll exhibited, the birds are (right) *hototogisu*, a species of cuckoo; (upper left) *suzume*, the common sparrow; and (lower left) *jōbitaki*, a redstart, (which Shikō labels a male, although it is almost certainly a female).

At the side of a plover on another section of the scroll is the date *Kyōhō 18* (1733).

Ink and color on paper.
From a *makimono*; height 26.8 cm.
Literature: *Rimpa*, Catalogue of a Special Exhibition Celebrating the Centennial of the Tokyo National Museum, Tokyo, 1972, No. 189.
Collection: Takanari Mitsui, Tokyo, Japan.

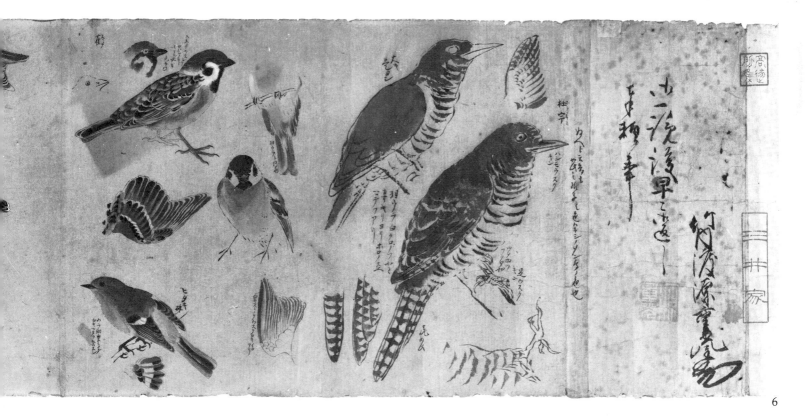

6

EKAKU HAKUIN
(1685-1768)

Hakuin is one of the most famous and influential Zen monks of the Edo period, and his calligraphy and paintings are now appreciated far beyond the confines of the sect in whose cause he produced them. His drawings have all the irrationality of the conundrums posed to acolytes and the sudden thump with a stick administered without warning to innocent questioners by unsmiling priests.

Hakuin entered the Zen temple of Shōin-ji, Hara, at the age of fifteen, and thereafter, with growing renown, traveled and taught in temples throughout the country. His writings have become part of the testament of Zen.

7. The seated figure of Daruma. He is in the traditional *menpeki* pose, the "facing the wall" position which he assumed during his nine years of withdrawal from worldly affairs at the Shaolin temple in Lo Shang. He is so drawn that the bold outline suggests the form of a *kanji* character, perhaps *tachimachi* ("in a flash").

Unsigned.
Ink on paper.
Kakemono; 32.5 x 44.8 cm.
Collection: Mr. and Mrs. Dennis Wiseman.

7

8. Two women on the bank of a river hanging lengths of cloth, already washed in the stream, on a timber framework. Behind them is a waterwheel worked by water coursing through a trough.

This is evidently a preliminary drawing for a print, an impression of which is in the Tokyo National Museum (No. 491 in the illustrated *Catalogue of Tokyo National Museum; Ukiyo-e Prints (1)*, Tokyo, 1960). The print differs in several respects from the drawing, especially in the upper part, where it bears the title *Chofu no Tamagawa* ("The Crystal River of Chofu"), and a poem associated with that river.

Although signed *Harunobu*, the form of the signature is that which appears on a number of prints thought to be by Harushige (Shiba Kōkan) who openly admitted in his memoires

to having forged Harunobu's signature. The style, the weakness of the drawing of the wheel, and the hairstyles also suggest another hand, and of slightly later period, than Harunobu's, though whether, in fact, the artist was Shiba Kōkan or another imitator of Harunobu, has not been conclusively proved.

Signed: *Harunobu ga.*
Ink on paper.
28.8 x 20.0 cm.
Literature: Franz Winzinger, "Eine unbekannte Zeichnung des Suzuki Harunobu," in *Pantheon* Bd. XXVII/4, Munich, 1969; Franz Winzinger, *Die Kunst der japanischen Holzchnitt meister. Sammlung Winzinger* (Catalogue of an exhibition at the Albertina, Vienna, 1972), Nuremburg, 1972.
Collection: Prof. Dr. Franz Winzinger, Regensburg, Federal Republic of Germany.

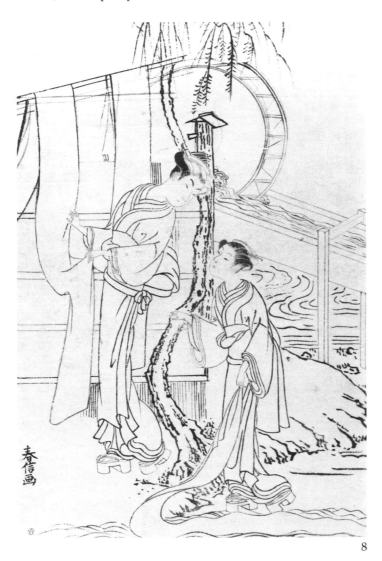

8

IKE NO TAIGA
(1723-1776)

Taiga is archetypal of Nanga painting in its maturity, but he had greater breadth and eclecticism than the majority of his successors. Born of farming stock, he was brought to Kyoto as a boy when his father moved there to work in the silver mint. He was a precocious artist who by the age of fifteen was said to have been supporting his family by painting fans, for which he sought inspiration from the *Hasshū Gafu*, a late 17th-century eight-volume work of Japanese woodcuts after Chinese paintings, including fans, that served as a source-book to so many aspiring Japanese artists.

Unlike many later Nanga artists, Taiga was from the first a professional artist, not always at liberty to paint entirely in accordance with his own inclination, and as a result he left an immense quantity of works variable in style and uneven in quality. His early style shows evidence of a reliance on Chinese models known largely through woodcut paraphrases rather than original paintings, his repertoire of brush strokes for foliage and rocks in particular recalling the flat-printed stereotypes of the block cutters. But in time, he achieved a vitality and a personal idiom that resulted in works decidedly original in either a Chinese or Japanese context. The bamboo in No. 10, so small in dimension, has the force and explosive quality of inspiration breaking through traditional bonds.

9. A river bordered by rocky banks, with a village in the distant inlet, and two boats plying on the stream.

Signed: *Mumei* (Arina); seals: *Mumei* and *Kashōsha*.
Ink on paper.
Kakemono; 27.1 x 63.8 cm.
Keigensai Collection, Berkeley.

10. A short length of a bamboo. The brush in its impetuosity leaves a broken trail (the "flying whites" extolled in China by connoisseurs of painting), and the cane and the leaves are electric with movement.

Signed: *Kashō*; seals not readable.
Ink and color on prepared paper.
Kakemono; fan-shaped, 20.8 x 52.2 cm.
Gift of Mr. and Mrs. James W. Alsdorf and The Alsdorf Foundation, The Art Institute of Chicago.

11. Daruma. The head and shoulders fill the fan and give an illusion of immense size—something which must have caused astonishment when the fan was slowly opened. The technique is intentionally rough, the outlines graceless, the shaded areas unevenly scrubbed in; but the power of the image is undeniable.

Signed: *Kashō*; seals not readable.
Ink on prepared paper.
Fan-shaped; 16.5 x 45.7 cm.
Literature: John Hay, *Nanga Fan Painting* (Catalogue of an exhibition at the Milne-Henderson Gallery, London, 1975), No. 2, illustrated.
Collection: Mrs. and Mrs. John Milne-Henderson, London.

9

10

11

YOSA BUSON
(1716-1783)

Buson is usually bracketed with Taiga as an equal in accomplishment and originality in the Nanga style, but their works are as different as their divergent personalities. Buson, coming from a similar peasant background, became a painter with at first no strong allegiance to any school, though he is believed to have known Hyakusen (d. 1752), one of the founding fathers of Nanga; but he pursued poetry with perhaps an even stronger inclination, and ultimately was assessed as one of the three greatest *haiku* poets, in company with Bashō and Issa. By the 1760s, however, he had become a professional artist, and his manner, in which a love of nature is expressed with something far closer to naturalism than is normal to Taiga, is imbued with the poetry of a dreamer, again the antithesis to the hard-edged massiveness of Taiga. Buson is the model *literatus*, and his free and elliptic drawings, especially for fans and *haiga*, are inseparable from the verses that accompany them, adding images that are obliquely related to the poems, deepening their significance rather than illustrating them, and in forms and line that are contrapuntal to the calligraphy of the written word. The fan of six irregularly spaced stones (No. 12), slight as it may seem, has the same sort of resonant spatial harmony as the *Persimmons* of Mu Chi; in the *Broom, Poems, Poets and Page* (No. 13) the pictorial elements and the text are in the same wildly cursive hand, and provide an enigmatic but satisfying whole even before the verses are translated for us.

12. Haiga with rocks. A group of six rocks of irregular size on a plain ground. At right is a *haiku*: "Willow leaves scatter, the clear stream dwindles, rocks here and there."

The *haiku* was the outcome of a pilgrimage of Buson to a willow tree in Ashino made famous in literature first by Saigyō (1118-90) and then by Bashō, who, retracing Saigyō's footsteps, mentioned it in his travel diary, *Oku no Hosomichi*. For an extended discussion of

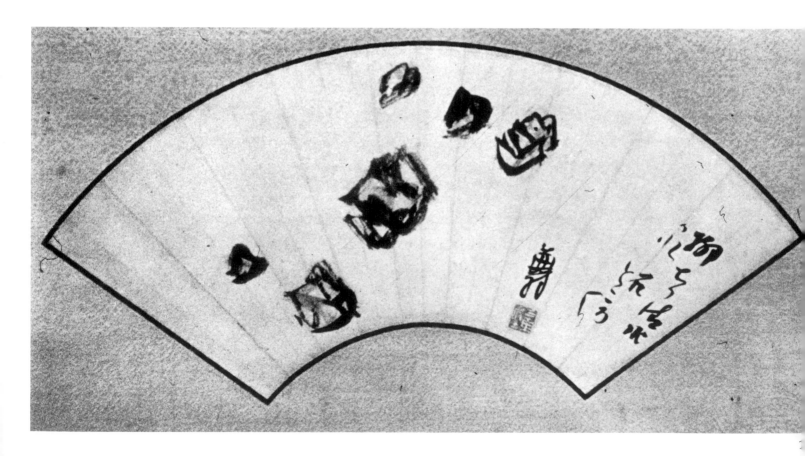

this fan, and of related "rock" paintings by Buson and other painters, see Calvin French and others, *The Poet-Painters: Buson and his Followers* (Ann Arbor, 1974), where it is stated that the *haiku* "first appeared as the opening poem of a series of *haikai no renga* (linked *haiku*) published in 1752 in an anthology entitled *Hogo Busumei*. The fan was painted around twenty years later. Apparently it was a popular theme, for Buson executed another version as a hanging scroll in 1780 (in Itsuō Museum, Ikeda, reproduced in *Itsuō Bijutsukan*, P1.19).

Signed: *Buson*; seal: *Sanka Koji*.
Ink on paper.
Fan mounted as *kakemono*; 22.2 x 47.0 cm.
Literature: *Poet-Painters*, No. 18, illustrated.
Private Collection.

13. Broom, poems, poet and page *(haiga)*.
Two themes are interlocked: the twig broom, prefaced by the verse,

> One sweep, one splash
> And earthly dust is gone,

and followed by another, signed *Buson*,

> Departing spring—
> I brush the fallen blossoms
> From my behind;

and the poet and his page, who may be imagined brushing petals from his master's coat, threading their way between that second verse and the two further *haiku*:

> First drizzling rain—
> A drop from my hat
> on the eyebrow;

and

> Passing the village
> Finding the willow
> Along the old walk.

The final verse is signed with another *gō* of the artist, *Yahan*.

Ink and slight color on silk.
16.6 x 29.2 cm.
Literature: *Poet-Painters*, No. 15, illustrated.
The University of Michigan Museum of Art, Margaret Watson Parker Art Collection.

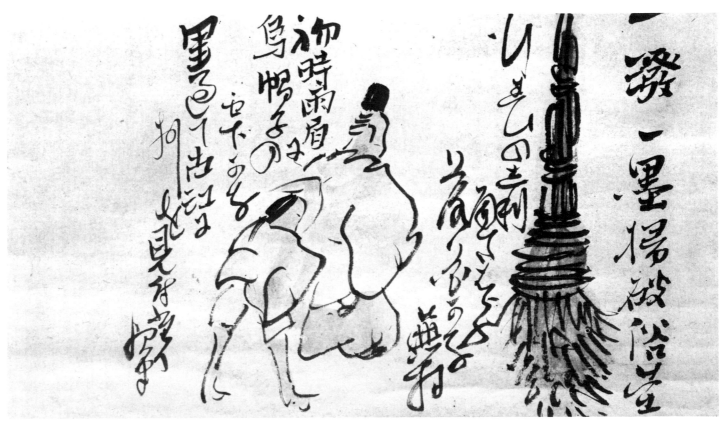

13

屋然依人軽恕牧

佛征衣欲出浮

游独山雪出岫

茂山亭舊作

廣水口并作

高陽山人廷沖

Kōyō was one of that band who, in the mid-18th century, became obsessed with Chinese culture, and he is said to have made hundreds of copies of Sung paintings. As a result of his preoccupation with Chinese art, he seems to have associated with Hyakusen, and may have been a pupil of that early Nanga master. Not a great number of original works by Kōyō are known, but he is interesting to us in any consideration of Japanese drawing because, as Professor James Cahill says (in a penetrating account of Kōyō's work which appears in an article devoted primarily to Hyakusen in *Bijutsu-shi,* see below): "he treats his paintings more as calligraphic than as pictorial performances; his line drawing is in constant movement, but the movement is confined to the surface."

It is this frank non-naturalism that, in a drawing like the one exhibited, reminds us strongly of the Fauvist paintings of such artists as Derain, Matisse and Braque; though Kōyō's effect is enhanced by the rakish calligraphy that complements the brusque drawing.

14. A Chinese sage—the eternal staffage figure of Nanga painting—leaves his hut, built below tall trees and in the shadow of a mountain bluff. Chinese poem above.

Signed: *Kōyō-sanjin Teichū*; seals: *Teichū* and *Shiwa*.
Ink on paper.
Kakemono; 30.5 x 17.8 cm.
Literature: James Cahill, "Sakaki Hyakusen no Kaiga Yoshiki," *Bijutsu-shi,* Nos. 93/96, 1976.
Manyoan Collection.

14

YOKOI YAYŪ
(1702-1783)

Yayū was a *samurai* in the service of the *daimyō* of Owari and can truly be thought of as an amateur in the arts of both *haiku* and painting. At his best, his *haiga* make their point as compositions in which the slight drawings complement the calligraphy and are read, as it were, as part of the poem. In a famous *haiga*, for the first word of the poem "Morning glories thatch my hermitage," Issa substituted a drawing of a flower on the vine; in the "Mushroom gatherer," Yayū's drawing literally underlines the verse, acting almost like those pregnant dots . . . that awake surmise as to something lying beyond the previous words.

15. A string of *kinoko*, the edible mushroom in season in the autumn. The accompanying *haiku* reads:

> Not looking up:
> Even the eye is greedy—
> The mushroom-gatherers.

Signed: *Yayū*
Ink on paper.
Kakemono; 31.1 x 49.1 cm.
Exhibited: Hoppō Bunka Hakubutsukan, Niigata, 1950; Kunstgewerbemuseum, Zurich, *Japanische Tsuchmalerie Nanga und Haiga*, 1962, P1.4.
Collection: Museum Rietberg Zurich (Gift of Dr. Eberhard Fischer, Zurich).

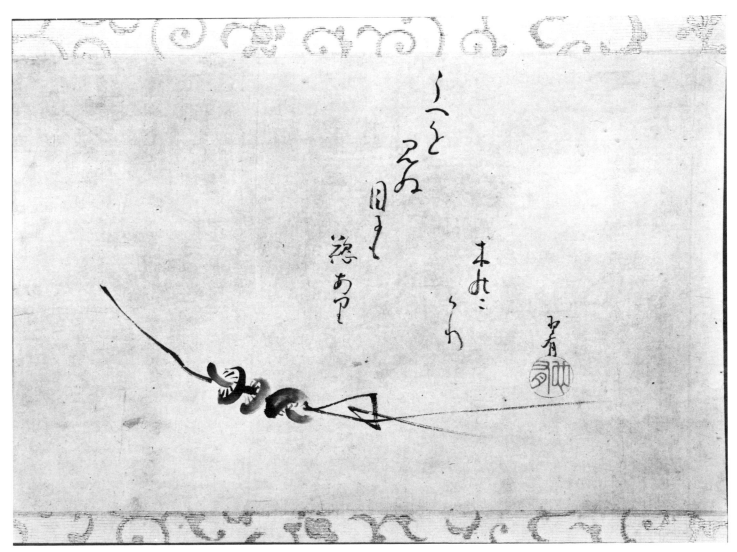

15

NAGASAWA ROSETSU
(1755-1799)

It is a modern tendency to undermine the Establishment, whatever the sphere, but sometimes iconoclasm turns to vandalism. Ōkyo today is suffering from a reaction against the over-fulsome idolization of 19th-century art lovers in Japan, an opposition voiced by Morrison as early as 1911 in his *Painters of Japan* where he wrote: ". . . I must confess that no other painter in the first rank—where he undoubtedly stands—leaves me as cold as does Ōkyo. The coldness is his own. His mastery over his means is almost too perfect, if such a thing may be"; and since then it has been repeated by others who have belittled Ōkyo in comparison with his brilliant pupil Rosetsu.

But if we look back to the time of Ōkyo's struggles as an innovator, as the reformer who led the "return to nature" movement and brought fresh air into areas of Japanese art that had become stagnant, we encounter some of the most vital naturalistic drawing of the 18th century. There is nothing cold in the bird and animal studies which he made in a new approach to the world about him, with a

reverence for nature that has led the Japanese themselves to compare him to Wordsworth. These firsthand studies were crucial to the development of the Maruyama and Shijō movements and had a profound effect on the course of Japanese painting in the 19th century. The finest of these studies, in scroll and album, remain in Japan and unhappily could not be lent to this exhibition, but Ōkyo's presence is felt in the works of a number of gifted pupils and followers who are well represented.

Not all the artists assessed in the 19th century as the "Ten Great Pupils of Ōkyo" impress us today, and other followers, not named in that company, like Nantei and Nangaku, are more highly thought of than, say, Kakurei and Kirei, who are. But in the promotions and reversals brought about by the evolution of taste, no artist has advanced more rapidly to the fore than Rosetsu, who in the last twenty years has claimed more of the limelight in literature and exhibition than Ōkyo. Robert Moes even goes so far as to

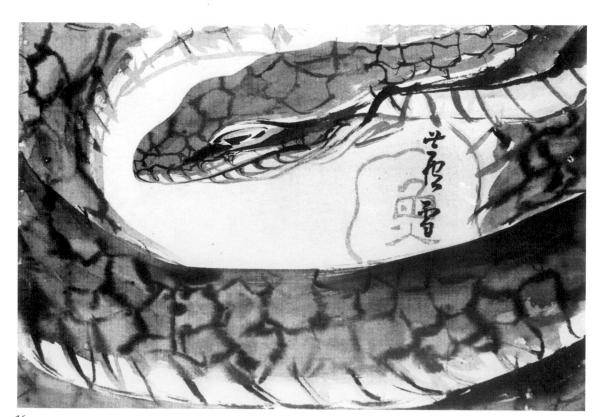

16

make the controversial statement, in his *Rosetsu*, 1973, that "The more one sees of Rosetsu's work, the more one is convinced that the pupil was a far greater artist than his teacher"—a personal view that would only have validity if we could all agree, for all time, what constitutes greatness in art.

But unquestionably, Rosetsu's obvious rejection of all academic restraints, his completely uninhibited approach to even hackneyed themes, and his dazzling brushwork, appeal to contemporary taste, both in the West and in Japan. He is at his most impressive in the superb large-scale *fusuma* painted for temples in the Nanki region and elsewhere, but the vital spark that we acclaim in those also suffuses even the smaller album sheets and fans.

16. The head of a serpent at the center of its coiled body. The wicked head and the sliminess of the body have been wonderfully suggested by sweeping brush strokes and by drawing the reticulations of the skin over a still wet surface.

Possibly a New Year's gift for the Year of the Snake. If this were the case, it would date the painting to the Snake year 1797, since the break in the Gyo seal (evident on this drawing) is known to have occurred before 1794.

Signed: *Rosetsu utsusu*; seal: *Gyo*.
Ink and slight color on silk.
Kakemono; 19.0 x 29.0 cm.
Collection: Robert G. Sawers, London.

17. Yama-uba and Kintoki. This drawing, on the small scale of the fan, has something of the demoniac power of the artist's great Yama-uba painting in the Itsukushima Shrine. This ugly hag, frantically clutching the baby to her bosom, is an entirely different concept from Utamaro's seductive woman in the series of prints he designed a few years later than the Rosetsu drawing.

Signed: *Heian* (Kyoto) *Rosetsu utsusu*; seal: *Gyo*.
Ink and color on paper.
Fan; 23.2 x 47.3 cm.
Literature: Hillier, 1965, P1. 35; Hillier, 1974, No. 48.
Collection: The Ashmolean Museum, Oxford.

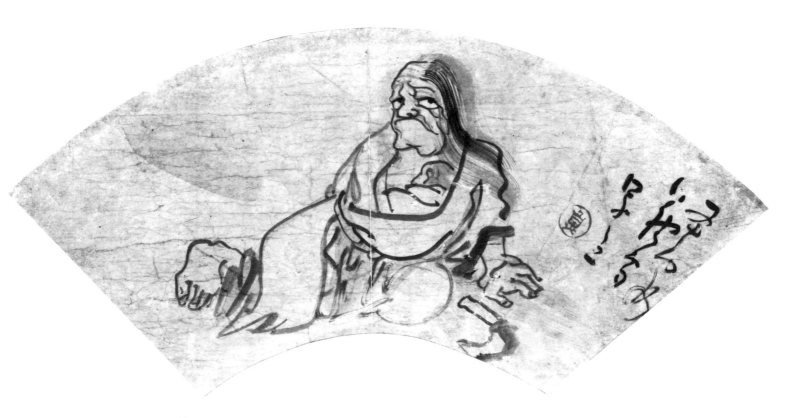

17

MATSUMURA GOSHUN
(1752-1811)

There were two great influences in Goshun's artistic life: the earlier, Buson, from whom he learned to compose *haiku,* to paint in Nanga style, and generally to develop an aura of literati culture; and, after Buson's death in 1783, Maruyama Ōkyo, whose "new Naturalism" he married to Busonesque Nanga, creating the engaging hybrid known as Shijō (a name that is derived from the location of Goshun's studio in Fourth Street, Kyoto). The Shijō school founded by Goshun numbers among its adherents many of the great artists of the 19th century, and it influenced many others, such as Hōitsu, Kiitsu and Hiroshige, who were attached to other schools.

As a follower of Buson, Goshun used the name Gekkei, which appears on numerous *haiga* showing obvious indebtedness to Buson. No. 18 is a case in point, though even

that, with its emphatic asymmetrical placing of the figure and the dashing stripes of the coat, exemplifies treatment that became a feature of Shijō style; and No. 19, although signed *Gekkei,* is now wholly Shijō in its reliance on lively outline and subtly accented areas of wash.

18. Yamabushi. A half-length figure, wearing the traditional rosettes and the *tokin,* a small polygonal hat. At left the poem:

Katsuragi-yama no fumoto nite
Basho-Ō
Nao mitashi
Hana ni akeyuku
Kami ni kao

This is a cryptic Bashō verse copied by Goshun. The meaning is that when the poet sees the beautiful dawn with cherry blossoms below Mount Katsuragi, he cannot believe the

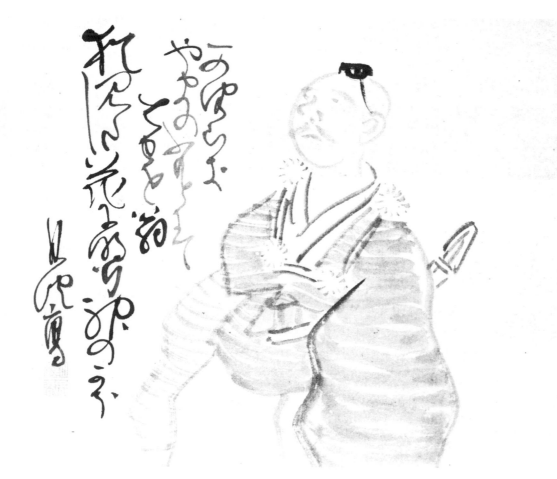

legend that the god of this mountain is ugly, and would like to see the god once again. (The god Hitokonushi no Kami, who only came out at night because of his ugliness, was supposed to live at the foot of Katsuragi-yama.)

Signed: *Gekkei utsusu;* seals: *Gekkei, Goshun.*
Ink on paper.
Kakemono; 26.5 x 44.1 cm.
Private Collection, Amsterdam.

19. Woman kneeling by a small *hibachi* (brazier). At left, the *haiku:*

> *Utsumibi ya*
> *urami yū beki*
> *yoi nikumi.*

"Banked charcoal! How hateful the evening is, as I heap reproaches." When the charcoal is banked, it burns slower and longer: and the verse suggests that the girl heaps reproaches on her lover who keeps her waiting—and her own fire in check.

Signed: *Gekkei dai* (as though to say the *haiku* gives the title to the drawing).
Ink and color on paper.
Kakemono; 30.4 x 51.0 cm.
Manyoan Collection.

20. Six poets seated in a huddle. If they are meant to represent the Immortal Six of tradition, they have been treated by Goshun in a cavalier, parodic manner, but the accompaniment of *haiku* is perhaps intended to identify the figures as modern *haijin* in a *mitate* (or burlesque) of the Rokkasen.

Signed: *Goshun utsusu tansho* (written on the first day of the New Year); seal: *Goshun.*
Ink and color on paper.
Kakemono; 28.3 x 58.6 cm.
Keigensai Collection, Berkeley.

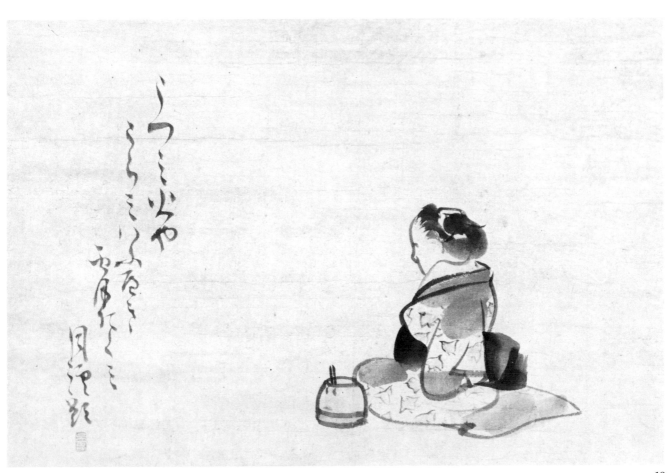

19

21. Five women in a mist. Goshun's vague washes and indefinite outlines give a mysterious air to these anonymous shapes, hurrying to an unknown destination.

Signed: *Goshun;* seals: *Goshun* and *Gekkei.*
Ink and slight color on paper.
Kakemono; 26.0 x 44.7 cm.
Literature: Hillier, 1974, Fig. 25.
Collection: Richard Lane, Kyoto.

22. A woodman wielding an axe. The *haiku* at left is a well-known verse by Buson,

> *Ono irete*
> *ka ni odoroku ya*
> *fuyukodachi.*

This has been translated by R.H. Blyth in his *Haiku,* Vol. IV, p. 351:

> Among the winter trees
> When the axe sank in –
> How taken aback I was at the scent!

Signed: *Gekkei;* seals; *Gekkei* and *Sompaku.*
Light color on paper.
Fan; 16.0 x 43.0 cm.
Collection: Richard Lane, Kyoto.

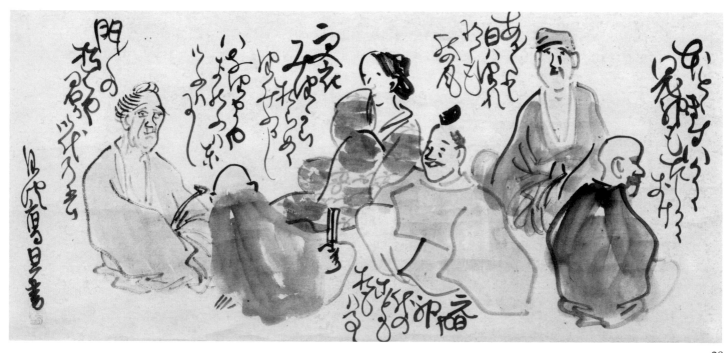

20

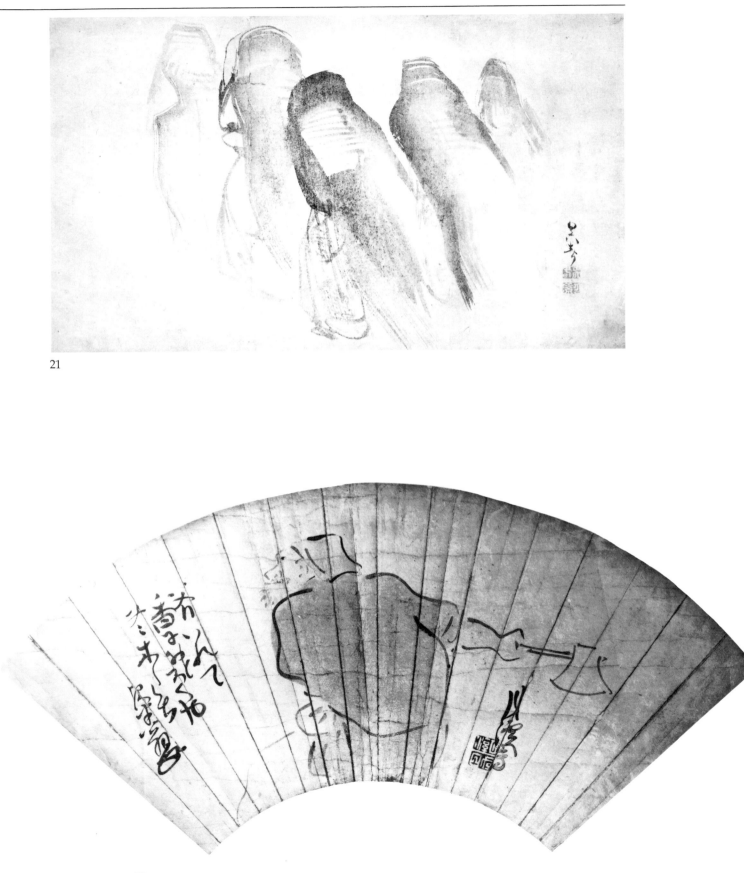

21

22

YAMAGUCHI SOKEN
(1759-1818)

In the West, Soken was for a long period the best known of Ōkyo's "ten most important pupils," not from his paintings, few of which left Japan, but by virtue of a number of *ehon*, notably the two parts of *Yamato Jimbutsu Gafu* (1800 and 1804), *Soken Gafu, Sōka no Bu* (1806) and *Soken Sansui Gafu* (1818), which, in figures, plants and landscapes respectively, all in *sumi*, comprised picture-books that collectors esteemed among the most exceptional of the late 18th to early 19th century. Even today, his paintings have no currency among us, and in any case, their suave competency fails to move us. We prefer the few drawings that remain, which have the same dash and expressiveness as the designs for the *Yamato Jimbutsu* prints.

23. Stalking cat and butterfly. In this confrontation of cat and butterfly, a subject that goes back to remote Chinese antiquity, the coiled-spring immobility of the cat is superbly captured—how relentlessly predatory is that rear leg!—but the ink patterning is half realistic, half decoration, in a manner as much reminiscent of Sōtatsu as of Ōkyo. The drawing is one of a succession of brilliant ink studies in *makimono* form.

Signed (at end of scroll): *Soken;* seal: *Kitsu (tachibana) Soken.*
Ink on paper.
From a *makimono;* height 28.9 cm.
Private Collection.

YAMAGUCHI SOKEN and NISHIMURA NANTEI
(1755-1834)

Like Soken, Nantei was a pupil of Ōkyo and is known mainly by two books of woodcuts after his designs, the *Nantei Gafu*, the first series of 1804 printed in *sumi*, and the second series of 1826 printed in colors.

24. Strolling entertainers. The use of broad brush strokes to give the form of the nearer figure and of both hats, the patterning of the dress of the further figure with stripes that are intended to seem dashed off impetuously—these are characteristics of Shijō style: and Goshun, the founder of the school, wrote the inscription at the side. The text is an old ballad of *torioi*, "wandering entertainers," and begins: "The *torioi* go round, and music can be heard in the Imperial Court," followed by nonsensical refrains.

The nearer figure is by Soken, the further by Nantei. Collaboration, as of the three men in creating this integrated but quite lively sheet, was something fairly common in Nanga, and even more so among Shijō artists, and bespeaks the geniality and ease of relationships in the cultural circles to which they belonged.

Signed: *Soken;* seal: *Yamaguchisai.*
 Nantei; seal: not readable.
 Gekkei; seal *Goshun.*
Ink and color on paper.
38.8 x 47.6 cm.
Ralph Harari Collection, London.

(Reproduced in color on p. 17)

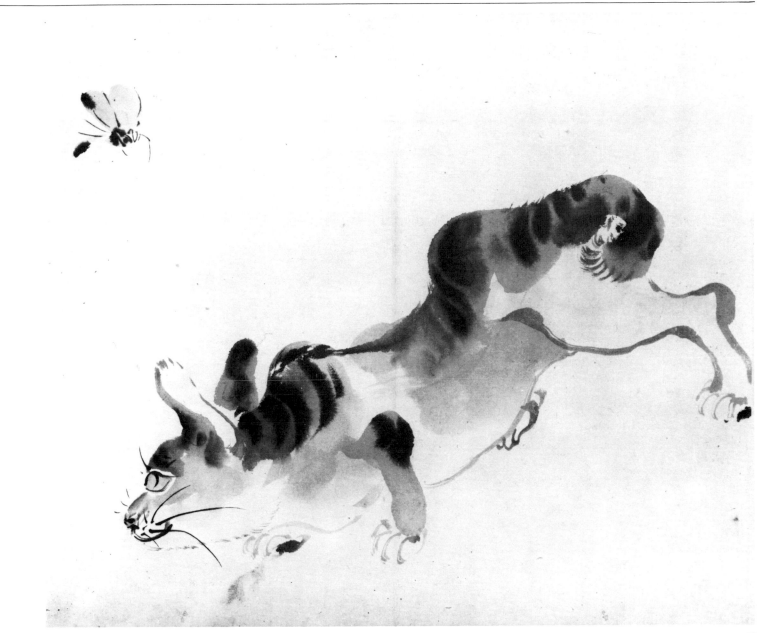

23

KI BAITEI
(1734-1810)

"The Poet-Painters: Buson and his Followers" was a memorable exhibition organized by Calvin French at the University of Michigan Museum of Art in 1974, and included fifteen paintings by Ki Baitei, who until that time was best known in the West by a remarkable book of *sumi* woodcuts based on Baitei's works, the *Kyūrō Gafu* (*Kyūrō* being his most commonly used art-name). For the first time, the stylistic relationship of his paintings to those of his master, Buson, was made manifest, but so also was his own original contribution to Nanga.

Baitei became a pupil of Buson probably in the mid-1770s, and after living for a time in Kyoto, settled in Ōtsu, earning the soubriquet "The Ōmi (or Ōtsu) Buson." He was a writer of *haiku*, but neither in verse nor painting approached the poetry of Buson; on the other hand, he had a certain acerbic wit, expressed in his *haiga*, album drawings and book prints by a laconic line that gives them uncommon bite.

25. A peasant holding a new-born puppy in each hand *(haiga)*. The *haiku* is by Buson (at the side is written *Yahan-ō no ku*, "a poem by Yahan-ō," i.e., Buson) and reads:

> *Meigetsu ni*
> *enokoro suteru*
> *shimobe kan.*

There is a translation by R. H. Blyth in his *Haiku* (Vol. III, p. 391): "The full moon: A man-servant leaving a puppy to die;" but David Waterhouse (by letter) has kindly suggested a much more illuminating version:

> By the light of an autumn moon
> he abandons puppies –
> just look at the scullion!

Signed: *Baitei kore shasu*, "Baitei copied this" (meaning, presumably, the verse: the drawing is very characteristic of Baitei).

Ink and color on paper.

Fan; 20.0 x 50.5 cm.

Collection: Mr. and Mrs. Dennis Wiseman.

26. Festival musicians and dancer. Three performers prancing in procession in a New Year's festival: at the center, one with a *shishimai* ("lion dance") mask over his head; to his right, a drummer; and at his left, a third blowing a wide-mouthed trumpet. Inscribed *Shunsha-zu*, "Spring shrine picture."

Signed: *Kyūrō;* seals: *Bai Tei.*

Ink and color on paper.

From an album; 16.5 x 21.0 cm.

Keigensai Collection, Berkeley.

(Reproduced in color on p. 18)

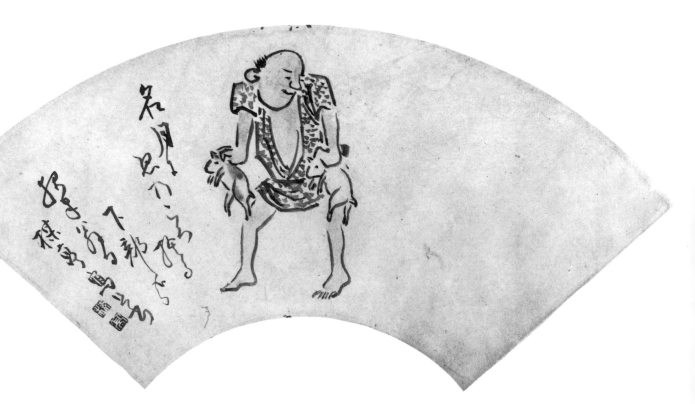

25

JICHŌSAI
(Active Last Quarter of 18th Century)

In the earliest known book with illustrations by this artist, published in 1780, the pronunciation of his *gō* is given as *Nichōsai,* but for some unexplained reason it has always been Romanized as *Jichōsai.* His name was Matsuya Heizaburō, and he was commonly called Matsuhei. A native of Osaka, he was a *sake* brewer and a curio dealer, and was involved as designer in the production of theatrical and puppet performances. He is best known, however, for his *kyōga* ("crazy drawings") and especially for his caricatures of actors.

His work has often been confused with *Toba-e,* the manneristic kind of caricature that earned its name from Toba Sōjō, once thought to be the artist of the famous "Frolicking Animals" scrolls of the 12th century: but Jichōsai's witty and satiric drawings are far more individualistic and the *Six Gods* could not properly be termed *Toba-e.* The fluency and dash of his brush have more in common with *bunjinga.*

Jichōsai illustrated a number of books, from the *Ehon Suiyaku* of 1780 to the *Ehon Kototsugai* of 1805, but his masterpiece is *Katsura Kasane* of 1803, a book of color prints gently making fun of the society of his day. He is believed to have died around 1802/3, but his birth date is not recorded.

27. Six Gods of Good Luck. A drawing in which six of the seven Gods of Good Luck are hit off with typically scurrilous brevity in a simulated childlike incompetence disguising a very adult sophistication. Reading from right to left, and ignoring the smaller attendant children, the figures seem to be Hotei, Ebisu, Jurōjin, Fukurokuju, Daikoku and Benten: but Bishamon is missing—either by a quirk of the artist or, just possibly, from a trimming of the fan at the left-hand side.

Signed: *Jichōsai;* two seals: *Nichi* and *Chō.*
Ink on prepared paper.
Fan; 18.0 x 45.0 cm.
Collection: Mr. and Mrs. Dennis Wiseman.

28. The Bridal Journey. This is a passage from a remarkable *makimono* depicting the scenes of the best-known of all Japanese dramas, the *Chūshinjura,* or "Loyal League." Tonase, wife of Honzō, and her daughter Konami, traveling together to the house of Yuranosuke, the leader of the "Forty-seven Rōnin," have reached Enoshima, and Fuji lies across the Bay. There is a vivid freshness in conception, brushwork and color that sets this version of a hackneyed theme apart.

Unsigned.
Ink and color on paper.
From a *makimono;* height 29.5 cm.
Literature: *Harari Coll.,* Vol. 3, No. 216.
Ralph Harari Collection, London.

(Reproduced in color on p. 19)

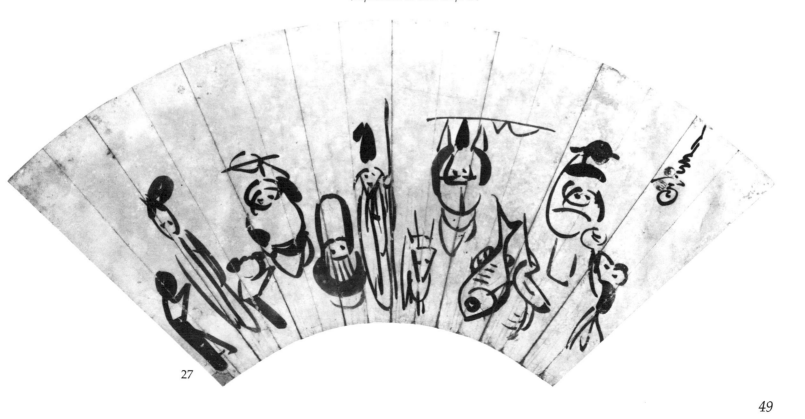

27

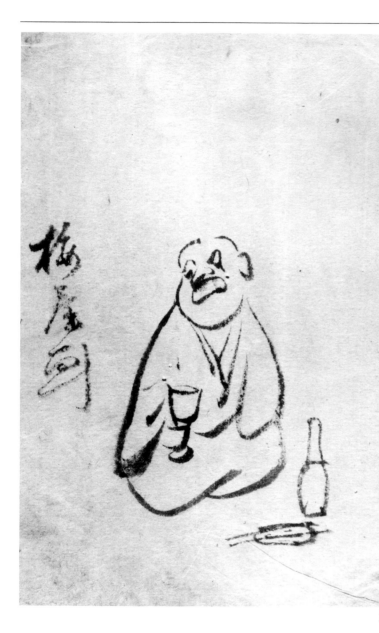

29

The reputation of this artist has grown steadily in the West in the last twenty years as more and more paintings and album drawings have become known and as the taste for literati paintings has developed. A retainer of Masuyama Sessai, a *daimyō* who was himself a Nanga painter of some accomplishment, Baigai was friendly with Gyokudō, and showed awareness also of the work of both Taiga and Buson; but his own very original approach, both in concept and treatment, especially in the smaller album-sized works, is apparent in the four examples exhibited.

29. Tippler, seated with a Western-shaped wine glass in his hand, a *sake* bottle standing and a dish, with *hashi* (chopsticks) resting on it, in front of him. This figure is wholly in the tradition set by Buson in an album, now lost, which served as the model also for Kinkoku for the imaginery portrait of Bashō (see No. 36). Baigai's brushwork gives the impression that the artist shared the inebriation of his drinking companion.

Signed: *Baigai ga.*
Ink and color on paper.
27.0 x 18.0 cm.
Collection: E. Biedermann, Bern.

30. Landscape with lake among hills.
Brushline and depth of color are varied to produce a drawing of immense vitality. From an album. The drawing is very much in style of one from an album in the Gitter Collection (illustrated in *Zenga and Nanga*, 1976, No. 56), and is probably of about the same date, 1802.

Signed: *Baigai Shi;* seals: *Toki Shi.*
Ink and color on paper.
27.1 x 30.6 cm.
Collection: Mr. and Mrs. Dennis Wiseman.

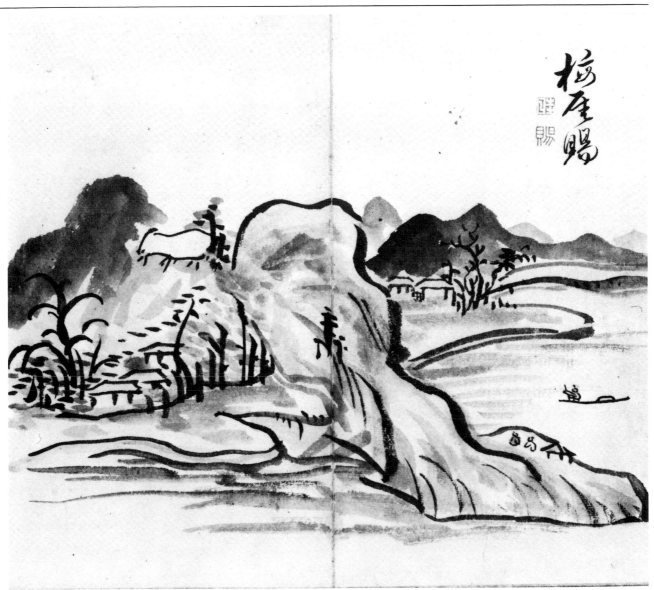

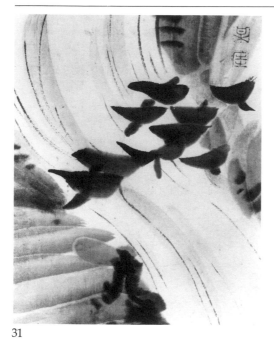

31

31. Flight of birds over a stream. A most daring and surprising drawing, even for an artist of Baigai's known originality. It comes from an album in which Baigai seems to have been trying ink and color experiments that led him far beyond the accepted confines of Nanga, or indeed, any other Japanese style of painting of his day.

Seal: *Baigai.*
Ink and color on paper.
From an album; 11.3 x 13.8 cm.
Manyoan Collection.

32. Valley bridge. An old man with a staff crossing a bridge in a bosky valley below rounded hills. From an album of drawings by Baigai.

Inscription: *Valley Bridge, Eshi.*
Signed: *Baigai;* seal: *Shoku.*
Ink and color on paper.
From an album; 17.8 x 14.6 cm.
Keigensai Collection, Berkeley

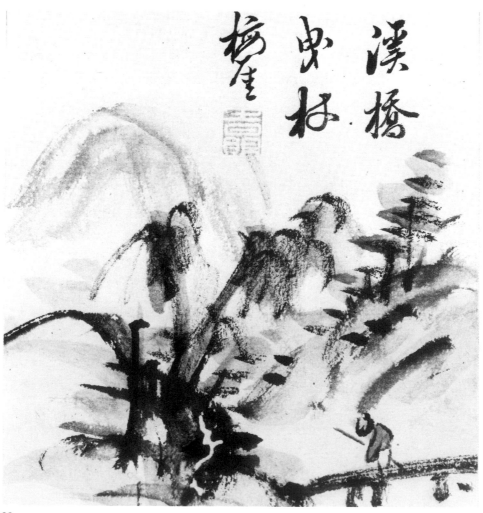

32

URAGAMI GYOKUDŌ
(1745-1820)

The unique contribution of this artist to Japanese painting—perhaps in his case we may be allowed to say to world painting—has already been referred to in the Introduction. Born in Bizen, now Okayama, his father was of *samurai* rank, and Gyokudō originally served a nobleman, Ikeda Masake, in Bizen. But his passion for music soon became evident, and he mastered the *ch'in,* the classic Chinese zither-like instrument, as well as studying painting and verse composition. In 1794 he became a wanderer, leading an often wildly Bohemian life, devoting himself to the arts, and ultimately coming to rest in Kyoto, where he joined the literati circles of Mokubei and Chikuden, both outstanding Nanga painters.

33. In the Ueno mountains. A drawing of two planes, foreground trees with stubby twigs signaling to a distant range of crags. Between them is a void recognized as a stretch of water only by two barely indicated boats. A typical touch of Chinese fantasy is provided by the bridge and pepper-pot pavilion beneath the trees. The inscripton reads: "I stayed here by chance, not knowing when I might return."

From an album of drawings by a number of well-known, chiefly Nanga, artists. Some of the drawings bear dates between the period 1800-1810.

Signed: *Gyokudō Kanshi tsukirite Ueno sanchū*
 ("created by Gyokudō in the Ueno Mountains").
Ink on paper.
From an album; 28.8 x 33.4 cm.
Collection: K. G. Boon.

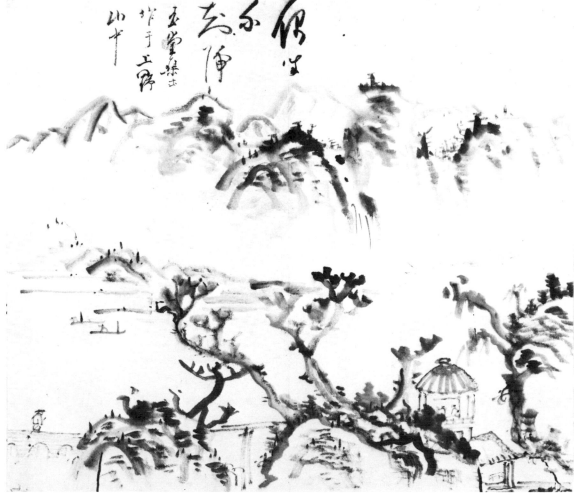

33

34. "Colors Change to Red and Gold." An autumnal landscape whose title, in four Chinese characters, persuades us to convert the *sumi* into autumn colors, and indeed, the variety of ink tone makes the transformation quite simple. The inevitable sage, on the bridge at right, is more than usually diminished by the immensity of the natural forms, and the hut is veritably an isolated lodging, whose resident, glimpsed at the window, awaits the approaching companion.

Signed: *Gyokudō, at the age of 70* (1814).
Ink on paper.
Kakemono; 26.0 x 30.0 cm.
Kurt and Millie Gitter Collection.

35. Three small landscapes and a panel of calligraphy. The landscapes, especially the center mountain scene, have the edgy, agitated line with the sort of penetrating timbre that persists even in complex choral passages. The titles of the landscapes inscribed by the artist are (from upper to lower): *Seeking the lake in the landscape ("clouds and smoke"); Craving summer clouds;* and *A way beneath the intoxicating moon and flowers.*

Signed (each drawing): *Gyokudō*
Ink on paper.
Kakemono; 129.0 x 32.3 cm.
Literature: *Suiboku Bijutsu Taikei 13: Gyokudō Mokubei,* 1975, Nos. 78/79.
Collection: Takashi Yanagi, Kyoto, Japan.

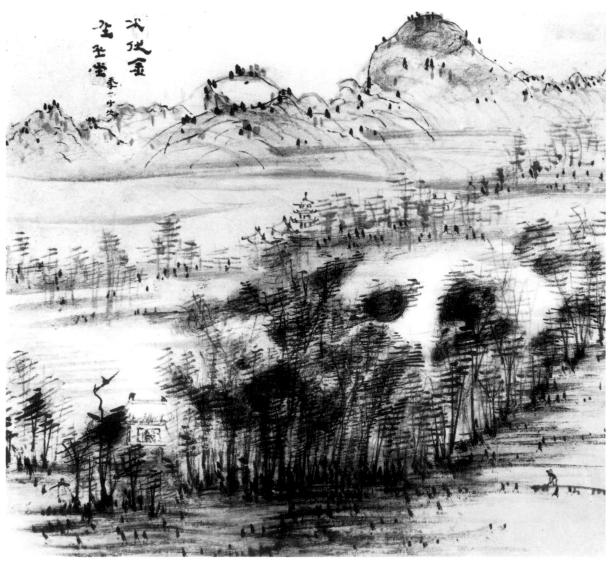

34

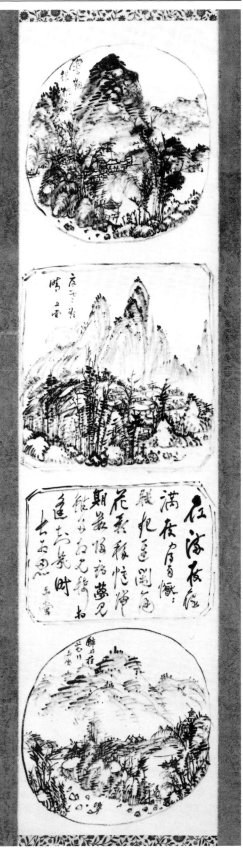

35

YOKOI KINKOKU
(1761-1832)

Kinkoku, another close follower of Buson, with whom he enrolled as a pupil at an early age, eventually became an itinerant priest, with a way of life not always consonant with that calling. As a landscapist he is uneven. Some of his paintings are among the most romantic of the Nanga school, but others bearing his name—if indeed they are all by him, for spurious works abound—seem to be drawn to a formula that stifles spontaneity. He also left portraits of *haiku* poets which demonstrate the casual, even careless, draftsmanship cultivated by every true *bunjinga* artist.

36. The master *haiku* poet Bashō. He is shown seated, leaning forward as if asleep. His hat and the shoulder pack of a pilgrim are behind him.

From an album of portraits bearing a colophon that states that the artist used as a model an album of paintings by Buson, signed with the name *Sha Shunsei*, which he used between 1763 and 1778. Although this Buson album is lost, something of its character is easily visualized from the posthumous block-printed book, *Haikai Sanjū rokkasen* ("Thirty-six Master Poets of *Haiku*"), of 1799. The inscription is a *haiku* by Bashō:

Karasaki pine –
more beautiful than flowers
in the evening mist.

(translated by Stephen Addiss)

Sealed: Kinkoku.
Ink and light color on paper.
Kakemono; 22.8 x 17.0 cm.
Literature: Addiss, No. 48, illustrated with other drawings from the same album.
Kurt and Millie Gitter Collection

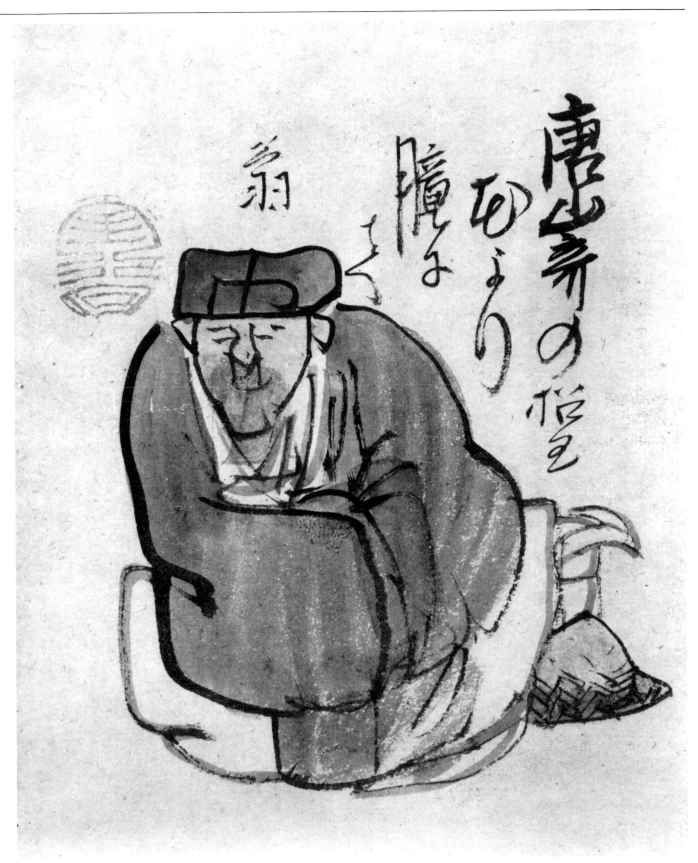

唐寺の
ひかり
瞳ま
く

翁

Although Kiyonaga no longer holds, in the pantheon of Ukiyo-e print designers, undisputed place as the "culmination of the culmination" as Ficke once described him, he is unquestionably one of the greatest artists of the school and the dominant influence throughout the 1780s. From the outset of his career in the Torii school of theatrical print designers, he was primarily concerned with producing outline drawings for the block cutters, and his great gifts were a fine sense of composition and a splendidly controlled line.

In the few surviving *shita-e,* one does not look for vivacity, or skittish flourishes: they display a suave, even-tempered line that promotes the sense of repose and harmony that marks so many of his prints.

37. Murasame and Matsukaze, the "brine maidens," carrying pails of salt water at the ends of yokes over their shoulders. These two girls figure in a *Nō* play as the befrienders of Yukihira during his exile in Suma. A first draft for the color print in the series *Fūzoku Azuma no Nishiki* ("Beauties of the East as Reflected in Fashions"), c. 1783-85. The note in the British Museum catalogue is worth quoting: "A preparatory sketch of this kind is of excessive rarity. The present example escaped destruction through being used in the binding of an album. It will be noted that, except for the black and green of the left-hand figure, the colors afford no indication of those finally employed.

The artist would doubtless supply a more finished drawing than this sketch to the printer; but it seems to have been the usual practice for the colors to be indicated by the artist on proofs of the line-block."

Unsigned.
Ink and slight color on paper.
38.0 x 24.0 cm.
Literature: Binyon, No. 23A (illustrated); Hirano, Nos. 576 A/B (illustrated).
Collection: Trustees of the British Museum (ex Satow Collection).

38. Preliminary drawing for a color print of a **scene from the** *shōsa Shi-tennō Ōeyama Iri,* played at the Kiri-za, 11th month 1785. At night, Segawa Kikunojō III as Yama-uba looking down at Ichikawa Monnosuke in the role of Kaidomaru, Yama-uba's son, who is holding a large axe. Ichikawa Danjurō V as Ninnaji no Saibei, a gatherer of firewood, is seated on a rock behind the young hero. The chanters, Tokiwazu Kanetayū and Tokiwazu Mikitayū, and the accompanist, Tobaya Richō, are seated on a dais at the rear.

Unsigned.
Ink on paper.
37.2 x 24.6 cm.
Literature: Hirano, No. 766, Pl. LXXXII (with an illustration of an impression of the print, reproduced from *Shibai Nishiki Shūsei,* Tokyo, 1919, but the drawing was not known to the author).
Collection: Victoria and Albert Museum, London.

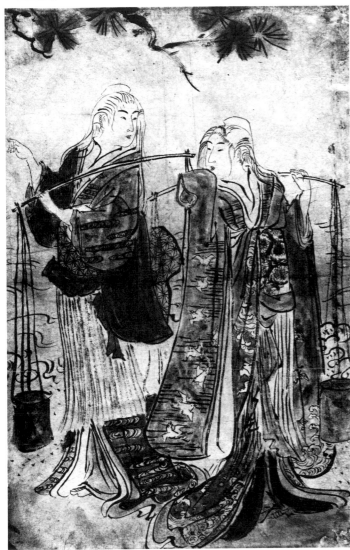

37

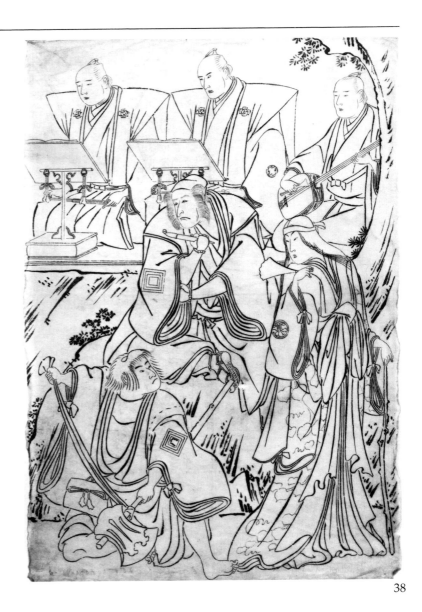

38

39

Eishi is best known for his color prints, but he was also one of the most distinguished painters of the Ukiyo-e school, both in the straightforward *bijin-ga* (pictures of beautiful women), executed with a deliberate brush, but also in a quite distinct "sketch" style that in some instances results, as in the *Woman with a Cat,* in what can be looked on as a drawing. His facility as a painter no doubt resulted from his early training, as befitted one of his *samurai* birth, in the Kanō school; but his tastes led him to Ukiyo-e, and as a print designer, after a period of strong Kiyonaga influence, he produced designs of an elegance and refinement that, even in the golden decade of the 1790s, were outstanding.

39. Young woman seated beside an arm-rest, a cat stretched at her feet.

Signed: *Chōbunsai hitsu;* seal: *Eishi.*
Ink and slight color on paper.
63.5 x 24.5 cm.
Collection: Mr. and Mrs. Dennis Wiseman.

Shunei's actor prints, at their best, have a penetrating psychological insight coupled with brilliant artistry and print-sense that place him among the greatest interpreters of Kabuki; but he is also known for his witty sketches, some of which were used for *surimono* and fan prints.

40. Street scene with women examining lengths of cloth displayed by a vendor on supported racks.

About 1790. The informality and intimacy of this glimpse of an open market in Edo, where a mother suckles her baby as she puffs at her pipe, and the other women examine the wares with critical eye, is achieved by what seems the casual brush of an observant pas-serby, in marked contrast to the studied line and theatricality of Shunei's Kabuki prints.

Very few drawings of this type have survived, but there are signed prints which support the ascription to Shunei: for instance, the fan illustrated in the Vignier and Inada *Harunobu, Koriusai Shunsho* exhibition catalogue, Paris, 1910; and the broadsheet of a woman making purchases from a curio dealer, illustrated in the Glendinning sale catalogue, 6th February, 1963, No. 57.

Unsigned.
Ink on paper.
15.5 x 27.0 cm.
Collection: K. G. Boon.

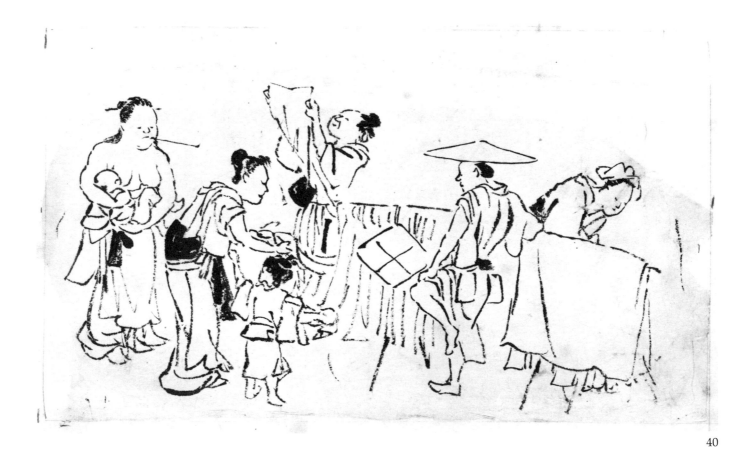

40

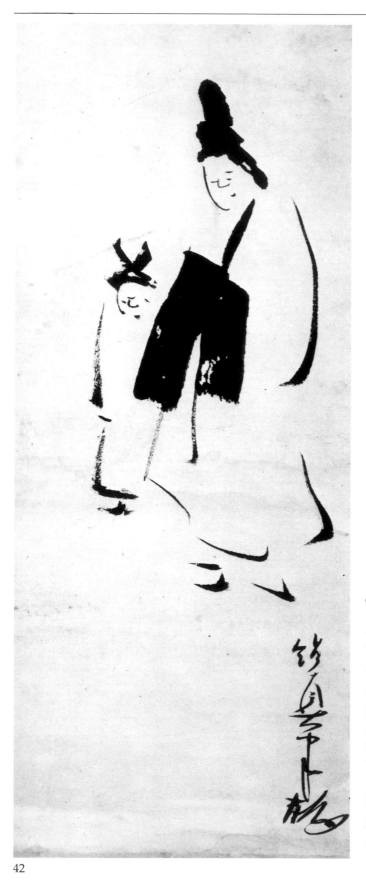

Masayoshi is one of the geniuses of Japanese art who, astonishingly, has yet to be the subject of a major monograph. His is the unusual case of an artist who, beginning as an orthodox Ukiyo-e follower, veered towards the classical schools, and ended as a complete independent specializing in what he termed *ryakuga-shiki*, a reduction of everything to the fewest possible telling lines and to patches of color applied with a childlike artlessness.

His first master was Kitao Shigemasa, and from the late 1780s he designed cheap *kibyōshi* ("yellow-backs") and a few broadsheets, as well as a topographical picture-book, *Miyako no Nishiki* ("Brocade-prints of the Capital"), in 1787, and a superb album of birds, *Raikin Zui*, in 1789. In 1795, however, appeared the first of his books in the *ryakuga-shiki* style. *Jimbutsu Ryakuga-shiki*, "Figures in the Abbreviated Style," represented a unique innovation in the color-print medium, though based upon classical precedents and not too far removed from the *bunjinga* of such artists as Buson and Goshun. In these later works he most frequently used the names Keisai and Shōshin.

41. A sheet of figures in the "abbreviated style," of the kind referred to above, but not actually used for any of the printed works.

Several such sheets exist, and the assumption is that at one time they were joined together to form a *makimono*. They no doubt date from the 1795-1800 period.

Unsigned.
Ink and color on paper.
28.6 x 60.2 cm.
Literature: Hillier, 1965, P1.45.
Collection: Rijksmuseum voor Volkenkunde, Leiden.
(Reproduced in color on p. 19)

42. Courtesan and *kamuro*. Here, with incredible virtuosity, Masayoshi carries his "abbreviated style" to the ultimate, and on a larger scale than in the picture-books, while still contriving to convey an almost psychological study of a courtesan (of a bygone age at that, the hairstyle being of the Kambun era, 1660-1670) of not too exalted a place in the hierarchy, shambling along with an attendant who seems to bridle at some imagined affront to her mistress.

Signed: *Shōsin hitsu*, with a *kakihan*, or written seal.
Ink on paper.
Kakemono; 41.0 x 17.0 cm.
Literature: *Harari Coll.*, Vol. 3, No. 24.
Ralph Harari Collection, London.

42

TŌSHŪSAI SHARAKU
(active 1794/5)

This is not the place to comment on the phenomenon of this artist's sudden emergence in 1794 as an actor-print designer of unique powers, his creation of about 150 prints in under a year, and his complete disappearance thereafter: but the inclusion of two drawings bearing his name does call for some reference to the unresolved controversy that persists concerning the authenticity of these and other drawings attributed to him. Two main sets of drawings are concerned: a series of ten portraits of *sumō* wrestlers, nine of which were destroyed in the Tokyo earthquake disaster of 1923, when they were in the collection of Kobayashi Bunshichi, the single surviving one remaining in the Vever collection until it was sold in 1974 (Sotheby Catalogue 1974, No. 264); and a group of nine that appear to have been designed for an unpublished *ehon*, eight of which were first illustrated in the Barboutau Sale Catalogue, Paris, 1904, and a further one, obviously of the same group, now in the Musée Guimet and exhibited here (No. 44).

The eight actor-print drawings sold in the Barboutau sale have all been accounted for save two: two are in the Museum of Fine Arts, Boston; two were in the Vever sale (Nos. 262/3 in the 1974 sale catalogue); one is in the Art Institute of Chicago; and one is in the Musée Guimet. The ninth, as already mentioned, is also in the Musée Guimet.

At the time Henderson and Ledoux compiled *The Surviving Works of Sharaku* in 1939, no doubts existed concerning the actor drawings. They wrote:

> The set has been studied with great care by Japanese as well as by foreign experts, and the inevitable conclusion seems to be that the drawings were made by Sharaku to be printed in a book that would record not actual stage scenes but various actors from the three leading theatres grouped together according to the fancy of the artist. No actor is portrayed more than once in the set. Changes in design are indicated by pasting the desired corrections over the parts to be altered and in some cases the *mon* of the actors seem to have been changed or written over with a probably later indication of the name or role which cannot always be shown to be correct.

They were also able to propose a date for them, based on the use of the signature *Sharaku ga* rather than the fuller *Tōshūsai Sharaku ga,* a change which occurred on prints in the 11th month of 1794; a date corroborated by the name for one actor appearing in a form that was altered after that month (Ōtani Oniji III, who then became Nakamura Nakazō II).

Certain figures in the drawings can be identified with plays that occurred earlier than that date, and indeed the pictures are not thought to relate to any particular play or plays but simply to link well-known actors in real or imaginery roles in compositions that give the semblance of portraying actual theatrical scenes.

However, the confidence expressed in the drawings by Henderson and Ledoux and by Japanese such as Nakata and Yoshida, has not been shared by all present-day scholars, and there are divergent views, from the moderate one of Segi, that they are relatively modern copies of lost originals, to the extreme one of Harry Packard, who dismisses them as outright forgeries.

My own view is that the drawings are contemporary with Sharaku: everything — paper, ink, brush-style — points to that, and two of the drawings bear the seal of Toyokuni I, which seems authentic and would belong to the period around 1800. It has to be admitted, however, that the brushline is not what we expect of a great master (compare, for example, the Kiyonaga *shita-e,* with their faultlessly unwavering line, with the often hesitant tentativeness of the Sharaku) and the safest conjecture seems to be that these are the *shita-e* drawn for the block cutter by an artist in the publisher's employ, who was copying preliminary sketches made by Sharaku himself. This view is not capable of proof either, since we do not have a sufficient body of brush drawings accepted as Sharaku's on which to base comparisons, and the indecisive line of the drawings may indeed have been characteristic of Sharaku himself, a weakness covered up in the published prints by the skill and resourcefulness of the block cutters.

It might be thought that with even a suspicion of doubt concerning the authenticity of these drawings, they should not have been included in this exhibition. The answer to that is that at the very least they come very close to what we would expect of original Sharaku drawings, and, more pointedly, allow us to explore, by practical example, the problems that arise in attempting to establish authenticity in drawings, especially those that have always hitherto been accepted in the canon of an artist's work, and vouched for by leading authorities.

43. Three actors in character: right, Iwai Hanshirō IV as Onna Kitsune; center, Matsumoto Kōshirō IV as Fujiwara Nakamitsu; and left, Ichikawa Monnosuke II as Sōba Ryōmon.

The setting seems to be the interior of a teahouse, with *noren* (shop curtains) hanging at the opening and a lantern standing before wall panels pasted with a fan and sheets of calligraphy. Behind Monnosuke, who is shown in the role of a priest, stands his traveling box (*oi*), labeled to indicate that the owner travels the sixty-nine Provinces; and Hanshirō is making a "fox gesture" as she avoids three rats at her feet.

Signed: *Sharaku ga* (on a separate piece of paper inserted in the main sheet); with the *toshidama* seal of the Utagawa school in the margin (not in the reproduction).
Ink and slight tinting on paper.
23.6 x 30.8 cm.
Literature: Harold G. Henderson and Louis V. Ledoux, *The Surviving Works of Sharaku*, N.Y., 1939; Teruji Yoshida, *Tōshūsai Sharaku*, Tokyo, 1957; Harry Packard, "Shin Hakken no Sharaku" (New Sharaku Discoveries), in *Bijitsu Shinchō*, 1966/7; Shinichi Segi, *Ukiyoe Eshi Sharaku* (Sharaku: "Floating World" Artist), Tokyo, 1970.
Collection: Musée Guimet, Paris (ex Paul Cosson).

44. Two actors: Matsumoto Yonesaburō as a woman with a single sword, kneeling at the feet of Segawa Yurijō II as a woman standing with a hand on each of her two swords.

If, as is supposed, the group of drawings was intended for a picture-book, this sheet, only half the size of the other eight, would no doubt have served as the opening half-page illustration (the last half-page normally being reserved for the afterword and colophon).

Signed: *Sharaku ga* (on a separate piece of paper inserted in the main sheet), with the *toshidama* seal of the Utagawa School in the margin (not in the reproduction).
Ink on paper.
25.9 x 17.7 cm.
Literature: As for No. 43. This drawing has been frequently illustrated, mainly from the first reproduction in the Barboutou Sale Catalogue.
Collection: Musée Guimet, Paris (ex Barboutau, and Paul Cosson).

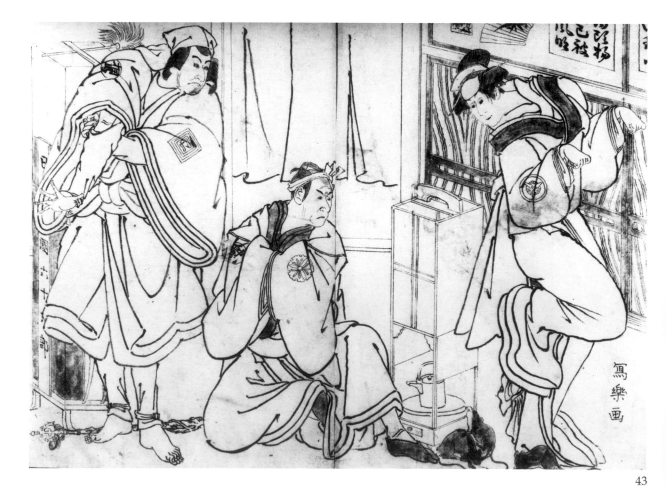

43

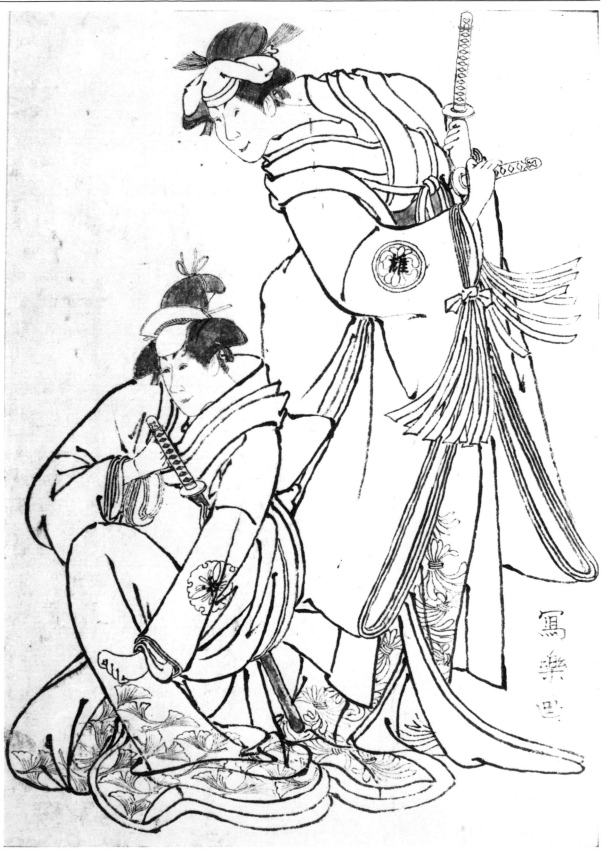

44

MORI SOSEN
(1747-1821)

Because of his naturalistic paintings of monkeys, Sosen made an immediate hit with Western art lovers, but he was a much more versatile artist than has usually been assumed, and as an animal painter he has few peers, east or west.

His life is not well documented, but his name appears in a *banzuke,* or directory, of artists in Osaka in 1807. His earliest tuition was under a Kanō artist named Yamamoto Joshunsai, but his own naturalistic bent was reinforced by contact with Ōkyo and his work, and ultimately his style became nearer to Shijō than anything else. It is said that Sosen took to the woods for a period of three years to study monkeys in their natural surroundings, and certainly his knowledge and realistic depiction of the monkey's anatomy and attitudinizing suggests that he may have observed them at close quarters.

45. Plunging pike. The details of head and eye are forcibly portrayed, but the indistinctness of the scales on the flank contribute to the impression of speed already suggested by the downward diagonal sweep of its movement.

The drawing was once in the collection of Philippe Burty, at which time Gonse described it as "un poisson lavé à l'encre de Chine, qui est une merveille de dessin large et résolu."

Signed: *Sosen* (using the "monkey" character for *So* that the artist used after 1807); seal: *Mori Shushō.*
Ink on paper.
38.0 x 52.0 cm.
Literature: Gonse, Vol. 1, p. 234, illustrated; Anderson, *The Pictorial Arts of Japan,* 1886, Pl.42; Chäikin, No. 90; Hillier, 1974, p. 256, Fig. 198.
Collection: Nathan Chäikin.

46. Monkey and Young. An adult female of the species *Inuus speciosus,* native to Japan, grasps with her rear paws the branch of a tree, rearing protectively over a young monkey clinging to the same branch.

The coloring for certain areas is written in with *katakana*—for instance, *haku* (white) and *usu* (probably for *usuakai,* "pale red"), and these markings strengthen the notion that this is a drawing from life which would later have formed the basis for a painting.

Unsigned.
Ink on paper.
35.0 x 23.7 cm.
Shin'enKan Collection.

46

MORI TETSUZAN
(1775-1841)

Nephew of Mori Sosen, but a student under Ōkyo and ranked as one of his "Ten Notable Pupils," Tetsuzan's range of subject matter was, like that of other members of the Mori family, concerned largely with animals and *kachō-e* (bird and flower pictures) generally, but in brushwork he was an experimentalist, and constantly surprises us with amusing quirks and eccentricities, sometimes clearly sacrificing naturalism for the sake of some trial technical expedient. His occasional prints designed for anthologies of verse also show uncommon originality.

47. Horse and crane. These are two opposing pages from an album of animals and birds by Tetsuzan, and by chance represent the two extremes of the artist's styles. The crane is quite orthodox, and, in fact, the bird served so frequently as a symbol for longevity that with any artist (save possibly Rosetsu) it tended to become a stereotype. The horse is quite different: it shows Tetsuzan's very personal use of a wide brush to hit off animals, to suggest, for instance, the undulations of the horse's flanks by a skillful loading of the brush, the staccato interruption in the line riveting our attention

like the sudden pause in a continuous thread of sound.

The horse signed: *Tetsuzan*; seal: *Shushin*. The crane sealed: *Tetsuzan*.

Ink and slight color on paper.

Album sheets; each 31.7 x 25.4 cm.

Dr. Eugene Gaenslen, Jr., M.D., Burlingame, California.

48. Elephant and carp. These two further opposing pages of the same album provide equally dissimilar drawings. The carp, another favorite subject in Japanese painting, rarely provokes an artist to original treatment; there is, as here, stock expertise for a stock subject. But the elephant has prompted Tetsuzan to drollery: he has found a sluggish, shambling wash-line that is the pictorial counterpart to the ponderous image given by Saint-Saens in his *"Carnival des Animaux."*

The carp signed: *Tetsuzan*; seal: *Shushin*. The elephant sealed: *Tetsuzan*.

Ink and slight color on paper.

Album sheets; each 31.7 x 25.4 cm.

Dr. Eugene Gaenslen, Jr., M.D., Burlingame, California.

48

WATANABE NANGAKU
(1763-1813)

Nangaku was a Kyoto man, and a highly regarded pupil of Ōkyo. He excelled in figure painting, and apart from that, had a reputation as a painter of turtles and of carp. Moreover, and exceptionally, he was famous for *sekiuō*, "impromptu sketches" by definition exactly within the province of this exhibition, and of which we display a notable example. Nangaku was the first major Maruyama artist to introduce Kyoto-style painting to the artists of Edo, where he lived for three years in the first decade of the 19th century, numbering among his pupils Nanrei, Chinnen, Raishō and Bunichi.

49. *Samisen* **player and blind singer.** From a scroll of sketches that appear wildly free: but Nangaku only feigns wildness, aiming at sketchiness but with an underlying control that belies any suggestion of frenzy.

Unsigned.
Ink and light color on paper.
From a *makimono;* height 27.2 cm.
Literature: Hillier, 1974, p. 97, Pls. 63/4.
Collection: Richard Lane, Kyoto.

49

KAWAMURA BUMPŌ
(1779-1821)

Bumpō was a pupil of Ganku, and traces of that master's idiosyncratic touch are recognizable in Bumpō's brushwork. He was, too, a student of Chinese painting, but through intermediaries like Kanyōsai rather than directly from Chinese artists. Given his skill and his synthesis of the various models he followed, ultimately it was by virtue of a cultured and imaginative mind that he achieved the highly personal manner in line and composition that gives rise to the admiration and affection we have for such delightful books as *Bumpō Gafu* (1807-1813), *Teito Gakei Ichiran* (1809-1816) and *Bumpō Sansui Gafu* (1824). In original drawings, all these attributes are brought home to us with greater force, with the freshness and limpidity that are lost in the prints, whatever else may be gained from the woodblock translations.

50. Monkey trainer. Bumpō uses outlines of different strengths for the *sarumawashi* but hits off the monkey with skillful dabs that not only suggest movement but contrive to detail the animal's features and toes. This is one section of a scroll of outstanding drawings with Japanese subject matter. The scroll is one of a pair; the other is devoted to Chinese subjects.

Signed (at the end of scroll): *Bumpō Basei sha;* seals:
 Basei and *Nanzan-ō.*
Light color on paper.
From a *makimono;* height 29.0 cm.
Literature: Hillier, 1974, pp. 243-244.
Collection: Richard Lane, Kyoto.

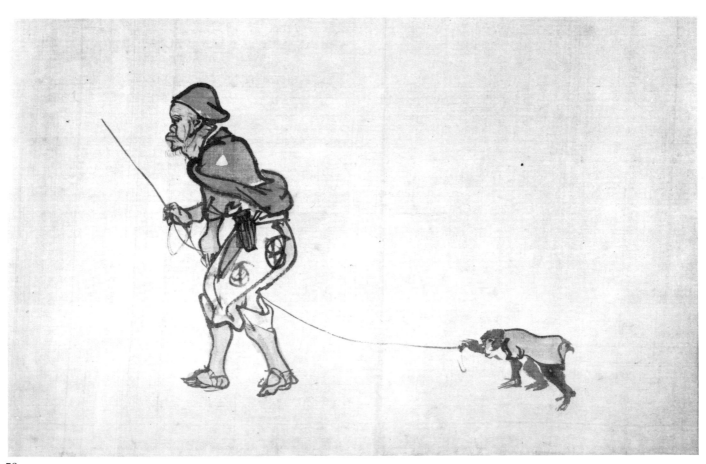

50

SATŌ SUISEKI
(c. 1806-1840)

This artist, renowned now by virtue of the remarkable prints he designed for two books, the *Suiseki Gafu* (Part I of 1814 and Part II of 1820), caused little stir in his own day. Almost the only evidence of his career, apart from his contributions to books and *surimono,* occurs in the same 1807 *banzuke* of Osaka artists to which reference is made in the note about Sosen on p. 66. In the brief entry he is described as a pupil of Gekkei (Goshun), and he is thus usually classified as a Shijō artist, though his work shows such strong individuality that he stamps himself as an independent, whatever school allegiance there may have been. His name was Satō Masuyuki and he used two *gō: Suiseki* and *Gyōdai.*

Curiously enough, for one so actively engaged in designing for books and *surimono,* Suiseki left few paintings or drawings, but the strange brooding stillness of the *Nō performer* suggests the power of an unusual personality.

51. *Nō* **performer as a Buddhist priest** kneeling at a shrine with a patterned curtain at his right.

About 1820. From an album, each sheet of which has a printed border, and outside it, at bottom left, the name of the collector, Sankōtei. The dated drawings in this and other albums of drawings on similarly bordered sheets are of the first two decades of the 19th century, and provide interesting evidence of the manner in which such albums were compiled. Having had sheets printed with the bamboo border, Sankōtei evidently commissioned, or solicited, artists and calligraphers to use the sheets for examples of their work, and afterwards bound the sheets in concertina fashion in albums.

Signed and sealed: *Masayuki.*
Ink and slight color on paper.
19.1 x 25.0 cm.
Literature: Hillier, "Satō Suiseki" in *The Fascinating World of the Japanese Artist,* The Hague, 1971, Pl. 5; Hillier, 1974, No. 147.
Collection: The Ashmolean Museum, Oxford.

51

MURAKAMI SHŌDŌ
(1776-1841)

Like Suiseki, Shōdō is better known for his occasional illustrations to books than for original paintings and drawings: the earliest known is in a book dated 1806, the latest in one of 1839. Although a pupil of Ganku, his style has more of the lightness and charm of Goshun-type Shijō than Ganku usually displayed, and occasionally, as in the drawing exhibited here, there is an intriguing fancifulness in his handling of stock themes that is typical of the Kyoto circle.

52. "Cooling off" in the evening at Naniwa Bridge. A scene of high summer, parties on the thronging boats seeking relief under awnings from the oppressive heat. From one or two of the boats rockets have been set off and explode in the sky. Naniwa (or Osaka) Bridge is summarily brushed in, and between its piles another more distant bridge can faintly be seen. The inscription is *Naniwa-bashi Yūsuzumi.*

This drawing is from the same album compiled by Sankōtei as the Suiseki (No. 51) and has the same block-printed bamboo border. The date must be roughly similar, c. 1820.

Signed: *Heian* (Kyoto) *Shōdō utsusu;* seal: *Shōdō.*
Ink and slight color on paper.
19.0 x 25.5 cm.
Collection: The Ashmolean Museum, Oxford.

52

KINOSHITA ŌJU
(1777-1815)

Second son and pupil of the great Ōkyo, Ōju practiced a rather softer version of the Maruyama style that blurs any distinction between Maruyama and Shijō. He is noted for his paintings of birds, animals and flowers.

53. Two bulls. Occasionally, an artist usually considered as of minor rank achieves, as Ōju does in this superb drawing, exceptional mastery. As so often in Shijō painting or drawings, the washes are limpid, and the brushmarks intentionally constructive and evident.

In the *Two bulls*, probably drawn about 1810, Ōju invites comparison with his contemporary, Goya.

Signed: *Ōju*; seal not readable.
Ink and slight color or paper.
29.7 x 32.0 cm.
Literature: Hillier, 1965, Pl. 2; Hillier, 1974, p. 103, Pl. 66.
Collection: The Minneapolis Institue of Arts, Bequest of Richard P. Gale.

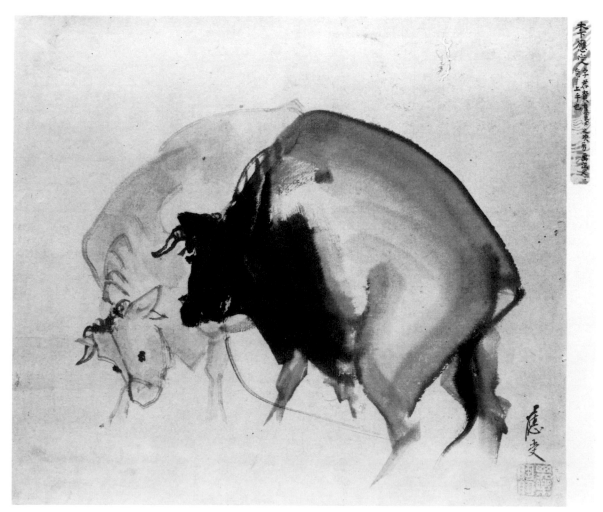

53

MIBATA JŌRYŪ
(fl. c. 1830s-1840s)

Although Jōryū was a pupil of the Shijō artist Toyohiko, he is best known for *bijin-ga* that are much in the vein of Maruyama specialists in that genre, like Genki, Soken and Nangaku. He is spoken of as the Kyoto counterpart to the Ukiyo-e artists in Edo, whose paintings of beautiful women were in constant demand. The *Three monkeys* is atypical, but gives ample evidence that Jōryū might have excelled as an animal painter had the need, or urge, arisen.

54. Three monkeys. They are moving, each in a crouching position, one behind the other, diagonally from lower right.

Signed: *Jōryū.*
Ink on paper.
Kakemono; 36.2 x 56.0 cm.
Collection: Mr. and Mrs. Dennis Wiseman.

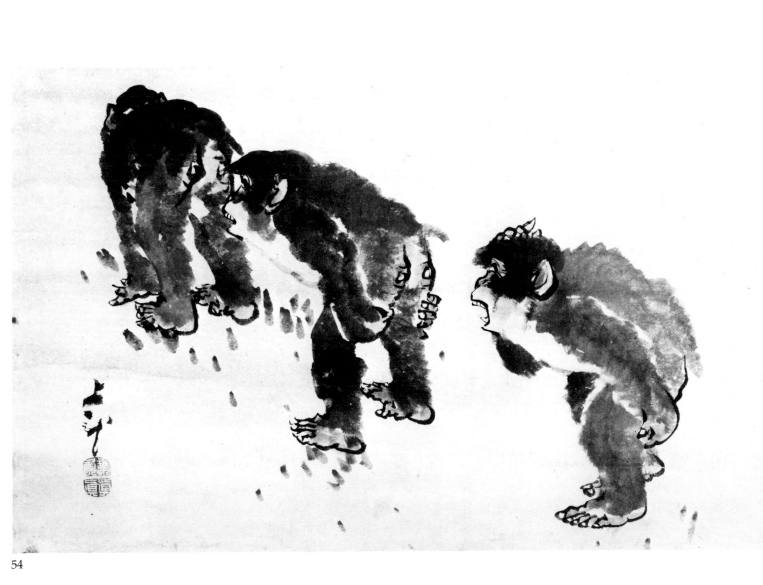

54

It is appropriate that the largest contributor to this exhibition should be Hokusai: it was his drawings, as much as his prints, that led to his being acclaimed above all other Japanese artists when Japan was opened up to the Western world after two hundred and fifty years of self-imposed isolation. In the intervening century, greater knowledge of Japanese painting of all periods has modified what now seems an uninformed adulation of Hokusai as the supreme artist of the country, but on the basis of his achievements over an immensely long career as painter, draftsman, print designer and book illustrator, he retains an unassailable position as a great and original master, infinitely more accessible to the West than many artists judged above him by the Japanese themselves.

This accessibility, the ease with which the work of this Oriental artist could be assimilated by Western art lovers, was especially pronounced in his sketches, whether in ink or ink and color, of which large numbers have been preserved. As early as 1883, Louis Gonse, in his *L'Art Japonais*, wrote of him, "He is at once the Rembrandt, the Callot, the Goya and the Daumier of Japan." No other Japanese artist's drawings were exhibited so early, or so frequently: in London in 1890, in Boston in 1893, and in Tokyo (under the aegis of the American, Ernest Fenollosa) in 1900. This century has seen a remarkable series of exhibitions all over Europe, America and Japan, and none was more indicative of the Western attitude to Hokusai than that held in Amsterdam at the Stedelijk Museum in 1951, when sketches of Rembrandt, Hokusai and van Gogh were hung together. It was Hokusai's intimate portrayal of the peasants and artisans of the countryside as much as the near-identify of his medium with our own that led to such an explicit association with those major Western humanist artists.

Hokusai, who came of artisan stock, was a pupil of Katsukawa Shunshō (1726-1792), and his earliest actor—and genre—prints were typical Ukiyo-e productions. However, with his insatiable experimentalism and personal idiosyncracies, he developed an eclectic style that cannot be classified under the heading of any school, and although he had numerous followers, none had his exceptional power or versatility. He occupies a unique and isolated eminence in the annals of Japanese art.

55. Turtle and goldfish in a bowl. The bowl is touched with white and visible only in certain lights.

Signed: *Hokusai ga.*
 Some guide to dating of Hokusai's works is given, not only by the style of brushwork, but by the form the signature takes, and by the seals used. In this instance, the use of the name Hokusai alone, and without seals, gives a date of roughly 1805-1810.
Ink and color on prepared paper.
Fan; 22.0 x 45.2 cm.
Literature: de Goncourt, p. 323 (the fan was at that time in Bing's hands); *Harari Coll.*, Vol. 2, No. 106 (illustrated).
Ralph Harari Collection, London.

56. Seated beauty with a fan. There is a like drawing in the Franz Winzinger collection (illustrated in his "Ein unbekannter Facher des Hokusai" in *Pantheon,* May, 1965), in which the girl's pose and features, and even a detail like the blue-and-white bowl, have obvious similarity to the one shown here. The fan is signed *Hokusai* and has been dated c. 1810, which can also be accepted as the approximate date for the Harari drawing.

Unsigned.
Ink and color on paper.
21.0 x 29.0 cm.
Literature: de Goncourt, p. 314, describes a drawing then in the Bing collection which may refer to the Harari work; *Harari Coll.*, Vol. 2, No. 109.
Ralph Harari Collection, London.

(Reproduced in color on p. 20)

57. Three studies of a young woman dressing her hair. The changes of viewpoint and of the position of the girl's hands seem to indicate that these were *ad vivum* sketches, possibly of the artist's daughter Oei. They display the consummate mastery of the so-called "presentation" drawings (see No. 63) but also all the freshness of extemporization to some extent lost in those with a more considered handling of the brush line.

The facial outline, the coiffure and the sweep of the draperies are close to what we find in No. 56, and a similar date, c. 1810, can be assumed.
Unsigned.
Ink on paper.
27.3 x 38.5 cm.
Collection: Musée Guimet, Paris.

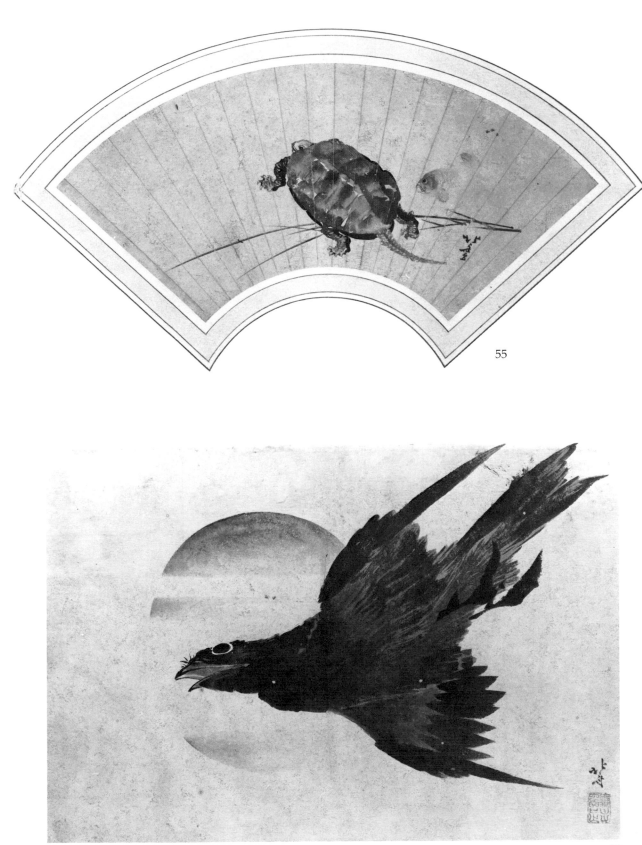

55

58

57

58. Cuckoo *(hototogisu)* **flying against the dying sun.** This bird, the harbinger of spring, is shown dark against the light of the setting sun. About 1810.

Signed: *Hokusai;* seal: *Kishitsu Kisoku.*

Ink and color on paper.

25.0 x 35.7 cm.

Literature: Hillier, 1966, Pl. 11; Chaïkin, No. 54, illustrated.

Exhibited: Seiferheld Gallery, 1961; Princeton Art Museum, 1964; Musée d'Art et d'Histoire, Geneva, 1972.

Collection: Nathan Chaïkin.

59. Two workmen. A street scene, a man walking right carrying what seems to be a huge *daikon* (radish) on his shoulder, and behind him, another seated beside a long box-like object with straps over it, perhaps for carrying it on his back. An illuminated sign at left reads, *Goyo no-sha* ("Your order . . .").

The brushwork, and the treatment of the heads—especially the frontal view of the face, where only the eyes are marked—relate this drawing to one of the most famous of Hokusai's albums of drawings, the "Day and Night in the Four Seasons" in the Spaulding Collection in the Museum of Fine Arts, Boston. The somewhat slurred line and the free use of a dry brush represent a phase of fairly short duration in the evolution of Hokusai's manifold styles. The evidence of the signatures and seals of the "Day and Night" series points to a date around 1815, and other drawings, with the same marked features, like the one here exhibited, are almost certainly of the same period.

Ink on paper.

13.2 x 10.2 cm.

Collection: The Tikotin Museum of Japanese Art.

60. The flautist. A young nobleman seen from behind as he walks away playing the flute. The brushlines are extraordinarily expressive, and the set of the head and casualness of the young man's movement have something of the indefinable aristocratic nonchalance of Watteau's *L'Indifferent.*

Ink on paper.

18.5 x 9.5 cm.

Literature: Hillier, 1955, rep. p. 126; Bowie, p. 91, Fig. 52.

Exhibited: *Hokusai,* Huguette Berès, Paris, 1958, No. 49 in the Catalogue, illustrated.

Collection: Huguette Berès, Paris.

59

61

62

61. Bullfinch *(uso)* **and weeping cherry.** A preparatory drawing for the well-known color print in the series of "Small Birds," first published by Nishimura-ya in the early 1820s. The final version prepared for the block cutter differed considerably, especially at the right hand, where blossoms had to be omitted to allow space for the verse. This may have been one of the drawings sold in the Hayashi sale of 1902, under Lots 50-60, described as "Études pour la serie des dix estampes, Fleurs et oiseaux," but there are no specific descriptions, nor are the sizes indicated.

Impressions of the print are illustrated in Hillier, 1955, Fig. 71; Michener/Lane, *Japanese Colour Prints,* No. 188; Narazaki/Mitchell, *The Japanese Print,* No. 85; and *Vever,* Vol. 2, No. 700.

Unsigned; seals of Tadamasa Hayashi and Winzinger collection.
Ink on paper.
27.2 x 19.8 cm.
Literature: Sotheby Sale Catalogue, 12.5.1975, No. 422 (illustrated).
Collection: Professor Dr. Franz Winzinger, Regensburg, Federal Republic of Germany.

62. Two *samurai* **wrestling.** Hokusai was at exceptional pains to obtain exactly the stress and strain of the two locked figures he had in mind, and there are numerous *pentimenti.* It appears to be a preliminary sketch for a *surimono,* an impression of which is illustrated in *Surimono Prints,* Richard Kruml Catalogue No. 15, 1975, No. 5. The wrestlers are there named Ki no Natora and Otomo no Yoshio. The print is signed *Zen Hokusai Iitsu,* which gives a date in the early 1820s.
Unsigned.
Ink on paper.
41.2 x 27.2 cm.
Literature: *Vever,* Vol. 3, 1976, No. 760.
Collection: John R. Gaines, Lexington, Kentucky.

63. Seated girl adjusting a hairpin. She is seen from behind, in a somewhat contorted pose that seems contrived to justify the convolutions of the artist's line. There is something humble, self-abasing or cringing in the girl's attitude, as if she were nervously retiring from a superior or intimidating person.

This is one of a large group that have become known as "presentation" drawings from the more-than-normally careful brushwork, firmly drawn and with an air of finality quite different from the sketchier, probing lines of the majority of Hokusai's drawings. This group, or a number belonging to it, are repro-

63

duced in woodblock prints in a publication called *Hokusai Koppō Fujin Atsume* ("Women in Hokusai's Structural Brushwork"), produced in Japan in 1897. The drawings reproduced were each on a separate piece of paper trimmed irregularly outside the lines of the drawing and remounted on a continuous roll of paper to form a *makimono*. In the woodblock copy, the shape of the original paper is contrasted with the darker surrounding area of the scroll on which it is mounted. According to the preface to the 1897 book, the drawings were made in 1822.

By the very studied style of these drawings, and by their obvious attractiveness, they have lent themselves to being copied more than most of Hokusai's drawings, and many of the group exist in several versions. An unwavering sweep of line and an infinitely gradual swelling from the touch of the brush tip to the blunt edge where the stroke ends, are the marks of those that have greatest claim to being from the artist's own hand.

Unsigned.
Ink on paper.
16.0 x 20.0 cm.
Literature: *Japanske Håndtegninger,* illustrated, p. 10.
Collection: Gerhard Schack.

64. Mother and son crossing a bridge. The bridge, of planks supported on high tree trunks serving as piles, crosses a reedy area at one end of a lake, with Fuji in the distance. There are thatched storage butts in the left foreground, and a hamlet on a promontory seen through the piles. The mother has a rod and line over one shoulder and with her boy's help, carries a creel hung over a pole carried between them.

This drawing, with the figures inserted on a separate piece of paper, comes nearest to our notions of a cartoon, perhaps for a *kakemono* painting. Another intriguing possibility is that

64

it is a first sketch intended for a *kakemono-e* print in the well-known series, "Poems of China and Japan mirrored to the Life" *(Shika Shashin Kyō),* but never published. The putative date, late 1820s, is consonant with that speculation. Formerly Henri Vever Collection.

Unsigned.
Ink on paper.
92.0 x 34.0 cm.
Literature: *Céramiques du Japon . . . Peintures et Dessins . . .* Catalogue of a sale at Hotel Drouot, 28/29 April 1948, No. 192.
Collection: L. L. Weill.

65. Duck and drake. In this enchanting study the foreground drake is boldly delineated with a full brush and warm tones, whereas the form of the mate behind is simply left in white reserve on a grey wash, only the beak and eye being marked with a brushline. But by these simple means, the essential character of the birds and their engaging clumsiness out of water are beautifully hit off.

Unsigned.
Ink on paper.
20.0 x 25.5 cm.
Exhibited: *Hokusai: Drawings and Water-Colours,* The Arts Council of Great Britain, London, 1954, No. 34, Pl. 6.
Collection: E. Biedermann, Bern.

66. Boy spinning a top. Half crouching, he is watching intently the top he has set spinning by means of the cord in his hand.

Unsigned.
Ink on paper.
15.0 x 10.0 cm.
Literature: Hillier, "Hokusai. Some drawings and problems of attribution," *The Connoisseur,* April, 1956; Hillier, 1966, Fig. 62; Bowie, 1964, Fig. 83.
Exhibited: *Hokusai,* Huguette Berès, 1958 (No. 43 in the catalogue).
Collection: Huguette Berès, Paris.

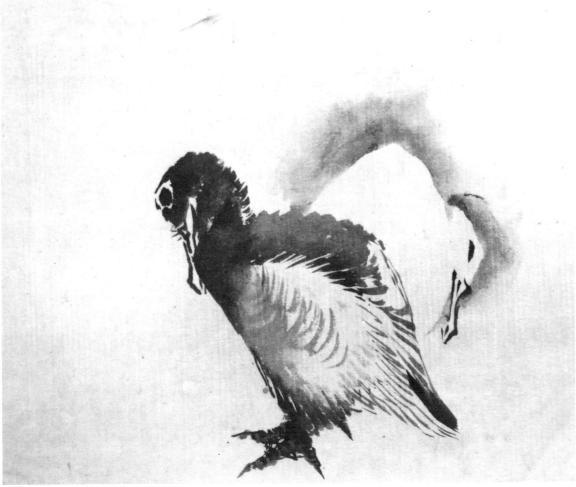

65

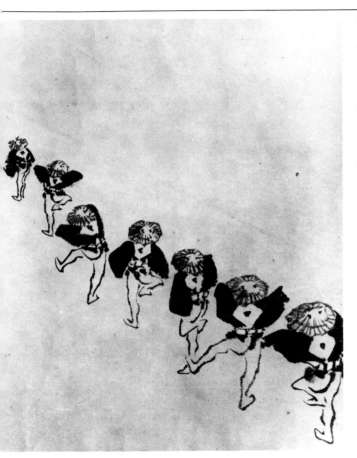

67. Sparrow Dancers. A feature of the dance was that the performers always kept their backs to the audience, fluttering the broad, winglike sleeves to simulate flight.

The two drawings shown originally formed a continuous composition, part of a famous *makimono* of forty-six diverse drawings once in the possession of Louis Gonse, to whom it had come from the collection of the painter Kawanabe Kyōsai. After the Gonse sale in 1924 the *makimono* was divided up, but there is a reproduction of the "Sparrow Dancers" section before it was cut in two in Gonse's *L'Art Japonais*, where the composition may be seen at its most effective, the figures receding diagonally in a diminuendo, and their dance movements given added syncopation by the break in the line made by two of the performers near the tail of the formation.

In his book Gonse described the *makimono* in rapturous terms: the drawings and watercolors were "of varied dimensions and

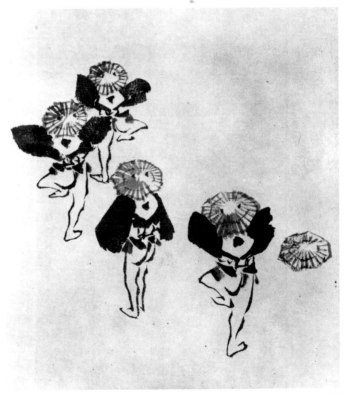

67

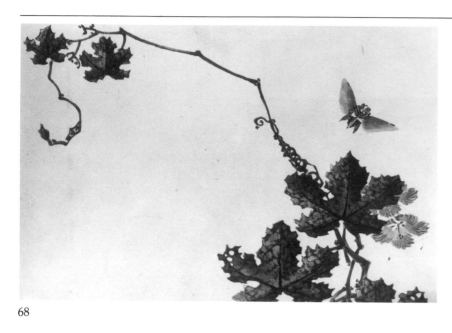

68

periods, and all of an extraordinary beauty. Never had a hand more accomplished passed over paper; one cannot touch it without emotion; it is absolute, it is Japanese art in its maximum éclat, freshness, life and imagination."

Unsigned.

Ink and slight color on paper.

a: 25.8 x 23.6 cm; b: 27.3 x 19.6 cm.

Literature: Gonse, pp. 282 286, Pl. VII; de Goncourt, pp. 309-10; Hillier, 1966, pp. 18-19, Pls. 72-3; Chaïkin, Nos. 52-3; Schack, Nos. 31-2; Franz Winzinger, *Hokusai, Holzschmitte und Zeichnungen,* Leipzig, 1977. Reproduced as endpapers.

Exhibited: Arts Council, London, 1954 (Pl. 8); Galerie Janette Ostier, Paris, 1958 (illustrated in Catalogue); Seiferfeld Gallery, 1961; Princeton Museum, 1964; Musée d'Art et d'Histoire, Geneva, 1972; Kunsthalle, Bielefeld, 1975.

Collection: Nathan Chaïkin.

68. Gourd vine and cicada. Another drawing from the scroll described in No. 67. The seriousness of Hokusai's approach as well as the grasp of natural forms seems to link this drawing with the "Large Flowers" series of color prints of the early 1820s.

Unsigned.

Ink and color on paper.

30.0 x 44.5 cm.

Literature: Gonse, pp. 282-286; de Goncourt, p. 309-10; Hillier, 1966, pp. 18-19, Pl. 55; Chaïkin, No. 64; Schack, No. 37.

Exhibited: Musée d'Art et d'Histoire, Geneva, 1972; Kunsthalle, Bielefeld, 1975.

Collection: Nathan Chaïkin.

69. The Rape. A preliminary study for the right-hand section of an illustration to Vol. 29 of the novel *Shimpen Suiko Gaden,* published in 1829. The book, a translation of a Chinese classic, concerns the bloodthirsty exploits of a band of brigands known, because they operated against corrupt rulers in the 12th century, as "The One-hundred-and-eight Heroes." There was, however, honor among the thieves, and in the left-hand section of the illustration Sokō, one of the "Heroes," is coming to the rescue of the assaulted Lady Fujiyo.

Unsigned; seal of the Vever collection.

Ink on paper.

29.8 x 31.5 cm.

Literature: de Goncourt, pp. 316-7; Focillon, p. 129, Pl. XXI (under the title "Le Rapt"); Bowie, 1964, p. 163, Fig. 116; Hillier, 1966, Pl. 34 (where it was wrongly located in Musée Guimet); *Vever,* Vol. 3, No. 745.

Collection: John R. Gaines, Lexington, Kentucky.

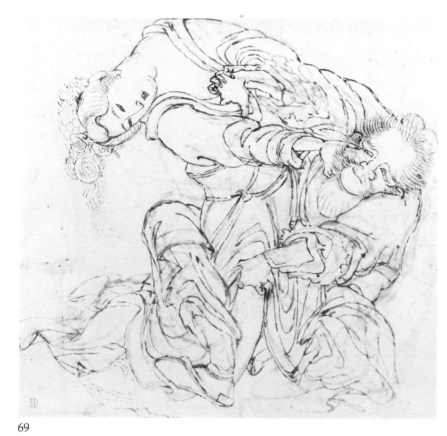

69

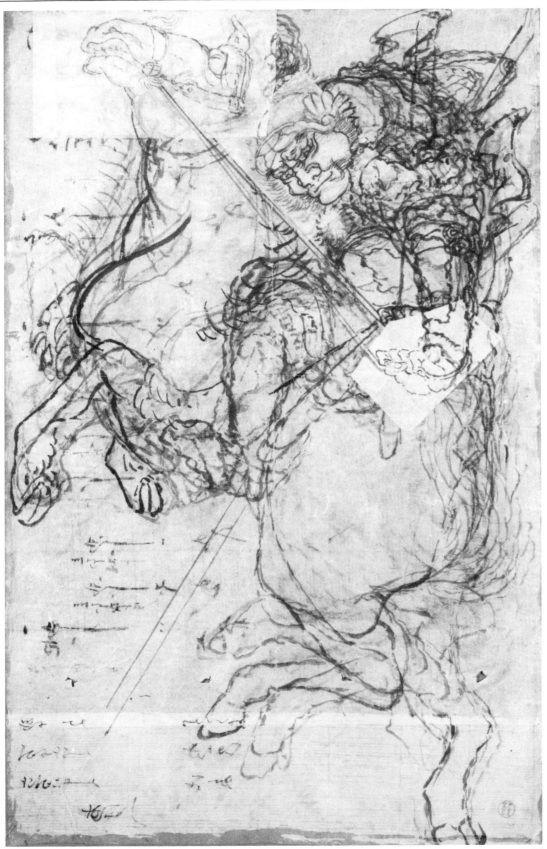

70

70. Warrior on a rearing horse. Known by some curious quirk of Henri Vever, who once owned it, as *"St. George,"* this drawing, like *The Rape,* helped to establish Hokusai as a preeminent draftsman in Western eyes. (See Introduction.)

It is very much akin to the illustrations for the *Shimpen Suiko Gaden,* referred to in No. 69, or for the series of *Musha-ehon* (books of warriors) that appeared in the mid-1830s, but no woodcut exactly corresponding to it has been located. Theodore Bowie (*op. cit,* pp. 146-150) gives his opinion that "the evidences of groping mean that the drawing was started by a pupil; the firm lines and refinements of detail found in the little pasted bits of paper are undoubtedly corrections in the hand of the master." I prefer to see it as an example of the indecision of even a great artist's hand trying to follow the urgent dictates of his inspiration; a drawing that records, like a sensitive cardiograph registering variations of the heartbeat, the much more complicated vacillations of an artist's mind in the stress of creation.

Unsigned; seal of the Vever collection.
Black and red inks on paper, with *pentimenti;* the columns of calligraphy are showing through the reverse side of the paper.
38.0 x 24.5 cm.

Literature: Focillon, p. 129; Bowie, 1964, pp. 166, 150, Fig. 102; *Objets d'Art du Japon,* Catalogue of a sale at Hotel Drouot, 8/9 April 1948, No. 283.
Collection: L. L. Weill.

71. A thunderstorm at the foot of Fuji, the cone of the mountain appearing above clouds, the lightning represented by a zigzag line descending diagonally from left to right. The rooftops of a hamlet are caught in the sudden glare, and are strongly outlined in the flash.

A preliminary study for a print in Vol. 2 of the "One Hundred Views of Fuji," *Fugaku Hyakkei,* accepted as one of the outstanding achievements of the artist, and among the great illustrated books of the world. The first two volumes were published in 1834 and 1835, and by inexplicable good fortune a considerable number of the artist's first drafts have survived, several of which were once in the collection of Henri Vever. In the printed version, *The Thunderstorm* has a title label, *Yūdachi no Fuji,* "Thunderstorm over Fuji."

Unsigned.
Black and red inks on paper.
18.2 x 24.4 cm.
Literature: *Vever,* Vol. 2, No. 753.
Private Collection.

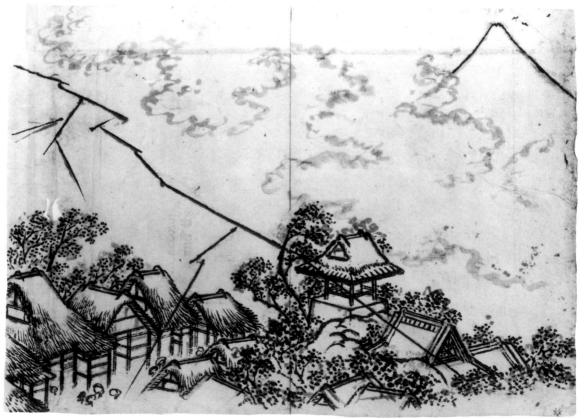

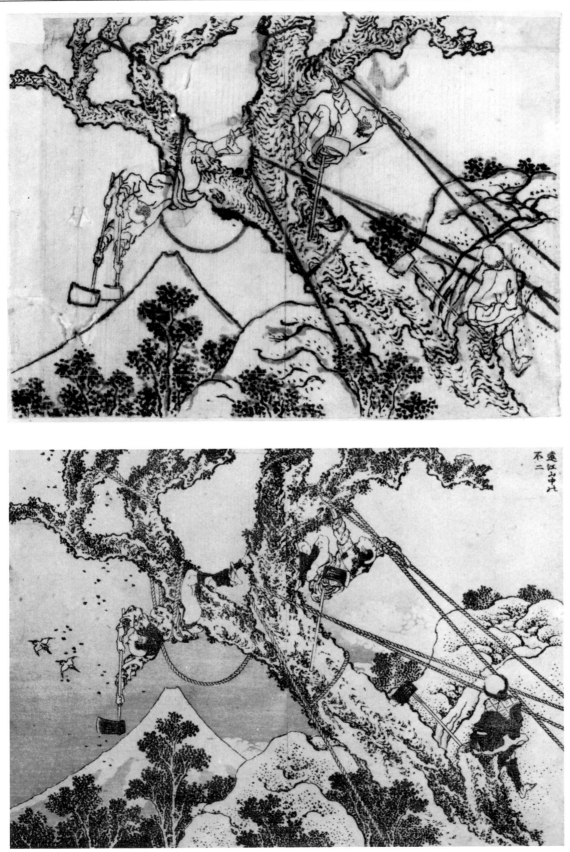

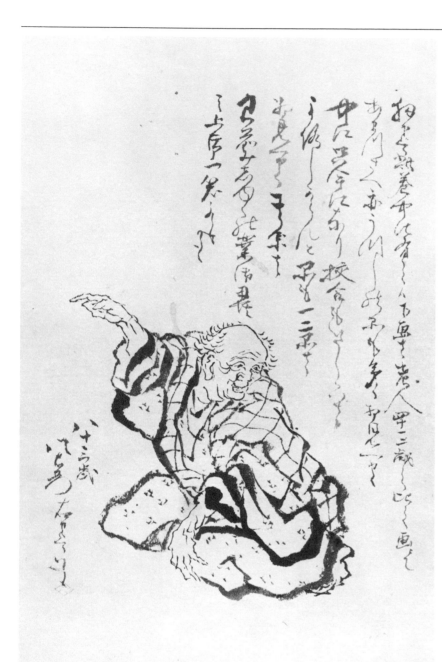

72. Fuji viewed from among the hills in the Province of Totomi. Another preparatory drawing for a double-page print in Vol. 2 of the "One Hundred Views of Fuji." The real interest of the picture lies in the efforts of acrobatic woodmen to fell a huge tree. The symmetrical form of the mountain is the only steadying feature in a complex composition where great play is made of the contrast between the irregularity of the angled trunk and branches and the rigidity of the lashed ropes under tension.

In the same frame with the drawing is the double-page print from a copy of the book, showing what refinements were added to the final version of Hokusai's original sketch before it was passed to the blockcutter.

Ink on paper.
18.4 x 25.0 cm.
Literature: Bowie, 1964, Fig. 42.
Collection: L. L. Weill.

73. Self-portrait of the artist at the age of 83. This lively and, one imagines, life-like drawing comes at the end of a letter believed to be to his publisher and apparently enclosing a batch of old *shita-e*, preparatory drawings. The fragment reads: "These *shita-e* are the work of the artist when he was about 41 or 42. Among them are one or two that are better in comparison with others. The rest belong to an immature period, at which you can laugh before throwing them away. That's all." It was signed with the name he occasionally affected at the time, *Hachiemon,* at the age of 83 years. It is sealed with the diamond-shaped *Manji.*

Such a letter, bearing in mind Hokusai's fame and the very few personal relics that have survived, would be precious in any case, but it is made trebly so by the marvelously revealing portrait, showing a man whose vitality is obvious despite his age, and who de-

73

ploys a repertoire of brushwork—from the fine, wiry line of the head and hands, to the heavy, slurred strokes for the clothes—that serves as an exemplar of the artist's later style, against which other less certified drawings can be judged.

Ink on paper.
26.9 x 16.9 cm.
Literature: *Catalogus der Tentoonstelling van Worken van Katsushika Hokusai,* Stedelijk Museum, Amsterdam, 1949, No. 142, Pl. 28; Ouwehand (cover illustration); J. Fontein, "Portretten en zelfportretten van Hokusai," *Bulletin Vereeniging van vrienden der aziatische kunst,* 3rd series, No. 7, Amsterdam 1956, p. 107; Tikotin (illustrated, with a note by Dr. C. Ouwehand); Bowie, 1975, No. 19, illustrated p. 72; Hillier, 1966, Pl. 110; *Shiborudo* (Siebold) *Edo Sanfu 150 nen kinen* (An exhibition commemorating the 150th anniversary of von Siebold's visit to Edo), Tokyo, 1976, No. 200, illustrated.
Collection: Rijksmuseum voor Volkenkunde, Leiden.

74. Le Massacre de l'Innocents. The French title has been retained for this horrendous image, since the drawing came to France via Hayashi, and has stayed there ever since, Octave Mirabeau being one of the previous owners. In the self-portrait (No. 73) we see the broad, fluid brush stroke used casually, under no duress; in *Le Massacre* it hurtles explosively over the whole figure to express the violence of the action: but it is Hokusai's great gift that however tempestuous, the line is still constructive and denotes the form and movement in masterly fashion.

Ink and color on paper.
39.0 x 28.0 cm.
Literature: *Hokusai 1760-1849.* Catalogue of an exhibition, Huguette Berès, Paris, 1958, No. 23 (frontispiece).
Collection: Huguette Berès, Paris.

74

75. Boy drumming for a dancer in a mask.
In this impetuous drawing with its evidence of urgent revisions, a boy is beating a drum, balanced on his knees, for a dancer who wears a mask of the Shintō deity Saruta-Hiko-no-Mikoto, and is cavorting with one leg raised.

Beneath this drawing is another, partially obliterated, in ink with touches of color, perhaps of Urashima Tarō seated on a *minogame* (turtle) and journeying through water.

Unsigned.
Ink on paper, trimmed outside the drawing and mounted on another sheet.
27.0 x 27.5 cm.
Literature: *Harari Coll.* Vol. 2, No. 145.
Exhibited: *Hokusai, Drawings and Water-colours,* The Arts Council, London, 1954 (illustrated); *Hokusai,* Stedlijk van Abbe-museum, Eindhoven, 1956; and in *The Harari Collection of Japanese Paintings and Drawings,* The Arts Council, London 1970.
Ralph Harari Collection, London.

75

AOIGAOKA HOKKEI
(1780-1850)

After a brief period of instruction under a Kanō master, Hokkei became one of the earliest pupils of Hokusai and from about 1800 used the name Hokkei, evidently derived from that of his new instructor. He was a close follower of Hokusai's style of the early 1800s, but unlike his master, did not develop in any marked fashion over his long working career. In designing *surimono* he showed genuine originality, but as a draftsman he has a pleasant touch, though none of the power of Hokusai.

76. Standing woman reading. She is seen from behind, and inclines to the right in such a way as to give an attractive sweep to the lines of her *kimono*. From an album, two further sheets of which are illustrated in Hillier, *Harari Coll.*, Vol. 2.

Signed: *Hokkei;* seal: *Aoigaoka.*
Ink and slight color on paper.
41.0 x 27.0 cm.
Literature: *Harari Coll.,* Vol. 2, No. 156.
Ralph Harari Collection, London.

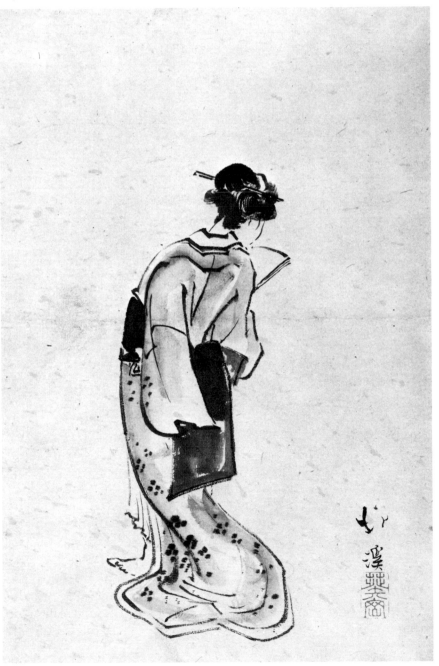

76

TEISAI HOKUBA
(1770-1844)

Among the numerous followers of Hokusai, Hokuba is recognized as the painter of greatest distinction, and his pictures of women have a refinement unusual in an artist of the Ukiyo-e school. He was also much involved with the *kyōka* poets, and although he produced no standard Ukiyo-e broadsheets, was active as a designer of *kyōka surimono* and as an illustrator of verse anthologies.

77. Iwafuji and Onoe. Iwafuji is about to beat Onoe with the slipper she is raising in her hand, an episode in a classic story extolling the virtue of loyalty and the duty of revenge. Both women were maids of honor at the court of the Prince of Kaga, but Iwafuji was corrupt and cruel, and did her worst to make the life of the virtuous Onoe unendura-

ble. The climax was this humiliating beating in the precincts of a temple, which led Onoe to commit *seppuku* and to reveal, in a last letter, that Iwafuji was plotting against the Prince. Just retribution came to the evil woman from Ohatsu, Onoe's faithful servant, who stabbed Iwafuji to death before ending her own life.

Hokuba makes a vigorous *contraposta* of the submissive Onoe and the violent Iwafuji, but the patches of color and the markings of Iwafuji's *kimono* give a certain gaiety to the sketch which belies the tragic import of the event.

Signed: *Teisai;* seal: *Hokuba.*
Ink and color on paper.
Kakemono; 35.0 x 49.4 cm.
Shin'enKan Collection

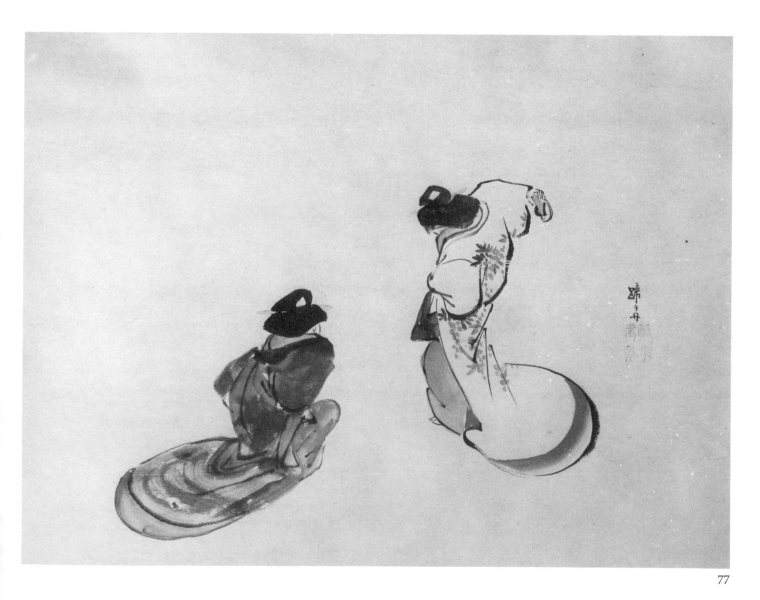

77

TANI BUNCHŌ
(1763-1840)

In contrast to the general lack of biographical data in regard to even the most prominent artist of the time, the life of Tani Bunchō is comparatively well documented: his renown as artist and teacher led him to become something of a public figure. Son of a *samurai* distinguished as a poet, his training as a painter was largely with masters of Nanga, in which school he became the central and most influential figure in the early 19th century. But he was curious about every style of painting, and though his work is predominantly Chinese-based, he was remarkably eclectic. In the past, he was regarded in Japan as one of the triumvirate of greatest masters of the Tokugawa era (the others were Tanyū and Ōkyo), but his reputation in the last fifty years has suffered as much as anything from the immense number and diversity of the works bearing his name, only a fraction of which are genuine.

Because of his unquestionable gifts, he is thrilling as a draftsman. In portraiture, he revived the realism which had only rarely been achieved since such early masterpieces of Zen priest portraiture as the 15th century sketch of Bokusai by Ikkyū (now in the Tokyo National Museum). His influence on both Watanabe Kazan and Tsubaki Chinzan in this kind of portrait drawing was particularly fruitful. In landscape, he was adept both at the swift, concise sketch from nature (Nos. 78, 81) and the studio composition where the ink-play and composition were more important than the topography.

78. Angling below the Katsu Mountain. Tall trees, pillars of close foliage, stand on a promontory in a lake, and on the bank beyond them a man is seated with his fishing rod sloped to the water. Behind him is a rounded hill with trees mounting to the summit.

The inscription gives the title as above and the date *hinoe tatsu* (1796), an autumn day.

This and the drawing next described came from an album which shows that at a comparatively early date Bunchō had thrown off the constraints of the orthodox Nanga schooling he had received under such masters as Watanabe Gentai and Suzuki Fuyō. Already he shows the freedom and *élan* of an artist confident of his own powers.

Signed: *Bunchō*; seal: *Bun Chō*.
Ink on paper.
From an album; 27.8 x 25.0 cm.
Literature: Hillier, 1965, Pl. 20.
Collection: Trustees of the British Museum, London.

78

79. Banana Leaves. Another free drawing from the same album as last, exploiting a subject which attracted artists for the opportunity the exceptional foliage presented for ink-play.

Signed: *Bunchō;* seal: *Bun Chō.*
Ink on paper.
From an album; 27.8 x 25.0 cm.
Literature: Hillier, 1965, Pl. 25.
Collection: Trustees of the British Museum, London.

80. Imaginary portrait of Dazai Shundai in *kamishimo* (ceremonial dress), kneeling with his hands hidden in the folds of his *hakama* (voluminous trousers).

The inscription (signed *Sawa Neiko, haisho,* "reverently written") gives the various names of the man portrayed, viz. Sundai Sensei, Daizai, Jun and Tokufu. Shundai (1680-1747) was a notable Confucian scholar and writer, whose best-known work is *Keizairoku,* "Discussion of Economics," of 1729. The writer of the inscription, Sawa Neikō, is better known as Nozawa Hikoroku, a scholar and poet contemporary with Bunchō.

To a man brought up with a strongly Confucian family background as Bunchō was, the veneration for Shundai is understandable, but the drawing is also of interest in that Bunchō has given it the appearance of an actual *ad vivum* portrait, with the marked individuality

in the features that we find in Bunchō's actual portraits "from life."

Ink and light color on paper.
Kakemono; 38.0 x 26.8 cm.
Kelvin Smith Collection, The Cleveland Museum of
 Art.

81. Travel sketches of Kōnodai. Bunchō made an album of sketches while traveling to Kōnadai (now Ichikawa in Chiba Prefecture), and the drawings were subsequently mounted as a handscroll. They bear all the signs of having been make *"sur le champ,"* marvelously capturing atmosphere and topographical detail in drawings of unusual freshness and color. Dated *Bunka 4* (1807).

Signed (at end): *Bunchō Ki* ("recorded by Bunchō").
Ink and color on paper.
From a *makimono;* height 16.3 cm.
Literature: Yoshizawa Chū, "Tani Bunchō hitsu:
 Sumidagawa Kōnodai Shinkei zu," in *Kokka,* No.
 837; Yoshizawa Chū and Yamakawa Takeshi,
 Nanga to Shasei-ga, Tokyo, 1969; James Cahill,
 Scholar Painters of Japan: The Nanga School, New
 York 1972, No. 55; *Edo Jidai no Fukei Suketchi Shin-
 kei Zu,* Catalogue of an exhibition at the Suntory
 Bijutsukan, Tokyo, 1978, No. 27; *Tani Bunchō,*
 Catalogue of an exhibition at the Tochigi Prefec-
 tural Museum of Fine Arts, 1979, No. 46.
Collection: Daisaku Hosoya, Kahoku-cho,
 Yamagata Prefecture, Japan.

(Reproduced in color on p. 21)

79

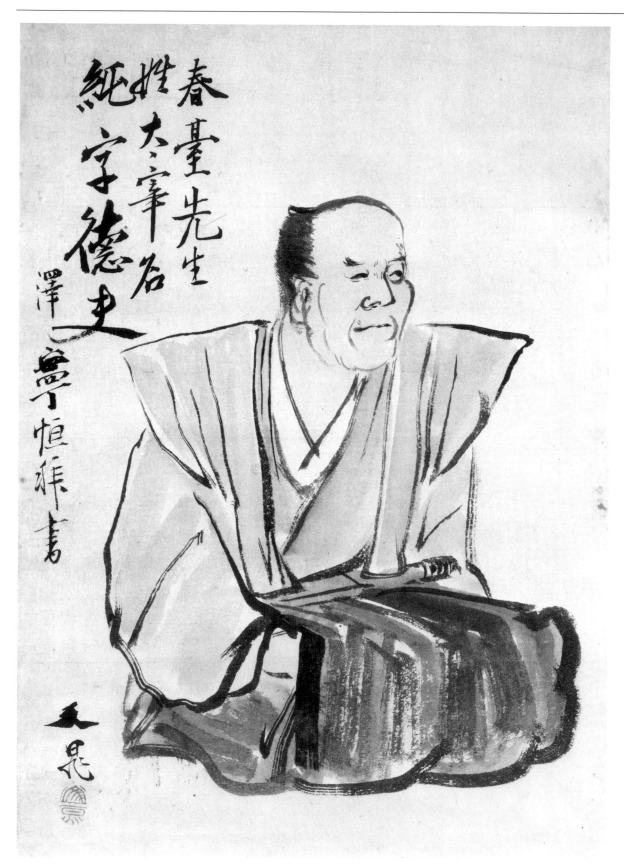

春臺先生
姓大字名
純字德夫
澤寧恒祉書

文晁

Considered one of the greatest *haiku* writers of his day, as an artist Sōchō is known mainly by his *haiga*, though he contributed a number of illustrations to books, especially anthologies, from 1801 onwards. It is said that he was a pupil of Tani Bunchō, but although his style is basically *bunjinga,* he is much further to the left than Bunchō, and indeed can only be classified as an independent, not relying for his livelihood on his paintings. He was a native of Edo, and associated with Issa, Seiba and other famous *haijin* of the day.

82. The outline of the crest of Fuji, seen as if above a heat haze beyond foreground hills crowned with trees on the shore of Enoshima Bay. The *haiku* by Sōchō is:

> *Enoshima ya!*
> *Kasa sashikakeshi*
> *natsu-sakana.*
> (Ah! Enoshima
> A parasol above our heads
> In the height of summer!)

This is a perfect example of the *haiga* where the pictorial motif is barely touched in, without definition, leaving the viewer to complete it, as he has to complete the *haiku,* from his own imagination.

Signed: *Sōchō;* seal: *Sōchō.*

Ink on paper.

Kakemono; 33.6 x 44.8 cm.

Literature: *Japanische Tuschmalerie: Nanga and Haiga,* Catalogue of Exhibition at Kunstgewerbemuseum, Zurich, 1962, No. 24.

Collection: Museum Rietberg Zurich (Gift of Dr. Eberhard Fischer, Zurich).

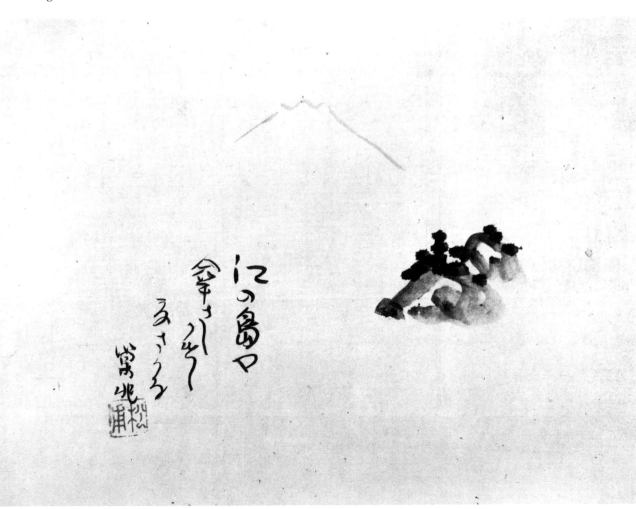

82

HAYASHI JIKKŌ
(1777-1813)

Jikkō (also known as Chōu) is not universally admired in Japan, for some critics are aghast at what has been called his "wild and incorrigible" style. He died young and is known by a small number of highly original *kakemono*, of which the scrawny, pugnacious "Bird Demon" (*konoha tengu*) is almost the only one known in the West (by reason of it being illustrated in the Heibonsha *Japanese Painting in the Literati Style*). He was born to a merchant-class family in provincial Mito, and is alleged to have been a pupil of Tani Bunchō, though it would have been easier to believe, from his unconventionality, that he was a disciple of Rosetsu. He wielded brush and ink with a dash and impetuousity that is exceptional even among the literati painters. To deploy his flamboyant brush, he demanded large areas of paper, and his works far overstep our notional limits for the size of a "drawing," but in every other respect they qualify for a place alongside the other examples of eccentric brushwork exhibited here.

83. Dragonfly. This is an awesomely predatory insect, the diagonal placement, the splintery line and the magnified size giving it an exhilarating impetus across the page. It suggests something prehistoric, out of our ken, rather than a common-or-garden *tombo*.

Signed: *Jikkō*; seal: *Sujiō*

Ink on paper.

79.0 x 56.2 cm.

Literature: *Mito ni Nanga,* Catalogue of an exhibition held in Ibaragi Ken Prefecture, Rekishikan, 1978; *Hayashi Jikkō,* edited by Ibaragi Kyōdō Bunka Kenshōkai, Tokyo, 1960, reprinted 1978.

Collection: Kosuke Hanawa, Mito City, Ibaragi Prefecture, Japan.

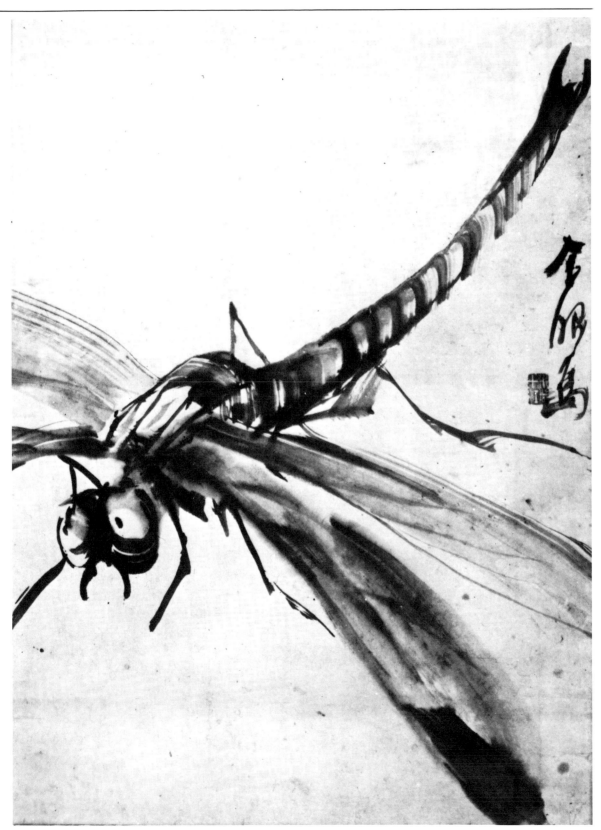

83

SAKAI HŌITSU
(1761-1828)

When Kōrin died in 1716, the Rimpa tradition of manneristic, colorful décor was continued by such followers as Shikō, Rōshū and Kagei; but after Rōshū's death in 1757 the style became moribund, and it was not until the early 19th century that it was revived by two artists, independently of each other it would seem: Hōchū and Hōitsu. Both made their allegiance to Kōrin explicit, Hōchū entitling his extraordinary color-printed book of Kōrinesque designs *Kōrin Gafu*, "The Kōrin Drawing Book," published in 1802; and Hōitsu, in 1815, recording in the *Kōrin Hyakuzu* ("One Hundred Works of Kōrin") the exhibits at a memorial meeting convened to celebrate the centenary of Kōrin's death, when guests displayed their collections of the master's work at Hōitsu's home.

Hōitsu was a patrician, with no need to earn his living as a painter, and there is a certain eclecticism both in his education and his output—he studied under masters of Kanō, Ukiyo-e, Maruyama and Nanga before settling for Rimpa—but there is nothing of the amateur in his attitude; few artists, in fact, have shown greater accomplishment. His screens and *kakemono* are widely admired, and the book of color prints, *Ōson Gafu* (Ōson was another of his names), published in 1817, is a Rimpa masterpiece.

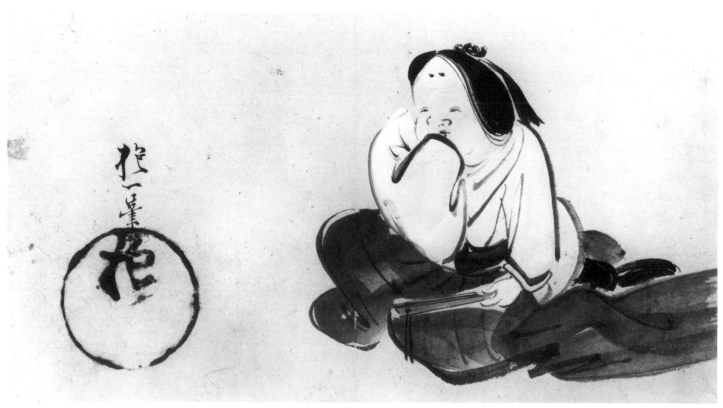

84

84. Ōkame seated holding a fan. Rimpa was essentially a Japanese style, and invariably the subjects chosen by Rimpa artists were nationalistic, without the deference to China that was seen constantly in Nanga and, to a lesser degree, in Shijō. Hōitsu has depicted Ame-no-Uzume-no-Mikoto, popularly known as Ōkame, who in primitive Shintō mythology was an attendant on Amaterasu, the Sun Goddess herself. According to legend it was she who, by her erotic dancing, excited the curiosity of the Sun Goddess and enticed her to leave the cave she had retired to in high dudgeon because of the conduct of her brother Susano-o. Hōitsu has drawn her in a manner which makes recognition immediate, with round face, blunt nose, two black spots (*bobo-mayugi*) high on her forehead, and the invariable "fat smile," half-covered by her sleeve.

Even in technique, this drawing, with its use of opaque washes, repudiates any possibility of a connection with China.

From an album to which artists of various schools contributed, with dates ranging from 1806-1815. By chance, on the opposing page to the Hōitsu drawing there is one by Watanabe Kazan (see No. 89) which as openly embraces China in subject and treatment as Hōitsu rejects it.

Ink, *gofun* and color on paper.
From an album; 14.0 x 25.4 cm.
Private Collection.

85. Wild musk melons hanging from a bamboo support. This is a page from another album, a true *liber amicorum* to which numerous artists and poets contributed, but this time the drawing, with its free brushwork and suggestion of form rather than solid outline, is far more Shijō in feeling than Rimpa. The diminuendo of the three pods, the suggestion of their recession by an increasing sketchiness from nearest to furthest, and above all, the daring asymmetry, give the drawing a distinctive, utterly Japanese piquancy. C. 1820.

Signed: *Hōitsu hitsu;* seal: *Bunsen.*
Ink and color on paper.
From an album; 19.0 x 12.8 cm.
Collection Baines, Antwerp.

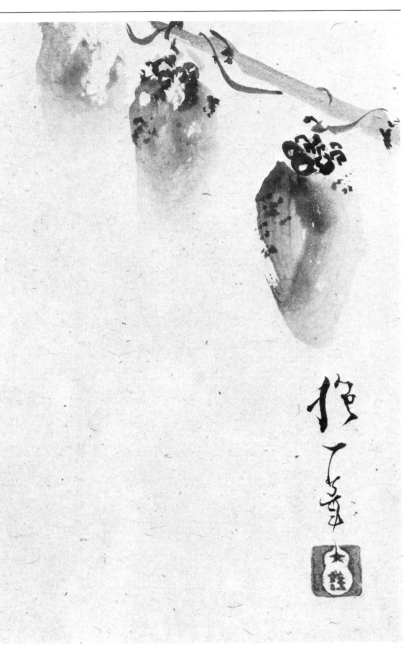

85

NAKABAYASHI CHIKUTŌ
(1776-1853)

Born in Nagoya, the son of a medical doctor, Chikutō was persuaded towards Nanga painting by Kamiya Tenyū, also a native of Nagoya and a prominent collector of Chinese paintings. With Baiitsu, a fellow townsman, he moved to Kyoto in 1803, and there became a member of the literati circle that had Rai Sanyō at its center. Chikutō's large-scale Nanga paintings tend to be repetitive with a somewhat monotonous exploitation of the "Mi Fei" dot technique, and he is often at his most attractive in smaller, album-sized works.

He was very consciously a Chinese-style artist, and was the author of treatises on painting in the Nanga manner, preaching his

methods in a number of illustrated *Gafu*, such as the *Chikutō Gakō*, "Studies in Painting by Chikutō," of 1812; and *Chikutō Shikunshi Gafu*, "Chikutō's Drawing Book of the 'Four Gentlemen' (Bamboo, Orchid, Chrysanthemum and Plum)," of 1853.

86. Landscape and a terraced hill. A small clump of diversified trees springs from foreground rocks.

Unsigned (from an album with a signed sheet).
Ink and slight color on paper.
29.8 x 36.0 cm.
Collection: Mr. and Mrs. Dennis Wiseman.

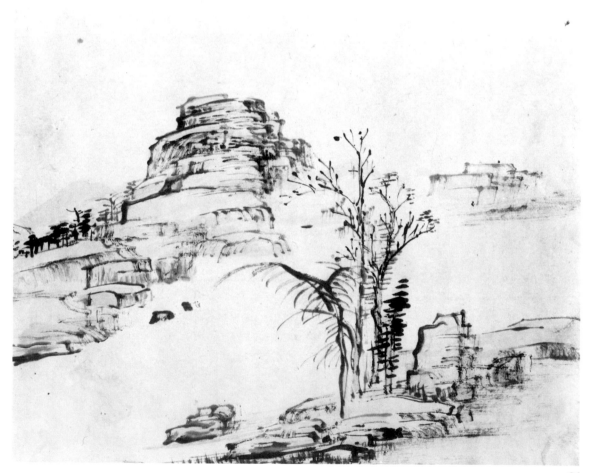

86

YAMAMOTO BAIITSU
(1783-1856)

A native, like Chikutō, of Nagoya, Baiitsu also became the protégé of Tenyū, the collector of Chinese paintings, and through that influence studied Chinese and eventually Nanga paintings. He was far from being sectarian, however, and was open to the influences towards naturalism that were in the air in the first half of the 19th century. Certain drawings and paintings by the artist have an intriguing ambivalence arising from this blend of styles. He associated closely with Chikutō and for many years worked in Kyoto, where he had numerous followers, before returning to his native city in 1853.

87. Rooks gathering at wintry treetops. The trees, almost bare of foliage, are drawn with spiky brushwork; the buoyancy of the birds planing down to the tree is achieved by the subtlety of the spacing.

Unsigned, but from an album one sheet of which is signed *Baiitsu*.
An undeciphered collector's seal.
Ink of two tones on paper.
21.0 x 30.4 cm.
Collection: Mr. and Mrs. Dennis Wiseman.

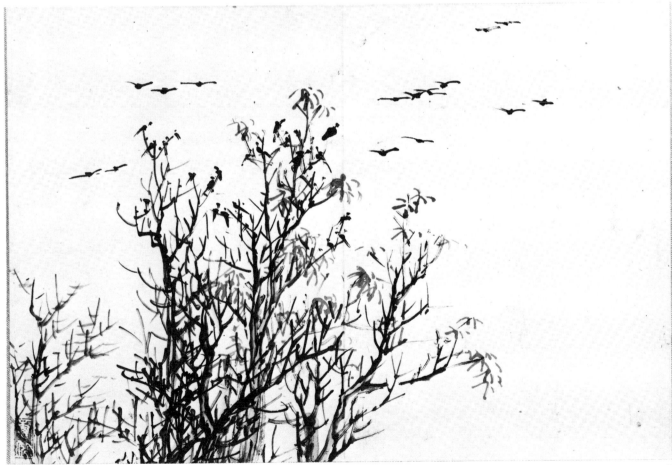

87

WATANABE KAZAN
(1793-1841)

Kazan was before his time in recognizing that Japan could not exist in isolation from the outside world; and he paid the penalty, dying by his own hand after being imprisoned on false charges. His poverty, his patriotism, and the tragic circumstances of his death have given him a special place in the annals of Japanese art, but should not obscure his achievements as an artist. As the son of a *samurai* and an intellectual, it was almost inevitable that his interest in painting should have been fostered in the Chinese school. He was a pupil of both Kaneko Kinryō and Tani Bunchō, and painted accomplished but orthodox landscapes and *kachō-e* in Nanga style; but his comprehensive study in *rangaku*, Dutch learning, led him also to an understanding of Western precepts in art, and in his landscape sketches from nature, and even more, his portraits, he anticipates by half a century the Westernization of Japanese art that ensued in the Meiji era, that is, from 1867 onwards.

88. Chinese groom and horse. This drawing is deceptively simple in appearance, but the line is very deliberate and admirably suggests the forms of both horse and man. The pale blue markings of the horse give an added distinction.

Of course, Kazan is invoking any number of Chinese precedents, from Chao Meng Fu onwards, but for all that the drawing is unmistakably Japanese.

Seal: *Kazan.*
Ink and slight color on paper.
Kakemono; 27.6 x 49.1 cm.
Keigensai Collection, Berkeley.

89. Lotus. This strongly asymmetrically placed plant is again evocative of Chinese flower-painting, and illustrates the kind of "boneless" painting that was a feature of such artists as Chinzan, Baiitsu and others as well as Kazan.

This is in an album on an opposite sheet to the Hōitsu drawing (No. 84).

Signed: *Kazan Gaishi;* seal: *Watanabe Noboru.*
Ink and color on paper.
From an album; 14.0 x 25.4 cm.
Private Collection.

90. The artist's family at home. The sketch forms the end of a letter from Kazan, believed to have been written from Nagasaki to his family, and is full of nostalgic memories of the domestic scene at home. The date at the end of the letter presents something of a problem in that Kazan has used an incorrect cyclical, *kinoe ne,* corresponding to Bunka 1 (1804), whereas the *nengō* is given as *Bunsei* followed by an indistinct figure 2 (1819).

Signed: *Watanabe.*
Ink and color on paper.
Mounted as *makimono;* 18.8 x 94.0 cm.
Ralph Harari Collection, London.

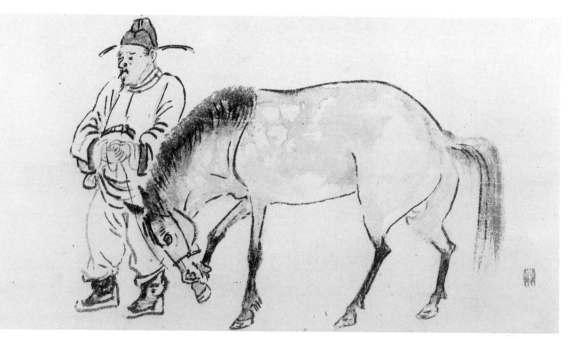

89

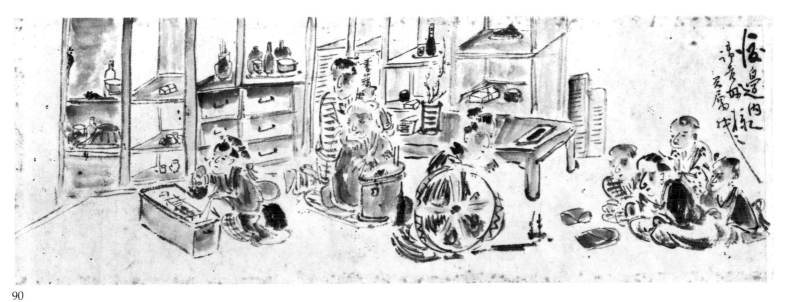

90

Chinzan's life was very much intertwined with that of Kazan, who was a few years older. A *samurai* in service to the government, Chinzan studied, like Kazan, under Kinryō and Bunchō, and became friend and eventually pupil of the great patriot. He was a Confucian scholar, calligrapher and musician (he played both *shō* and *koto*). His painting shows indebtedness to Chinese floral painters and a preference for free brush-painting in the "boneless" style.

91. Two camels. A deliciously humorous drawing that marvelously captures the sinuous flow of the animals' gangling limbs in controlled washes of ink, and hits off the supercilious sneer of the further beast with the deftest of touches.

The drawing almost certainly depicts the pair of camels that caused such a great stir when they arrived in Nagasaki in 1821. Many artists could not resist recording the outlandish beasts, and a number of color prints were published in Nagasaki to commemorate their arrival.

This drawing has always been ascribed to Chinzan, and it comes from an album of drawings presumably by the same hand, none of which is signed. The subtle humor is not something one is accustomed to finding in Chinzan's work, but the actual wash technique with a minimum of outline is quite usual to him and one can easily believe that the sight of these unfamiliar animals inspired him to a drawing of unusual insight and verve.

Unsigned.
Ink on paper.
39.4 x 26.6 cm.
Literature: Illustrated in *Tikotin*.
Collection: E. Biedermann, Bern.

92. Epidendrums and peonies, from a long scroll of flowering plants.

Chinzan excelled in "boneless" painting. When this technique was used, the plant forms were established as the washes dried and left a firm edge. *Premier coup* was essential, since any afterthoughts or retouching would have destroyed both the limpidity and the clearcut edges.

Signed: *Chinzan Tsubaki Hitsu*.
Ink and color on silk.
From a *makimono*; height 34.5 cm.
Collection: Trustees of the British Museum, London.

92

FUJIMOTO TESSEKI
(1817-1863)

Tesseki was another of those *samurai* artists who, like Watanabe Kazan earlier, was caught up in the tumultous events that decided Japan's future, and he met his death as a loyalist swordsman in the Emperor's cause. He had instruction from a number of Nanga painters and is said to have admired Chinese painting of the Sung period, but his strong personality gives his brushwork a pronounced individuality with a tendency to wildness that might well have been the reflection of a headstrong character.

93. Summer in the valley. The end section of a long handscroll. A rock of grotesque form at right threatens a fishing hamlet at the edge of a lake, a needle peak at left and a range of more believable mountains beyond. The inscription includes the cyclical date *mizuno-e inu* (1862).

Ink on paper.
From a *makimono*; height 27.0 cm.
Collection of Betsy and Karel Reisz, London.

GIBON SENGAI
(1750-1837)

The Zen religion encouraged artists and calligraphists to spread its teaching in painting and inscriptions. For us in the West, except the few to whom the religion is not irredeemably obscurantist, Zen art is viewed with as much lack of "understanding" as, say, Blake's illustrations to his "prophetic" books, or the Expressionist diatribes against society in the 1920s: the fact that there is a "message" comes over in the fervor of the pictorial images, but we ignore it, whether religion, prophecy or nihilism, as incomprehensible and appraise the paintings purely on the aesthetic values which we now recognize as valid. Hakuin and Sengai, probably at the head of the artists of the Zen sect, have achieved their distinction in the eyes of Zen adherents on quite different grounds from those which have led foreign outsiders to revere them.

Sengai was a monk from boyhood, spent his youth in temple pilgrimages, settled at the Shōfukuji (a temple in Kyūshū,), became abbot there, and finally retired from the post. He studied painting under the basically Nanga priest Gessen, but it is obvious that he modeled himself on Hakuin and Suiō, though he was blessed with a gift for humor which is half his appeal to us and needs no interpretation.

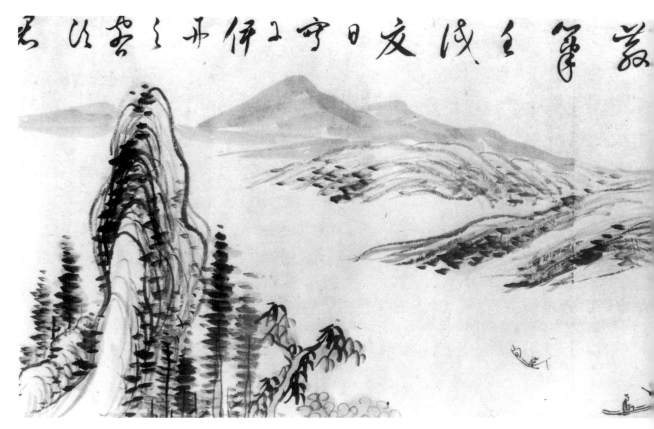

94

93

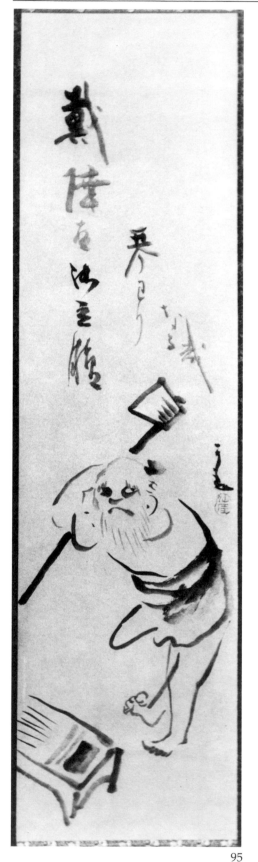

94. The Deserted Fields. Kanzeonji, the temple in Fukuoka, was a favorite subject of the artist, and it stood near the site of the former Western Capital of Dazaifu, a circumstance which explains the poem inscribed on the painting. It has been translated by Stephen Addiss as follows:

> When you come to see
> the ruins where once stood the
> Western Capital -
> At evening the tolling of
> Kanzeonji's temple bell.

Signed: *Sengai giga,* "playfully sketched"; seal: *Sengai.*
Ink on paper.
35.0 x 54.0 cm.
Literature: Addiss, No. 26.
Kurt and Millie Gitter Collection.

95. Tao Chi about to destroy his *ch'in* (the Chinese *koto*) with an axe. The verse identifies the incident: it says "Tao Chi is angry. He forcibly makes his excuses," using the word *kotowari* for "makes his excuses," which can also be read "breaks his *koto.*" Tao Chi was a counsellor to a Chinese emperor of the Sung period. Stephen Addiss, in the catalogue referred to below, explains that "One day Tao Chi was asked by the Emperor to play his *ch'in*, and considering himself an advisor and not an entertainer, Tao Chi broke his instrument in half." Zen followers might find an analogy in Daruma refusing to teach an Emperor and retiring to a cave to meditate.

Sengai obviously enjoyed this story, and another version is known, illustrated in *Ontsu Zenshi Iboku* (1894).

Ink on paper.
Kakemono; 119.5 x 29.0 cm.
Literature: *Japanese Ink Painting in the Edo Period,* Catalogue of an exhibition at Meadowbank Art Gallery, Rochester, Michigan, 1972, No. 40.
Shōka Collection.

95

SUZUKI NANREI
(1775-1844)

Suzuki Nanrei was practically unknown in the West, and of no great reputation in Japan, until about twenty years ago, when a collection of albums and *makimono* was unearthed by Richard Lane and acquired by various collectors in England. The haul came from a family in Mikawa, where Nanrei's pupil Keigaku had lived, and the storage cabinet was inscribed in Keigaku's calligraphy. The album drawings, and the drawings in *makimono* form, proved Nanrei to be one of the most exciting of all Shijō artists, with an unsurpassable mastery of the brush and of *mise-en-page*, a lively sense of humor and above all, a lyricism that was exceptional even in a school noted for artists of poetic spirit.

Nanrei and Chinnen represent the ultimate in Shijō style. The new freedoms won by Ōkyo with respect to naturalism and by Goshun in the handling of the brush culminated in these two in drawings that were concerned as much or more with the art of the brush as they were with what the brush depicted: an exploitation of the medium that had always been inherent in the best of Chinese and Japanese paintings, but which was now made more explicit. All the exhibited drawings of these artists attest to this aspect of their art, but none more so than the *Ferret*, where one incredible stroke gives the form of the animal, from the head firmly outlined by the fully charged brush, along the sinuous back, to the last hairs of the tail from the now almost dry brush.

Nanrei had the best of masters in Nangaku, one of the earliest of the Kyoto-based Maruyama school to teach in Edo, and he is said also to have studied with Tōyō and with Toyohiko. Something of Toyohiko's influence is evident in Nanrei's landscapes, but in this, as in other genres, Nanrei transformed his models in a uniquely personal use of brush and color.

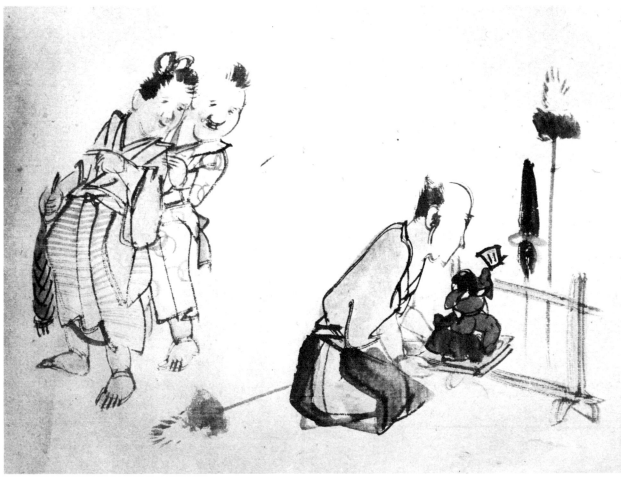

96

96. Preparing for the Boys' Festival. Two men watch a fond father setting up a display for the Boys' Festival, held on the 5th day of the 5th month. The father is holding on a stand a figure of Kintarō with an axe, typical of the heroic figures featured on these occasions.

Unsigned.
Ink and color on paper.
One section of a *makimono;* height 28.8 cm.
Anonymous loan.

97. Hilltop house. Beyond a group of pines, steps ascend the hill, at the crest of which is a small house with a thatched roof. At the right is a higher cliff, and the distance is closed by another range.

This spacious drawing, with its firm grasp of the terrain, is given especial atmosphere by the expressive drawing of the trees, and by the subtle touches of color.

Unsigned.
Ink and color on paper.
One section of a *makimono;* height 28.2 cm.
Anonymous loan.

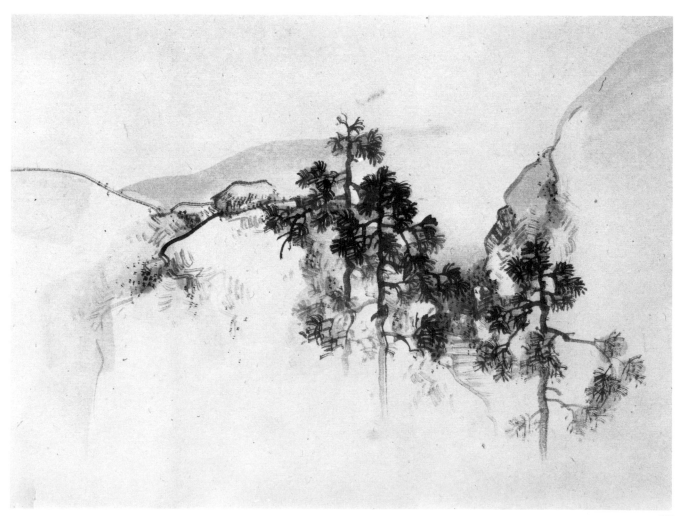

97

98. Pines and drum bridge: moonlight. The pines perform a dance movement about the semi-circular bridge, and the effect of moonlight is uncannily captured by the varied accents on the foliage of the trees.

The drum bridge is probably that on the grounds of the Kameido Temple, the subject of one of Hiroshige's "One Hundred Views of Edo."

Unsigned.
Ink and slight color on paper.
From an album; 27.5 x 38.0 cm.
Literature: Hillier, 1965, P1.23; Hillier, 1974, P1.239.
Collection: Mr. and Mrs. Dennis Wiseman.

99. Ferret. It is interesting to compare Nanrei's virtuoso brushwork with Ōkyo's handling of the same animal of about 1780 (see Hillier, 1974, P1.5). This and the other Nanrei drawings shown here belong to the 1820-1830s period. In the space of about fifty years the development of naturalism coupled with free brushwork has reached its apogee.

Unsigned.
Ink and color on paper.
From an album; 27.4 x 39.2 cm.
Collection: The Ashmolean Museum, Oxford.
(Reproduced in color on p. 22)

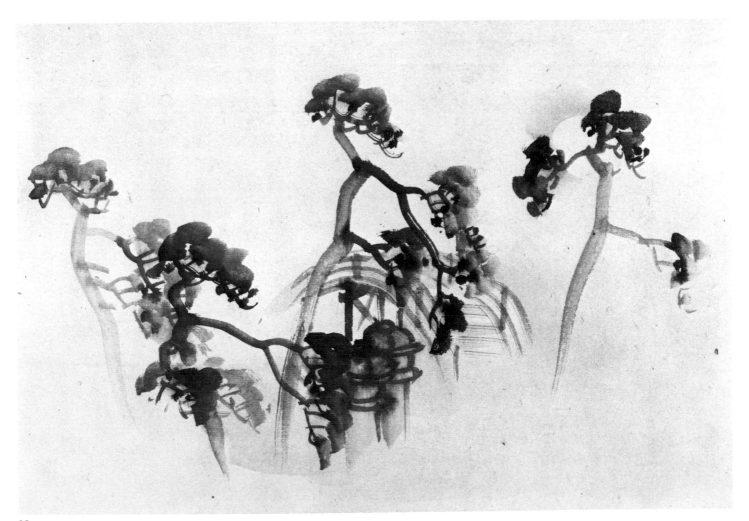

98

100. Snowbound village. The houses are huddled within sight of the sea at the foot of a hillside whose bulk is stressed by massive brush strokes that, as I wrote in *The Uninhibited Brush*, "are combed by the brush-hairs and as evocative as the raked sand of a Zen garden."

Unsigned.

Ink and color on paper.

From an album; 27.4 x 39.3 cm.

Literature: Hillier, 1965, P1.24; Hillier, 1974, P1.238.

Collection: Mr. and Mrs. Jack R. Hillier, Redhill, England.

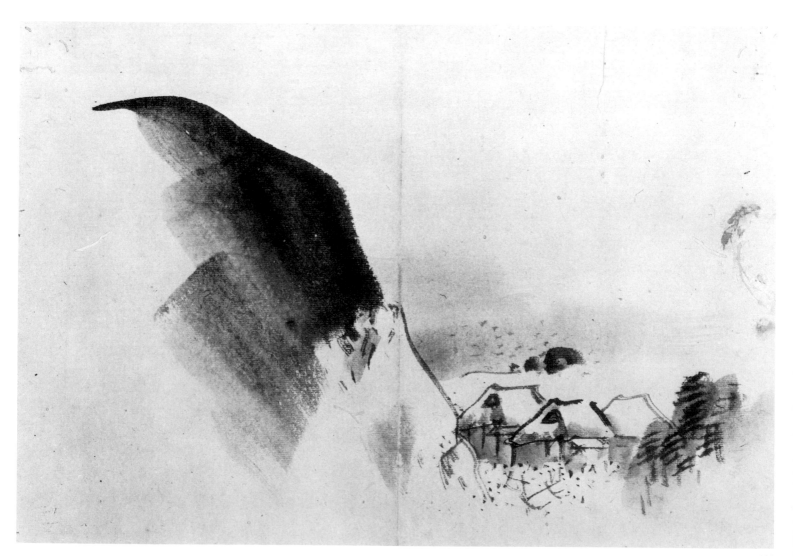

100

ŌNISHI CHINNEN
(1792-1851)

Like Nanrei, Chinnen had the benefit of Nangaku's teaching, but he also studied with Tani Bunchō, and his style is recognizably different from Nanrei's, veering sometimes more closely towards Nanga than Nanrei ever did. He was a younger man than Nanrei, but both reached the peak of their powers in the 1820s and 1830s.

Chinnen's reputation was established early in the West through the medium of two fine color-printed books: the *Azuma no Teburi* ("Souvenirs of the East," with a secondary title *Taihei Uzō,* "Images of the Great Peace") published in 1829, and *Sōnan Gafu* ("The Drawing-book of Sōnan," Sōnan being one of Chinnen's art-names) of 1834. Many of the sketches on which *Azuma no Teburi* was based have survived, and one is included in the exhibition.

101. Tekkai Sennin. This Taoist Immortal identifies himself by his "rapt upward look," and by the vapor he exhales—the form taken by his spiritual essence in mounting to the celestial sphere. Chinnen has contrived to suggest religious ecstasy as powerfully as Bernini or a metaphysical poet.

From a *makimono* dated 1823 of varied figure drawings, including a number of heads and half-length figures.

Unsigned.
Light color on silk.
From a *makimono*; height 29.7 cm.
Literature: Hillier, 1974, pp. 318-319.
Collection: Richard Lane, Kyoto, Japan.

102. Man, wife and son on their way to draw "young water" for New Year's Day. The explanation of the objective of this family is given in *Azuma no Teburi,* for a double-page print of which this drawing provided certain of the figures. The first meal of New Year's Day was a great event, and in Chinnen's time called for fresh water drawn at daybreak, from well or neighboring stream. The group as finally drawn for the book was enlarged by two

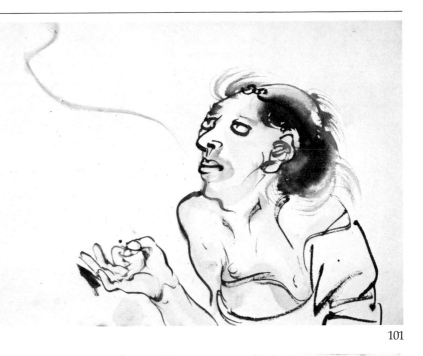

101

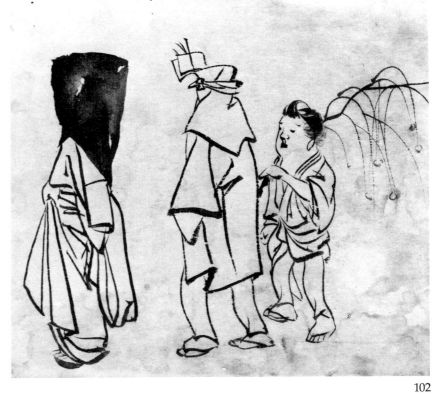

102

further figures, and the extravagance of the woman's *zukin,* or hood, a feature of the original drawing, was somewhat toned down. Curiously enough, although Chinnen provided the caption for this print in a table of contents, and specified this as a water-drawing expedition (the decorated branch carried by the boy and the *gohei,* or paper strips, held by the man denote a Shintō occasion), none of the participants appears to be carrying a water vessel.

Unsigned.
Ink and color on paper.
22.5 x 26.0 cm.
Collection: Gerhard Schack.

103. A gardener potting shrubs. Another sketch from the same group as the last, but not used for the printed book. Several of these sketches are free renderings from the *Yamato Jimbutsu Gafu* of Sōken (books published in 1800 and 1804), clear evidence of the attraction to Chinnen of these very free renderings of the people of Kyoto, which certainly encouraged him in his own uninhibited approach to figure-drawing.

Unsigned.
Ink and color on paper.
21.0 x 26.5 cm.
Collection: Gerhard Schack.

103

104. Snail on bamboo. The dash and skill of the brush in establishing not only the shapes of the leaves, but their angled position relative to each other and the recession from those in the foreground to those on the stem sloped slightly backwards, is immediately felt: but the crowning touch of mastery is the way in which, with a marginally more watery stroke, the artist has hit off the snail and its slow, inquisitive, slimy progress.

This is a section of one scroll from a set of three *makimono,* one of which is signed *Chinnen* and dated 1834.

Ink and slight color on paper.
From a *makimono*; height 28.6 cm.
Literature: Hillier, 1965, Fig. 4; Hillier, 1974, P1.249.
Collection: The Ashmolean Museum, Oxford.

105. Reclining ox. Everything suggests the inspiration of a moment—the fact that the drawing is in an album of the *liber amicorum* type strengthens the idea that it was thrown off to meet an importunate demand. But it is under such duress that the innate skill of an artist like Chinnen is pushed to its limit: and the result can be breathtaking.

Ink on paper.
From an album; 26.5 x 32.5 cm.
Literature: Chäikin, No. 98; Hillier, 1974, P1.248.
Collection: Nathan Chäikin.

104

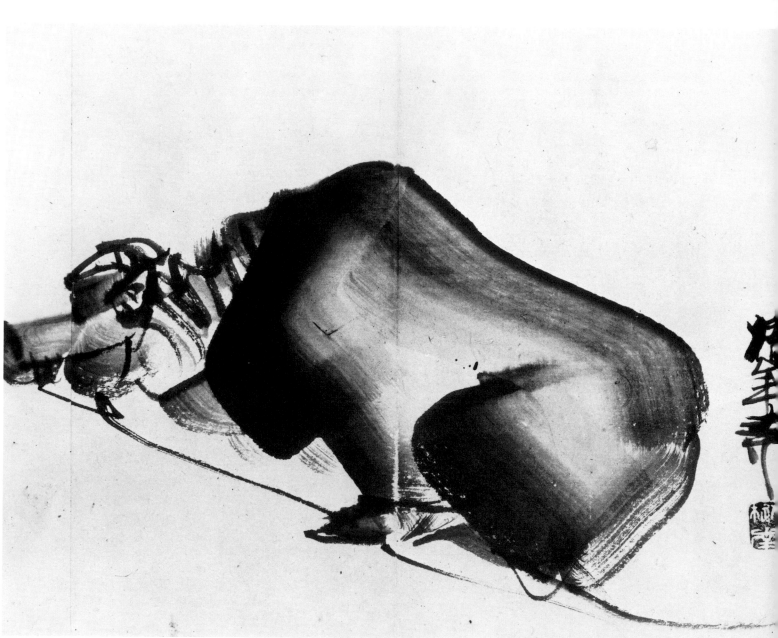

105

UEDA KŌCHŌ
(fl.c. 1830-1860s)

Although the actual dates of this artist's life are unknown, the preface to one of his books, *Kōchō Ryakuga* ("Kōchō's Simplified Drawings") published in 1863 (probably soon after his death), records that he was well known as a calligrapher and as an expert on old paintings, as well as an artist. He is reported to have been a pupil of Goshun and Nakai Rankō, but although he may have been influenced by both, it is more probable that Nagayama Kōin was his actual teacher. The book mentioned above, and the earlier *Kōchō Gafu,* issued in two parts in 1834 and 1850, are not among the most attractive books of the period, but in those brush drawings that have survived he seems to have had the freedom and verve that characterizes the best Shijō work.

106. Scene from a *kyōgen.* This comes from an album with subjects drawn from several of the comic plays.

Signed: *Kōchō*; seal not readable.
Ink and color on paper.
From an album; 21.5 x 29.0 cm.
Literature: Hillier, 1974, P1.218.
Collection: The Ashmolean Museum, Oxford.

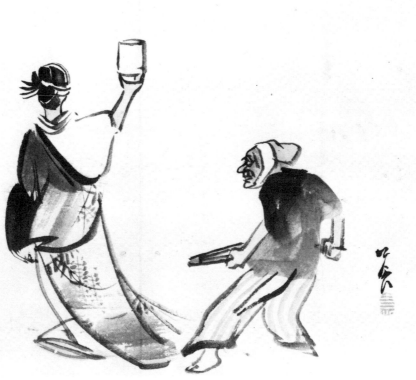

106

YOKOYAMA KAZAN
(1784-1837)

Yokoyama Kazan studied under Kishi Ganku, an artist who lies rather outside the mainstream of Shijō, and whose brush style was decidedly individualistic. Unlike most of Ganku's pupils, Kazan managed to break away from the domination of a master who seems to have been somewhat doctrinaire, and his paintings show more sympathy with Goshun's warmer, more engaging manner.

Painters in Japan, as a class, seem to have been more addicted to drink than most, and Kazan has become a legend as a drunkard: he is known to have carried written apologies for any misdemeanors of which he might be guilty when under the influence of *sake*. But this weakness did not infect his painting, which is usually elegant and restrained.

107. Autumn landscape with a village below a mountain. The ink washes and the slight touches of rust color on the trees and houses, the absence of any life about the dwellings, give an air of elegiac sadness to the scene.

Signed: *Kazan utsusu*; seal: *Kazan*.
Ink and slight color on paper.
39.7 x 29.3 cm.
Literature: Hillier, 1965, P1.83; Hillier, 1974, P1.173.
Collection: Mr. and Mrs. Dennis Wiseman.

(Reproduced in color on p. 22)

Attributed to
KATSURA SEIYŌ
(1786-1860)

This artist, although a physician by profession, had the benefit of studying painting under Goshun, and his prolific illustrations to books, mostly anthologies of verse, from 1824 until 1851, belie any notion that he was simply a gifted amateur. As we know from the *kyōka* books, he was a facile artist with a tendency to the prettiness that became the besetting sin of late-19th-century Shijō artists. Hardly any original paintings or drawings by him are recorded, but an album of figure drawings brought back from Japan by von Siebold, and now in the Leiden Rijksmuseum, is thought to be from his hand. The drawing exhibited is from this album.

108. Standing figure of a young woman drawing her *uchikake*, or outer robe, around her.

Unsigned.
Ink and color on paper.
From an album; 29.2 x 24.6 cm.
Collection: Rijksmuseum voor Volkenkunde, Leiden.

(Reproduced in color on p. 23)

NONOYAMA KŌZAN
(1780-1847)

There is little recorded of this artist except that he had training under Kanō Yoshinobu, that he was ugly, pock-marked, and lived to an old age at Negishi. He was obviously naturalist first and artist afterwards, but like his English counterparts such as Curtis or Sowerby, he succeeded in breathing life and beauty into what, when recorded by less gifted hands, became too obviously lack-lustre "specimens" in the laboratory or exhibition case. Kōzan's butterflies, which he embellished with powdered gold, giving them mealy bodies and diaphanous wings, are widely known from drawings at Leiden, but the *kawa-ebi* shown are equally exquisite.

109. Seven *kawa-ebi* (river shrimps). At top right, the name *"kawa-ebi"* is given in *katakana*, followed by *"ebi"* in *kanji*.

Dated: *Tempō 6 (1835) 12th month 27th day.*
Sealed: *Kōzan.*
Red and black inks, with touches of *gofun.*
11.5 x 31.7 cm.
Collection: Rijksmuseum voor Volkenkunde, Leiden.

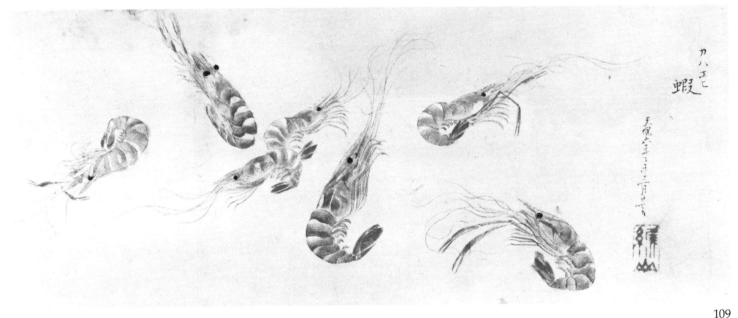

109

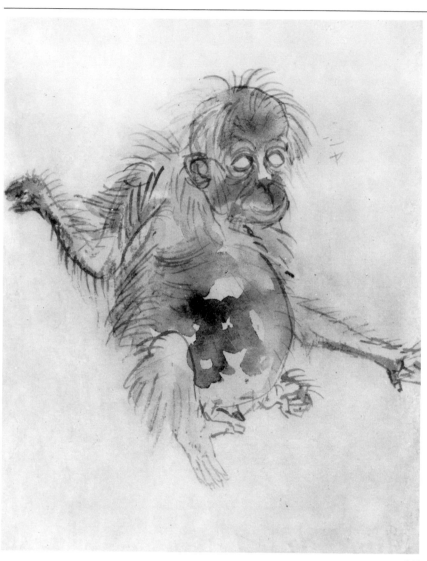

110

This artist, apparently unrecorded in Japan, is known to us first from an article by Collingwood Ingram, written for *Country Life* in 1957, entitled "Birds in Japanese Art," where two of Hōen's bird drawings were illustrated; and second by a considerable corpus of original drawings of birds, animals and flowers, in the Berlin Museum für Ostasiatische Kunst. Many of these Berlin drawings bear dates in the latter part of the 19th century, and Ingram confuses Kagawa with an earlier—and greater—artist, Nishiyama Hōen.

Kagawa Hōen had a gift of capturing the attitudes of birds in flight or perched, and brings a naturalist's knowledge and understanding to his portrayal of apes. His style can no longer be termed "Shijō," for although not consciously "Westernizing," he was working at a time when it was almost impossible for a Japanese artist to avoid being influenced by the alien realism of the foreign art with which the country was being flooded from the 1860s onwards.

110. Young ape. The *Inuus speciosus,* the only species native to Japan, is still fairly common in parts of the country.

Unsigned.

Ink and color on paper.

21.5 x 17.0 cm.

Collection: Museum für Ostasiatische Kunst, Berlin, Staatliche Museen Preussischer Kulturbesitz.

ICHIYŪSAI KUNIYOSHI
(1797-1861)

In the last thirty years, which have witnessed an enormous upsurge in Western interest in Japanese art, certain artists, like Utamaro, Hokusai and Hiroshige, whose greatness was recognized from the earliest contacts last century, have continued to maintain their dominance, but no Ukiyo-e artist has advanced so much in reputation during the period as Kuniyoshi. A number of reasons can be adduced: initial underestimation because of his belonging to the so-called "decadent" period of the 19th century and because of his prolific output; the tardy recognition of his incredible versatility and accomplishment; and the availability of his prints to collectors at a time of growing scarcity of earlier prints. But another reason is his mastery as a draftsman, which we have been able to assess from the phenomenally large number of his drawings that have survived. Kuniyoshi attracted numerous pupils, and among them were those that felt it a duty to preserve every scrap of paper that Kuniyoshi had used, whether for a hasty thumbnail sketch or an elaborate shita-e.

The history of these drawings is particularly germane to this exhibition and no one was better fitted to summarize it than B. W. Robinson, for many years a champion of the artist and his work and the compiler of the first significant catalogue of Kuniyoshi's drawings, that made in 1953 of the Lieftinck Collection (and bequeathed after the owner's death to the Leiden Rijksmuseum). Robinson, in a catalogue of an exhibition at Paul Brandt's in Amsterdam in 1971, wrote:

> It seems that when Kuniyoshi died his pupils gathered up the innumerable sketches and drawings that littered his studio and stuck them hap-hazard into over fifty albums, roughly stitched up for the purpose out of old commercial accounts and other scrap paper. These albums were purchased in Japan about twenty years later by the French dealer and collector, S. Bing. Two of them were bought from him by the Victoria and Albert Museum, and eight others . . . also remained bound up just as Bing had acquired them; these were in 1961 the property of Mr. Thomas Stauffer of Chicago, who kindly lent them to the Victoria and Albert Museum Exhibition. The remaining albums seem to have been broken up and the drawings separately mounted; a large proportion of them, after passing through the Bing, Javal and Tikotin collections, were acquired by the late Ferd. Lieftinck of Groningen, Holland, by whom they were bequeathed to the Leiden Museum.

Kuniyoshi was a pupil of Toyokuni, the head of the Utagawa family, which was primarily concerned with producing Kabuki prints. Kuniyoshi did his share of theatrical work, but his most characteristic prints were those illustrating with great gusto and wealth of detail the heroic episodes in Japanese history. He was obviously acquainted with Western art, largely through the medium of Dutch prints, and certain landscapes and figure prints which show his borrowings and adaptations from such material are intriguingly attractive.

111. The foiled attempt to execute Nichiren.
The 13th-century founder of the Hokke-shū Buddhist sect fell afoul of the ruling Regents several times, and in 1271 was condemned to death by Tokimune. As the executioner raised his sword to behead him it broke in his hand, a supernatural light fell over the scene, and Tokimune's palace at Kanura was struck by lightning.

Kuniyoshi gave one version of this event as one of his series of ten *oban* prints of about 1835 dealing with the life of Nichiren, but this drawing seems to have been intended for a print in triptych format that was never, so far as we know, produced. It is a brilliantly dramatic conception in which everything is in violent motion as the lightning flashes, except the praying figure of Nichiren.

Unsigned.
Ink on paper.
39.3 x 59.5 cm.
Literature: Robinson, No. 23 (illustrated); de Bruijn, No. 8 (illustrated); Bowie, 1975, No. 108.
Collection: Rijksmuseum voor Volkenkunde, Leiden

112. Shunkan and his daughter abandoned in exile. The two had been exiled together with Shunkan's confederates, Naritsune and Yasuyori, by the all-powerful Taira no Kiyomoro for their part in a conspiracy to overthrow him. A year after their exile began in the forlorn island of Kikai-ga-shima, Kiyomori granted an amnesty as a way of propitiating the gods in favor of his daughter the Empress, who was expecting a child, but when the ship arrived only Naritsune and Yasuyori were taken off. In Kuniyoshi's drawing Shunkan and his daughter are seen despairingly watching the ship departing. The design is a beautiful one, with a foreground tree playing an important role as it does in other compositions of Kuniyoshi. It was intended to be one of a series with the title *Yokairi Zukushi,* "The distance of the turbulent seas," but although the publisher's name, Yamada, is given, no such series seems ever to have been published.

Signed: *Ichiyūsai Kuniyoshi ga.*
Ink on paper.
27.9 x 40.1 cm.
Literature: Robinson, No. 107; de Bruijn, No. 27.
Collection: Rijksmuseum voor Volkenkunde, Leiden.

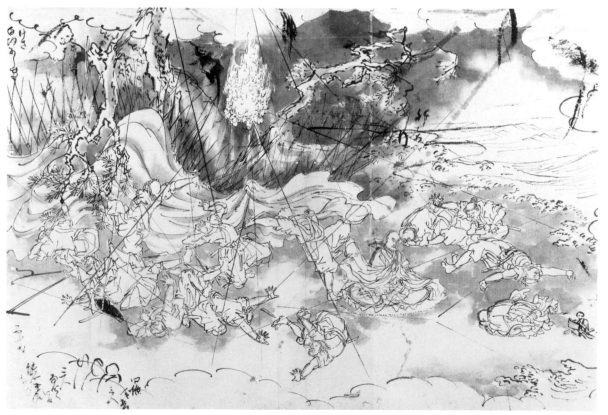

111

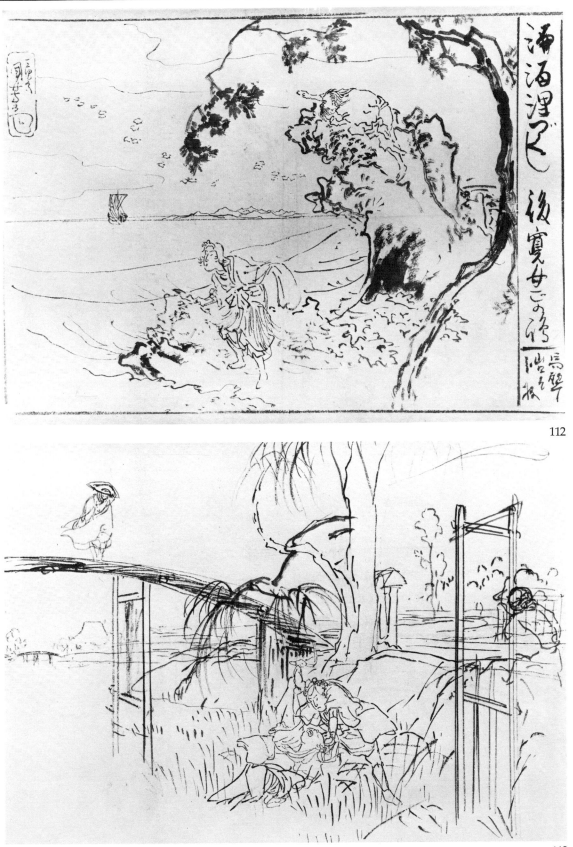

112

113

113. Yoemon murdering his wife Kasane with a sickle. This legend, of how Yoemon killed his ugly wife in a fit of jealousy and was thereafter plagued by her revengeful ghost, became a popular plot in both Jōruri and Kabuki. A macabre scene, made particularly sinister by the masterly placement of the figure high on the bridge, watching the crime apparently unmoved.

Unsigned.
Ink on paper.
24.2 x 34.4 cm.
Literature: Robinson, No. 123; de Bruijn, No. 30.
Collection: Rijksmuseum voor Volkenkunde,
 Leiden.

114. Sketch for a *kakemono-e* of Tokiwa Gozen. This is a first study for a known print, and only hints at the child, Ushiwaka (Yoshitsune), that Tokiwa Gozen is carrying in her flight in the snow from Kiyomori's son Shigemori after the attack on Owari.

Unsigned.
Ink on paper.
56.9 x 24.6 cm.
Literature: Robinson, No. 368; Ouwehand, No. 14.
Collection: Rijksmuseum voor Volkenkunde,
 Leiden.

115. Young boy playing a *samisen*. He is destined to be a musician, and begins his career on a child-size instrument.

Unsigned.
Ink on paper.
14.1 x 14.3 cm.
Literature: Robinson, No. 403; Ouwehand, No. 18.
Collection: Rijksmuseum voor Volkenkunde,
 Leiden.

116. Three studies of a cat. Kuniyoshi was notoriously fond of cats, and introduced them into many prints, one a superb triptych that shows dozens of them in every conceivable attitude. Several of his drawings of cats have survived, but none is more expressive in line or more tender in feeling than the one exhibited.

Unsigned.
Ink on paper.
23.5 x 32.5 cm.
Literature: Robinson, No. 567; de Bruijn, No. 79;
 Ouwehand, No. 16; Hillier, 1965, P1.69.
Collection: Rijksmuseum voor Volkenkunde,
 Leiden.

114

115

116

117. Blind Man's Bluff. A party of young women playing this ever-popular game in a large room looking onto a pleasant garden. A *tsuitate* (single-leaf screen) stands prominently in the room, and some of the players are hiding behind it.

This has all the appearance of being a first sketch for a triptych color print, but it has not been possible to trace any corresponding print.

Unsigned.
Ink on paper.
33.0 x 77.0 cm.
Collection: Gerhard Schack.

118. The ghosts of the Taira rising from the sea and attacking Yoshitsune and his fleet. This is a first sketch for a well-known color-print triptych. The attack came as a storm broke over the sea, and only the prayers of Benkei, Yoshitsune's henchman, fended off the vengeful ghosts.

An impression of the triptych is in the British Museum.

Unsigned.
Ink on paper.
37.5 x 79.0 cm.
Literature: Binyon, No. 216, p. 556.
Collection: Gerhard Schack.

117

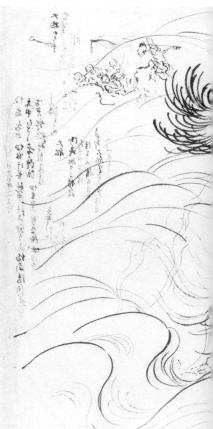

118

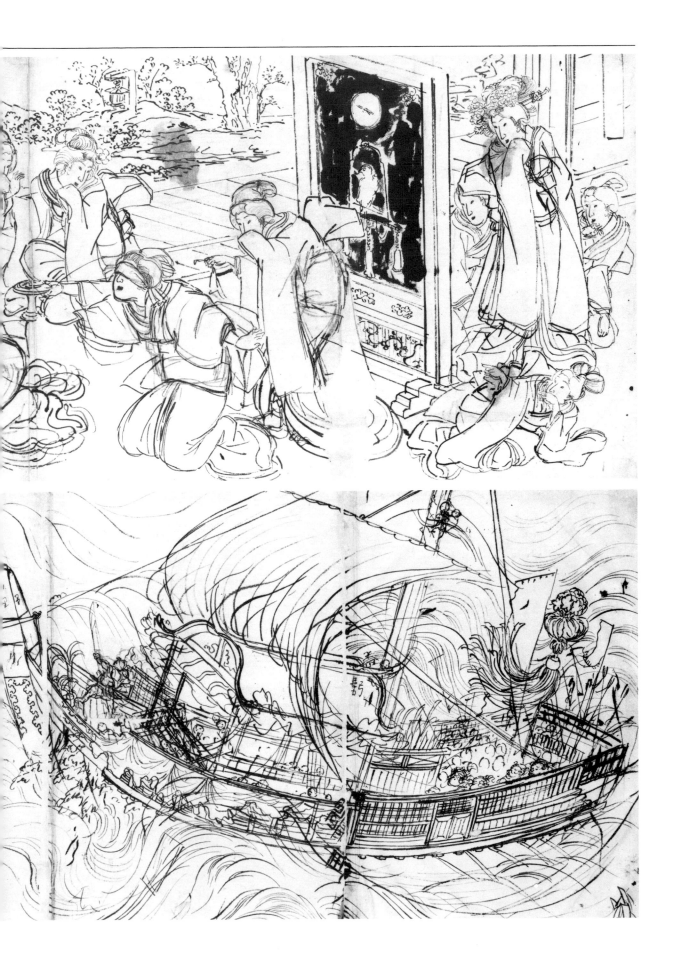

UTAGAWA KUNISADA
(1786-1864)

Kunisada became the head of the Utagawa school after the deaths of Toyokuni in 1825 and of Toyoshige, who contended for the position, in 1835. He was if anything more prolific than even Kuniyoshi, and a far greater proportion of his output was devoted to the theater, much of it of mediocre quality. But he had considerable powers as an artist, and a careful selection of prints places him among the half-dozen or so most significant print designers of the mid-19th century. Such drawings of his as remain are largely *shita-e* for theatrical prints or *bijin-ga* and do not greatly enhance his stature, but the *haiga* exhibited proves that it would be wrong to think of him as invariably pedestrian in his use of the brush.

119. Ichikawa Danjūrō VIII in the Shibaraku role. Kunisada's dashing sketch of the actor—who is identified by the *mon,* as his role is by the red garment and the immensely long sword—was obviously intended to be complemented by the *haiku* brushed in by Emba, and his verse reads:

> As the spring rains begin to fall,
> A nightingale's single song
> Says to the plum blossoms
> "Wait awhile" (*Shibaraku*).

This *haiga* belongs entirely to the world of Kabuki: the role in *Shibaraku,* the best known of all dramatic interludes, was the prerogative of the Ichikawa family, of whom Danjūrō VIII was one of the illustrious members; Emba was a novelist and one of the earliest authorities on Kabuki and he signs himself in full: *Tatekawa Danshūrō Emba*; and Kunisada was the theater's acknowledged champion and recorder.

Signed: *Kunisada ga*; seals: *Kuni Sada.*
Ink and brick-red wash on paper.
Kakemono; 46.0 x 35.0 cm.
Literature: Hillier, 1965, P1.55; Hillier, *Harari Exhib.,* No. 116; Hillier, *Harari Coll.,* Vol. 1, No. 93.
Ralph Harari Collection, London.

GOUNTEI SADAHIDE
(1807-1873)

Gountei Sadahide, a pupil of Kunisada, was one of the most versatile of the later Ukiyo-e artists, but is renowned particularly for his Yokohama-e, that is, pictures of Yokohama in the 1860s, and of the foreigners who thronged the newly-built concessions there. His pictures of Europeans, in color prints and a few exceptional ink-printed books, bear witness to the full impact upon Japan of an alien cilvilization that, in the preceding 250 years, they had only sampled, in the limited and strictly controlled presence of the Dutch at Deshima. The initial reaction of the artists, and Sadahide was the finest of them, was for them to record with considerable originality the foreigners in the style of painting native to them. It was only later that some began to imitate Western styles to portray the Western invaders, and there is a world of difference between the apparent naivete of Sadahide and the brilliant Western-influenced improvisations of Yoshitoshi (see Nos. 138-140).

120a&b. Pictures of glass-paintings depicting a Western man and his wife. This pair of drawings was evidently made with color prints in mind, but although other prints are known with the same series title (at top right *Yokohama-Shōka Urimono*, "Things for sale in Yokohama Stores") no prints were produced from these two. The inscription at top left is interesting because it describes the two portraits as *Pidro-kagami*, "Glass-mirrors," with oil-painted pictures, *pidro* being the word used in the 16th century when glass was for the first time introduced to Japan from the West.

Although the drawings give the impression of being portraits, the attempt at modeling is more to identify the sitters as foreign than to give likeness, and it is improbable that Sadahide had real portraiture as his intent. The man is something of a dandy, and possibly the fancy buttons may at least give a clue to his nationality. The back-paintings are partially obscured by rolls of cloth; that in front of the man's head has a label identifying the fold pattern as Chinese waves.

The publisher's sign and name, Yamamoto Heikichi, is given in a cartouche on each print.

Signed: *Gountei Sadahide ga.*
Ink on paper.
Each 36.0 x 26.5 cm.
Collection: The Tikotin Museum of Japanese Art.

ICHIRYŪSAI HIROSHIGE
(1797-1858)

Hiroshige has endeared himself to both Japanese and Western art lovers more than any print designer, more even than Hokusai, whom many would concede is the greater artist. His landscapes have an appeal that is not calculable merely in terms of composition and power of line, though in both he is often admirable. To the Japanese they bring nostalgia for a "land of lost content," the uncontaminated beauty of the countryside before industrialization, the reverence for historical or scenic landmarks; for us, there is the sense of locality, of the invocation of atmosphere, under changing season, time and weather, an intimacy that reminds us, for all the strangeness of the places, of the topographical drawings of our own landscape artists. But Hiroshige's unrivaled popularity is due in very large part to the collaboration of the printmakers: It is by his color prints that he is known—his effects of moonlight, of sunset skies, of brilliant color contrasts in snow scenes, were the triumphs of the color print, however far prompted by his designs.

By comparison, his drawings, which were almost invariably made with prints in mind, are comparatively tame. There is little feeling for the brush itself, or exploitation of its potential; it rarely develops beyond an almost pen-like evenness of line which has its value, certainly, and often imbues compositions with considerable effectiveness, but it is less sensuous, less expressive, than the ever-varying strokes of, say, Hokusai.

Hiroshige, as a pupil of the Utagawa artist Toyohiro, did not neglect figure composition, especially in his earlier years, and occasionally challenges Kuniyoshi and Kunisada in a sphere we think of as their own. In bird and flower prints, he shows a surprising kinship with the Shijō artists and in these his brushwork, as interpreted by the print makers, is more painterly. Indeed, in certain drawings, such as the Iwafuji and Inoue shown, when he is no longer thinking in terms of an eventual color print, he displays a brush-sense that puts us in mind of such contemporaries as Nanrei and Chinnen, though he never aims at their virtuosity.

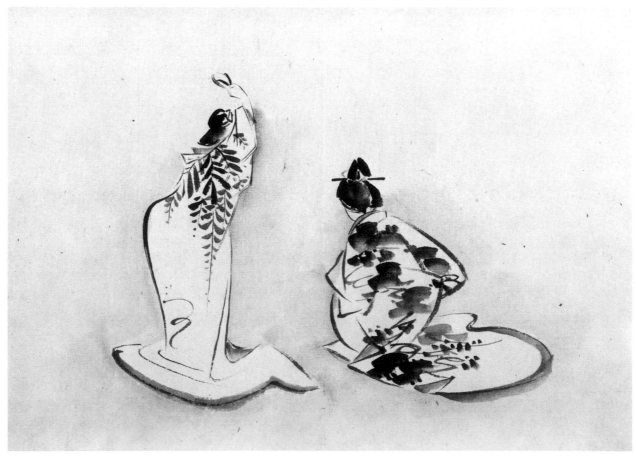

121. Iwafuji beating Onoe with a sandal.
This subject has already been explained under Hokuba (No. 77) and it is interesting to compare the manner in which the two artists handle the theme.

The Hiroshige drawing is in an album of ten drawings of pronounced Shijō style. The postface to the album, dated 1892 and written by Hō-ū-dō, explains that it had come from his father, who had been an admirer of Hiroshige and preserved this album of drawings.

Unsigned.
Ink and color on paper.
From an album; 23.0 x 32.0 cm.
Literature: Hillier, 1965, P1.64; *Harari Exhib.,*
No. 183(d).
The Ralph Harari Collection, London.

122. Dragonfly and hydrangea; cicada on
shūkaidō **(a species of begonia).** This drawing, designed for "two prints on a block," was clearly ready for the block cutter—the poems have been inscribed, the artist's signature and seals inserted. Two things cannot but strike us: how much was left to the imagination and power of interpretation of the block cutters, who had to keep in mind what the printers could achieve; and how Hiroshige's natural freedom in the Shijō vein was curbed by the need to ensure that there were at least sufficient outlines, or guidelines, for the craftsmen who were to convert the drawing into a print.

Signed: *Hiroshige hitsu*; seals: *Ichiryusai* and *Hiro*
(in a diamond).
Ink and color on paper.
18.3 x 32.7 cm.
Literature: E. F. Strange: *The Colour-prints of
 Hiroshige,* 1925, P1. facing p. 112.
Collection: The Victoria and Albert Museum,
London.

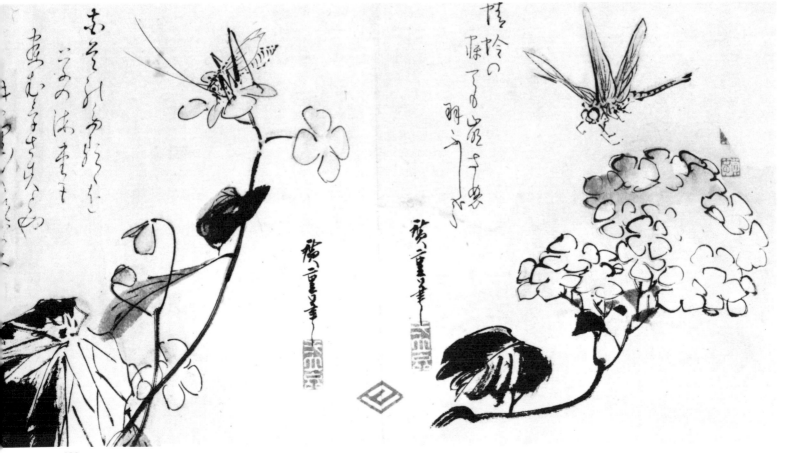

122

123. Evening Snow at Mount Hira. A preparatory drawing for one of the numerous sets designed by Hiroshige for *Ōmi Hakkei,* "Eight Views of Lake Biwa." The poem is the one that usually accompanies the subject, and has been translated:

When the snow has ceased falling
The whitened peaks of Hira toward evening
Surpass in beauty the cherry-blossoms.

The title, *Hira no Bōsetsu,* has been written in two places. This is an impressive first sketch, impetuous in line and decisive in composition. No print based on the drawing has been traced.

Signed: *Hiroshige*
Ink on paper.
24.7 x 34.7 cm.
Collection: The Tikotin Museum of Japanese Art.

124. Fuchū on the Tōkaidō. A preliminary drawing for a color print in the series called the *reisho Tōkaidō* because the title is in the formal script called *reisho.* It is in an album of forty studies for prints in this series with a provenance that traces it back to Hiroshige's pupil, Hiroshige II, and from him, through Wakai, and Hayashi, to Henri Vever. The blank cartouche at upper right was intended for the title, *Tōkaidō,* and the sub-title, written at the side, reads *Gojūsan tsugi, Fuchū,* "A Series of Fifty-three, Fuchū." The set was published around 1848-1850 by Marusei.

A procession of travelers is shown arriving at the lighted entrance to the licensed quarter. Various alterations were made in the final woodcut (impressions of which are illustrated in Tsuneo Tamba, *The Art of Hiroshige,* P1. 75 and Jūzō Suzuki, *Hiroshige,* No. 162), the most noticeable being the omission of the two figures at the extreme right of the drawing.

Unsigned.
Ink on paper.
22.0 x 32.5 cm.
Literature: *Hiroshige 1797-1858. dessins. aquarelles. estampes,* Catalogue of an exhibition at the Huguette Berès Gallery, Paris, 1955, No. 20.
Collection: Huguette Berès, Paris.

125. Kawasaki on the Tōkaidō. A sketch for another print in the Tōkaidō set published by Marusei in 1848-1850, but not in the album referred to above. The drawing shows ferries crossing the Tamagawa or Rokugō. The sub-title is *Gojūsan tsugi no uchi, Kawasaki* ("From a series of Fifty-three, Kawasaki").

Unsigned.
Ink on paper.
24.0 x 33.5 cm.
Collection: Dr. Walter Amstutz.

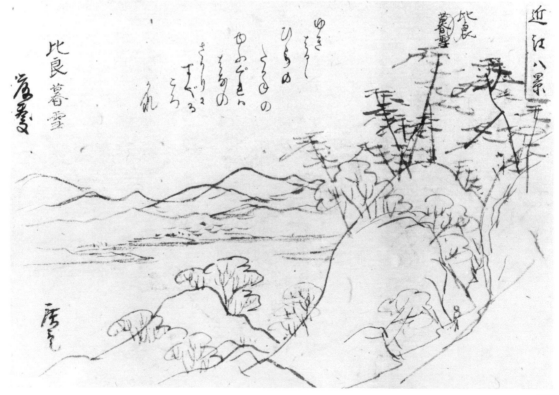

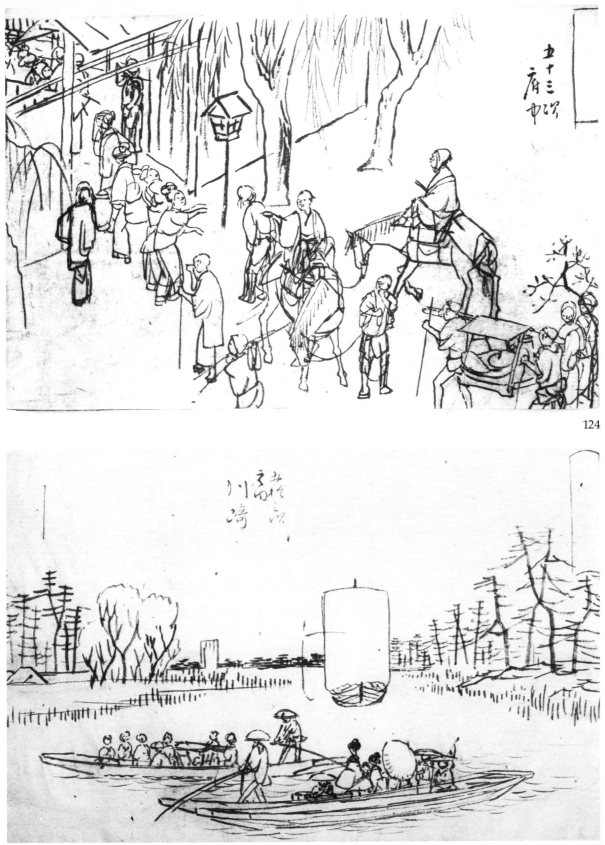

124

125

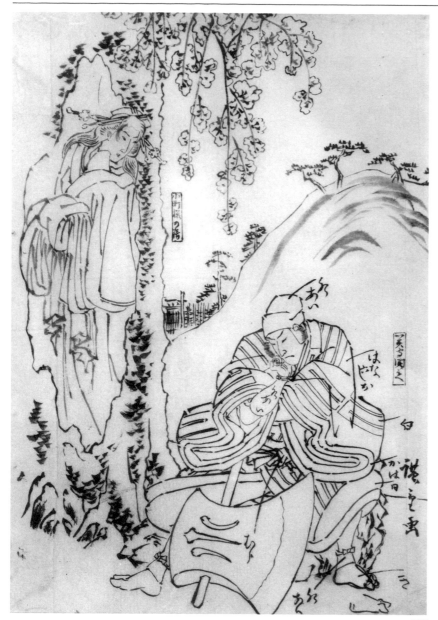

126

126. The spirit of the cherry tree. The figure at right is the poet courtier Otomo no Kuronushi, disguised as Sekihei, guard of the barrier at Mount Osaka (or Ansaka) near Kyoto. He has been bewitched into slumber by the Spirit of the venerable cherry tree that he had been about to fell for firewood: not for warmth, but as part of some evil sorcery concerned with his plan to usurp the Imperial throne. The Spirit takes the form of the very earthly courtesan Kurozome, the lover of a young courtier Yasusada, who has been murdered by Kuronushi's henchman. Kurozome blends her essence with that of the tree-spirit so as to protect the tree, and also to avenge her lover's death. The play in question, called *Tsumori Koi Yuki no Sekinoto,* was first performed in 1784, and is popular enough to have remained in the Kabuki repertory to this day. Hiroshige made the drawing for a color print in a series entitled *Kokon Jōruri tsukushi,* "A Series of Old and New *Jōruri*," published by Sanoki about 1849-1850. An impression of the print is illustrated in Tamba, *op.cit.,* No. 457.

Signed: *Hiroshige ga.*
Ink on paper.
24.3 x 17.2 cm.
Literature: J. D. Metzgar: *Adventures in Japanese Prints,* n. d. (1943), repr. opposite p. 12.
Collection: James DeLong, Los Angeles.

For a long time, Zeshin's preeminence as a lacquer artist tended to obscure his achievements as painter and print designer, but in the more searching light of studies in the last twenty-five years, both in Japan and in the West, aided by some memorable exhibitions, he has emerged as one of the more significant figures of 19th-century pictorial art. At the age of twelve he was apprenticed to a lacquermaster; in 1822, at age sixteen, he began the study of Shijō-style painting with Suzuki Nanrei; soon after he began an association with Kuniyoshi that lasted many years, and saw fruit as late as the period 1847-1852, when they collaborated in designing certain now celebrated *surimono.* He also studied landscape painting with another Shijō master, Okamoto Toyohiko.

In his handling of the brush, Zeshin is fluent and often dashing; he had perfect sense for the placement of his subject in space, often with asymmetry or truncation of figures that can startle us even now, when modern Western art has made such devices commonplace. With him, the technical brilliance is inseparable from and is a means of expression of a really humorous attitude to the daily round, and of a point of view that makes us look afresh at birds, or flowers and common objects of everyday use.

127. The "Wisteria Maiden" and the "Earthquake Fish." These two ill-assorted subjects come near the end of a long *makimono* of very varied drawings. *Fuji-onna,* the "Wisteria Maiden," was a favorite subject of the *Otsu-e* —folk-art productions originally made for souvenirs at Otsu. The *Namazu,* or "Earthquake Fish," was supposed, by popular legend, to cause earthquakes by its subterranean wriggling.

The scroll is prefaced by a letter from Zeshin to an early pupil, Matsumo Oshin, discussing the scroll and dated 9th month, 3rd day (no year); it is terminated by a colophon in Zeshin's hand giving to his pupil the art-name of Oshin, dated *Koka 5* (1848). The scroll seems to have been presented to Oshin as a diploma.

Ink and color on paper.
From a *makimono;* height 26.5 cm.
Literature: Hillier, 1965, Pls. 84-85, *Harari Exhib.,*
 No. 116; *Harari Coll.,* Vol. 3.
The Ralph Harari Collection, London.

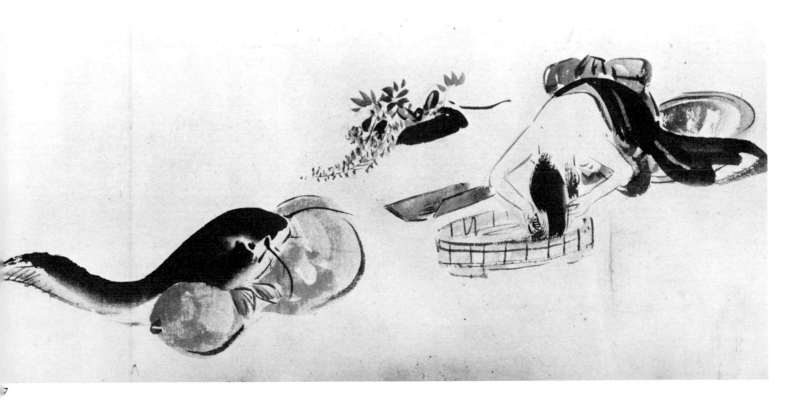

128

This great artist has grown in stature as we have been able the better to get the Meiji period into perspective. He studied at an early age under Kuniyoshi and later under Kanō masters, but eventually he went his own independent way. Essentially a nationalistic painter, he was nonetheless fully aware of Western art—indeed, he dealt with it quite broadmindedly in his book *Gyōsai Gadan* published in 1887—but he was robust enough not to succumb, as so many of his contemporaries did, to the blandishments of foreign styles, and was one of the last great painters in the truly Japanese tradition. If he has a fault, it is over-exuberance: he paints vigorously with a full brush, but his immense bravura and skill are sometimes a little overpowering.

But this very impetuousness and daring is often more economically used in smaller sketches and drawings and they have always elicited greater Western praise than many of his more important works.

Kyōsai, because of the warmth of his personality, his eccentricities and his known love for *sake* over and above his gifts as a painter, was a legend in his lifetime, and by great good fortune we have two intimate Western accounts of him at work: one by Émile Guimet, who with Felix Regamey, visited him in Japan in 1876, and wrote about him in *Promenades Japonaises,* published in 1881; the other by Josiah Conder, the British architect, who studied painting under Kyōsai in the 1880s, and who, in his *Paintings and Studies by Kawanabe Kyōsai,* published in 1911, gave a very full account of the artist's methods. Both Guimet and Conder were impressed by Kyōsai's "attack." A fan illustrated in Guimet's book of two frogs, one pulling the other along in a *jinrikisha* whose wheels are lotus leaves, has the kind of humor, in which animals imitate men and women, that is as old as the so-called Toba Sōjō scrolls of the 11th century: and Guimet describes how Kyōsai painted it, chatting as he did so and finishing it with a few touches of the brush. It would have been ideal for this present exhibition but, unfortunately, it can no longer be located.

128. Rat scratching its head. Although hardly "drawn from life," this drawing shows Kyōsai's acute observation and power to memorize. Conder mentions that Kyōsai "was an ardent advocate for constant study and sketching from nature." But he had reservations (which we may not always share): he maintained that "while the drawing from na-

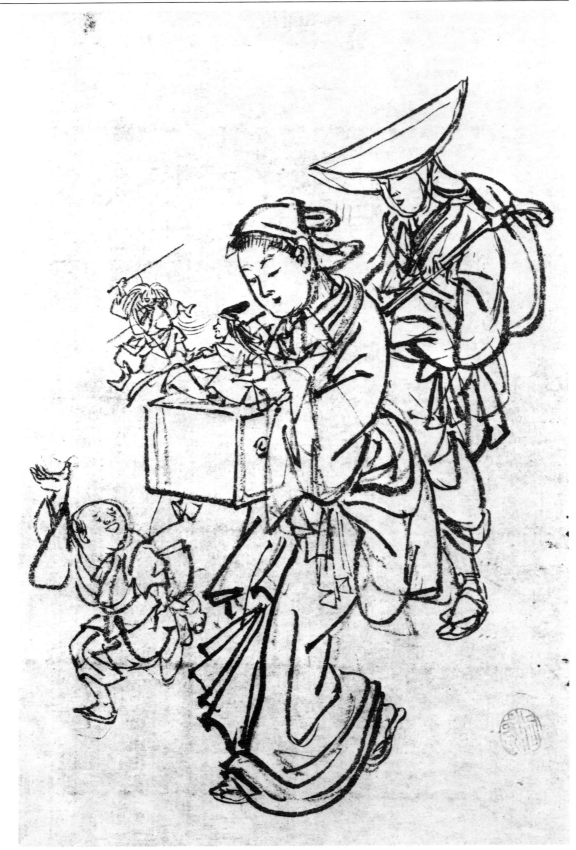

129

ture was too natural to be artistic, it was, at the same time, not natural enough to be classed as a work of art."

Unsigned.
Ink on paper.
7.6 x 9.9 cm.
Literature: Hillier, 1965, P1. 79.
Collection: Rijksmuseum voor Volkenkunde, Leiden.

129. Street puppeteers. A girl is operating two lively combatting puppets on a box-like stage supported over her shoulders; another girl walks behind her, playing a *samisen*. The audience is confined to one obviously delighted urchin, but he may be the forerunner of the crowd which the performers hope to attract. Quite often, as mentioned under No. 4,

these street shows were put on by *ame-uri*, "sweetmeat sellers," simply to attract children with the object of selling them their wares.

That Kyōsai was in the great tradition of Japanese draftsmen is made evident if this drawing and that of Itchō (No. 4) are compared: more than that, in these drawings and many others of the two men, one can sense comparable extrovert human beings, both with a great zest for life.

Another drawing of somewhat similar subject is in the Victoria and Albert Museum (illustrated in Hillier, 1965, P1. 71).

Unsigned. The seal, not readable, is probably a collector's.
Ink on paper.
21.3 x 14.2 cm.
Collection: Mr. and Mrs. Dennis Wiseman.

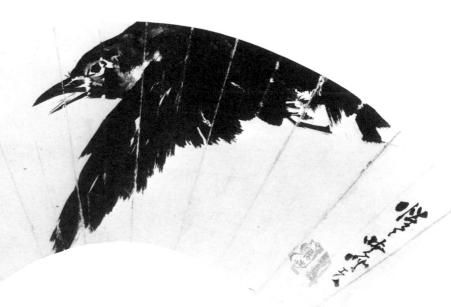

130

130. Crow in flight. Kyōsai had a pronounced partiality for drawing crows, and several paintings and woodblock prints are known. In this drawing it is the remarkable placement of the bird—cut by the upper arc and placed on the right-hand side of the fan—that makes so compelling a design.

Signed: *Shōjō Gyōsai ga*; seal: No. 24 in Conder's list of Kyōsai seals: "Seal in the design of two talon-shaped jades *(mago-tama)* with alternately raised and sunken characters reading *Jioku Kyōsai.*"
Ink on paper.
Fan; 20.0 x 45.4 cm.
Collection: Rijksmuseum voor Volkenkunde, Leiden.

131. Postman falling over his bag. The explanation of this volatile, expressionistic drawing is provided by a *kakemono* (like the drawing, in Leiden). The *kakemono* depicts a startled postman, his letters scattered all around him; from his bag, the ghost of a girl is emerging, causing him to stumble.

Unsigned.
Ink and some color on paper.
22.7 x 26.6 cm.
Literature: Ouwehand, No. 29; Hillier, 1965, P1. 74.
Collection: Rijksmuseum voor Volkenkunde, Leiden.

132. A falconry expedition. A nobleman traveling in a *norimon,* or carriage, drawn by courtiers setting off on a falconry expedition; at the head of the procession, a dog-handler and three falconers with birds on their wrists.

This is a preliminary drawing for one of the illustrations in Kyōsai's book *Ehon Taka Kagami* ("The Picture-book: The Mirror of Falcons"), published in two parts, the latter part dated 1877. A large number of the drawings for the book have survived and are described in Gerhard Schack's book listed below.

Unsigned.
Ink on paper.
18.5 x 26.0 cm.
Literature: Gerhard Schack, *Kyōsai's Falkenjagd,* Hamburg and Berlin, 1968, P1. 6 (the drawing), P1. 17, (the woodcut illustration); Schack, No. 91.
Collection: Gerhard Schack.

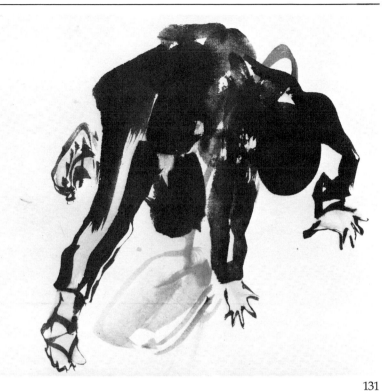

131

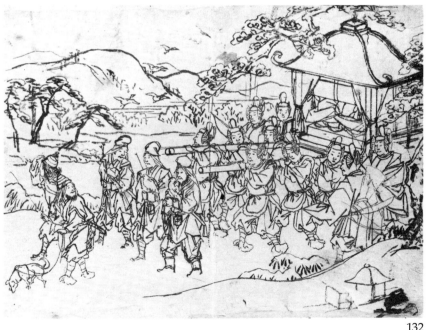

132

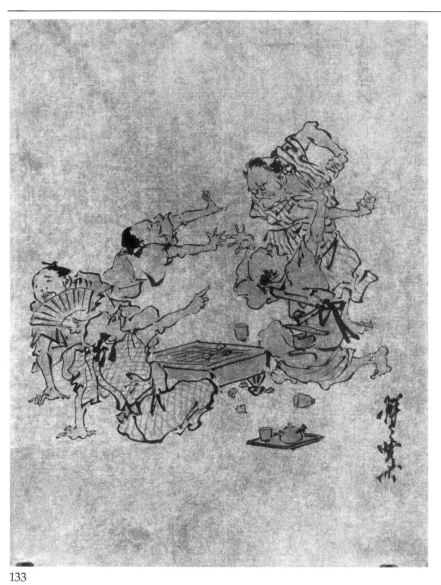

133

133. An interrupted game. Four men around a *go*-table, the tea cups evidence of a long convivial game, are suddenly set on by someone who seems to have been driven to desperation by the noisy players. Nobody was more adept than Kyōsai at portraying a fracas: not even Hokusai or Kuniyoshi could convey violent action and tumult so vividly.

Signed: *Shōjō Kyōsai.*
Ink and color on paper.
35.0 x 26.5 cm.
Literature: Schack, No. 105.
Collection: Gerhard Schack.

134. The Customs office at Yokohama. In this summary sketch, Kyōsai seems almost to be epitomizing the new look of Japan since the opening of the country to foreigners—the architecture, the horse-bus, the people in Western clothes. But the scene is hit off with something of the intimacy of the Nabis, and the everyday eventfulness of T. S. Lowry.

Unsigned.
Ink on paper.
26.0 x 37.0 cm.
Literature: E. J. Modderman: *Japansche Teekeningen en Schetsen.* Catalogue of an exhibition at the Franz Hals Museum, Haarlem, October, 1938, No. 85; Ouwehand, No. 30; Hillier, 1966, Fig. 6.
Collection: Rijksmuseum voor Volkenkunde, Leiden.

135. A scene in the new Tokyo. This drawing, apparently intended for a fan, shows a curious mixture of the traditional and the new-fangled, both in the subject and the treatment. Nothing could be more modern than the frontage of the emporium or hotel, with its standard gas lamp at one side and paper-covered lantern at the other; or more traditional than the bands of mist used by Kyōsai for decoration and for avoidance of distracting detail in the same manner as the earliest painters of Yamato-e scrolls.

Unsigned. The seal is that of the dealer Felix Tikotin.
Black and red inks on paper.
21.2 x 22.0 cm.
Collection: Rijksmuseum voor Volkenkunde, Leiden.

134

136

Bairei, a pupil of Raishō and Bunrin, both good Shijō artists, was another of those who continued to paint in traditional style, and who endeavored by his teaching and his membership on various Imperial committees to further the cause of Japanese-style painting. He was a more than competent painter with a real feeling for the brush, though even he was unable wholly to avoid, in his well-known drawings of birds particularly, a certain reliance on Western drawing "in the round."

136. *Oharame.* A peasant girl from Ohara carrying a bundle of faggots on her head. Bairei lived in Kyoto, at that time still close enough to the countryside for *oharame* (usually faggot sellers) and other rustic figures to be common sights. The *oharame* was a particular favorite with artists.

Unsigned, but from an album by Bairei dated 1894.
Ink on paper.
39.3 x 26.6 cm.
Literature: Chaïkin, No. 4
Collection: The Cleveland Museum of Art.

137. Rear view of a young woman walking.
She has a sort of chaplet on her head and
wears an extravagantly wide *obi,* so that one
suspects she is part of a festival procession.
This is a bold impromptu drawing, in which
the slightly deferent inclination of the
musume's head is marvelously suggested. It
has something of the strength and expres-
siveness of a Manet drawing, and is probably
by a contemporary of that artist.

Unsigned. The seal, unreadable, may be that of a
 collection.
Ink on paper.
22.5 x 10.4 cm.
Collection: K. G. Boon.

137

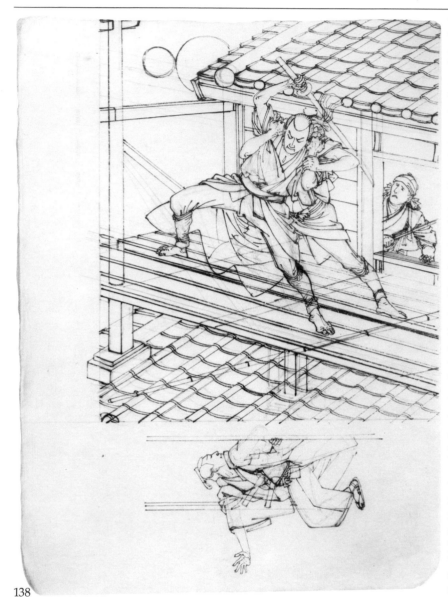

138

Unlike Kyōsai, his near contemporary, Yoshitoshi, equally talented, deserted the native traditions of art and became Westernized. But the conversion was not an easy process, either technically or psychologically. As Charles Mitchell has written, "More than any other artist of the period, Yoshitoshi's work symbolizes the disturbed and shifting social forces of the Meiji era." The latent stress and emotionalism give a curiously strained appearance even to his works of a superficial nature.

A pupil of Kuniyoshi at the age of twelve, his first prints, from 1853 until a nervous breakdown in 1873, had heroic and historical and, in the 1860s, Yokohama-e themes. After 1873, with increasing evidence of a study of Western art, his style developed significantly and his greatest prints appeared in the 1880s, by which time he was the acknowledged and very popular leader of the Ukiyo-e school. His immense output and an obsessional concern about the future seem to have placed too great a strain on a suspect constitution, and he ended his days mentally deranged.

Many of his drawings attract us not only because of their evident and often astounding virtuosity of brushwork, but because we recognize something of ourselves in what are often rather haunting offsprings of East and West.

138. Inuzuka Shinano and Inukai Kempachi fighting on the roof of Horyūkaku. This is recounted in Bakin's formidable novel *Hakken-den*, and Kuniyoshi's fine triptych of the subject must have been known to Yoshitoshi, who was presumably designing another print of the same subject. Shinano had killed many of the retainers of the Daimyō of Satomi, who ordered his *samurai* Kempachi to kill Shinano. Shinano sought refuge on the roof of Horyū-kaku, but Kempachi reached him there; in the ensuing struggle, both fell from the roof into a boat below, and survived.

A *kakemono-e* (vertical diptych) of the subject by Yoshitoshi is known, but this drawing does not appear to be connected with it.

Unsigned.
Ink on paper.
24.5 x 20.5 cm.
Collection: Dr. and Mrs. Lawrence R. Bickford.

139. Tsunemoto and the deer. Roku-sonnō Tsunemoto attacking with the shaft of his bow the great stag he has already brought down with an arrow. According to this 10th-century legend, the deer appeared on the roof of the Joneidan Palace in Kyoto, and was killed by Tsunemoto because it was thought to bode ill for the Emperor Shiyaku.

The title in a cartouche is *Dai Nippon Meisho Kagami*, "Famous Warrior Paragons of Japan," a well-known series published by Funazu Chūjirō during the years 1879-1882.

Signed: *Ōju* ("by request") *Yoshitoshi.*
Ink on paper.
38.0 x 28.0 cm.
Literature: Sotheby Sale Catalogue, "The Property of a Lady," Part 1, April 19, 1966, No. 130 (illustrated); *Harari Coll.*, Vol. 1, No. 99.
Ralph Harari Collection, London.

140. A classroom in a high school for girls.
Three visiting parents are being conducted around the school by one of the staff teachers. The three women are in the height of the 1880s fashion for frills and furbelows, and Yoshitoshi revels in the opportunities for rococo provided by the cascades of ruched ribbon and the sweeping trains trailing across the tiled floor. Moreau le jeune did not show greater infatuation with the intricacies of dress.

The schoolroom, obviously in a very modern, Westernized building, opens onto a balustraded balcony, and is lit by gas lamps with glass globes. The teenage girls are seated at long rows of desks modeled on the austere furniture of Western schoolrooms.

Signed: *Oju* ("by request") *Yoshitoshi ga.*
Ink on paper.
18.1 x 24.0 cm.
Collection: Dr. and Mrs. Lawrence R. Bickford.

139

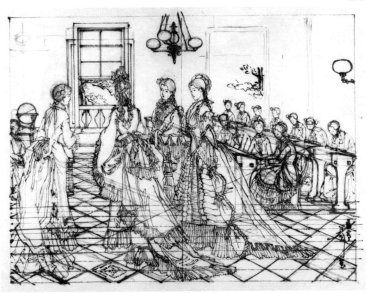

140

WATANABE SHŌTEI (SEITEI)
(1851-1918)

Although Shōtei was a pupil of Kikuchi Yōsai, a confirmed Japanese-style painter (that is, one not won over to Western style), Shōtei is one of those ambivalent artists who was too conscious of world art (he was, after all, editor of *Bijutsu Sekai*, "Art of the World") and too receptive of outside influences not to have picked up foreign ways without even realizing it. He is best known for his *kachō-e*, both in paintings and in a *gafu* published in 1890-91 (the *Shōtei Kachō Gafu*) where the traditional color woodblock technique strives to interpret drawings more than half Westernized.

In the landscape shown, the handling of the wash to obtain atmospheric effect, successful though it is, is more suggestive of Whistler than Nanrei: except in the outline of the bridge, the touch of the brush, so crucial to

the truly Japanese drawing, is forfeited, and in this regard it is instructive to compare the Nanrei landscapes (Nos. 98 and 100). The *Bridge and willows* is charmingly atmospheric, but it is typical of the work of artists like Shōtei and the far greater Takeuchi Seihō, who took Japanese art away from its traditional nationalistic strongholds, to which it could never return.

141. Bridge and willows. A wooden bridge crosses a narrow stream with trees on either side. Rain is falling, and everything except the lines of the bridge handrail is misty.

Signed: *Shōtei*; seal: *Shōtei.*
Ink on paper.
43.5 x 53.3 cm.
Collection: Victoria and Albert Museum, London.

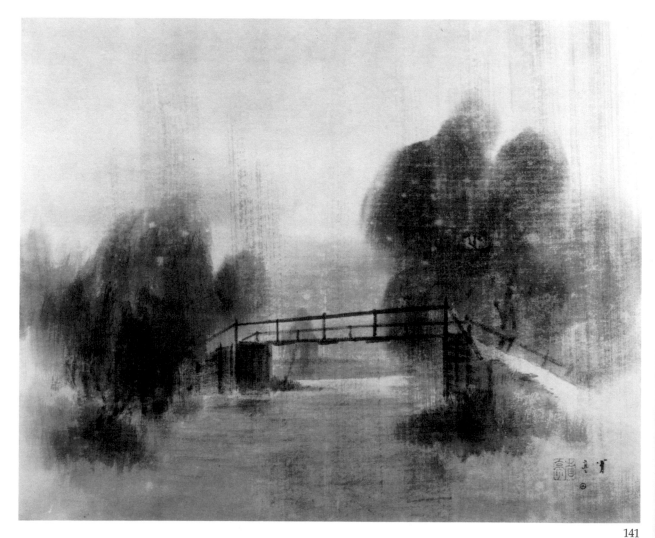

141

NAKAMURA AKIKA
(fl. end of 19th, beginning of 20th century)

In the last decades of the 19th century, the ferment in the whole Japanese way of life caused by the sudden confrontation with the West led not to a diminishment but a proliferation in the number of painters, print designers and book illustrators, working in styles that no longer bore the old school names, but were either nationalistically Japanese or wholly Westernized, or else were a curious hybrid whose ambivalence is one of its charms. Many of these artists remain obscure, their work of minor and transient interest, and Akika is of their number. There are no early traceable biographical facts, but his existence is vouched for (assuming, as seems likely, that it is the same Akika), by at least one color-printed triptych, a *bijin-ga* entitled *Yamato Fūzoku (Mutsuki)* — the First Month in a series of "National Customs and Costumes," signed *Akika* (and sealed in *hiragana* giving this reading of the characters, which could also be read *Shūkō*); and by illustrations signed *Akika* in some of the twenty-four volumes of a work entitled *Otogi Gachō*, the first volume of which is dated 1908.

142. Two young women, one standing by a cherry tree, the other hanging up a lantern. A page from an album, whose intended publication as a book of color prints might be assumed from the fact that the border of each page, the title and publisher's name, are already printed from a woodblock. The title, *Akika Manga*, "Miscellaneous Sketches by Akika," would be entirely in keeping with the nature of the contents, and the other inscrip-tion on the *hashira* (turnover), *Okada Shinzō*, is one form in which a publisher's name might have been given (*shinzō*, "new owner," would refer to the blocks normally). But no book with this title can be traced, and indeed, it was not normal for an artist to present fully colored drawings of this finished kind to be cut on the blocks, in which process they would of course have been destroyed.

But the truly interesting feature of the drawings is their style: they are not merely in a pronounced Western style, they are typically *fin de siècle,* and the artist seems familiar with the work of the Nabis and Symbolists in France. The cherry tree behind the girl on the right is reminiscent of the famous Hiroshige print of which van Gogh made a copy, but Akika has translated it into a version that recalls Vuillard or Maurice Denis.

It is not possible accurately to date this album of drawings, and it may well belong to the first years of the 20th century, but it seems permissible to close the exhibition with a drawing that although perhaps overstepping the notional time limit, demonstrates how quickly even a minor artist in Japan followed Western trends, involuntarily perhaps, and without any formal training under a foreign master, either at home or abroad.

Unsigned (but many drawings in the album are signed *Akika*).
Ink and color on paper.
From an album; 26.7 x 17.0 cm.
Collection: Felix Tikotin.
(Reproduced in color on p. 24)

Glossary

bijin-ga: pictures of beautiful women

bunjinga: paintings by literati, or in the literati tradition

daimyō: a feudal lord

ehon: picture-book

fusuma: paper-covered panels used as sliding partitions for dividing Japanese rooms

gafu: book of drawings

gō: a name or pseudonym privately assumed or, as with an artist, conferred by a master on a disciple

gofun: white pigment produced from ground calcium carbonate

haiga: a drawing related to and accompanying a *haiku*

haiku: a 17-syllable poem

haijin: *haiku* poets

hiragana: one of the two phonetic Japanese scripts, of more general use than the other, *katakana,* q.v.

kachō-e: flower and bird paintings

kakemono: a vertical hanging scroll

kanji: Chinese characters

katakana: the formal Japanese syllabery used for foreign words and other special purposes

kyōka: a 31-syllable satirical or comic poem

makimono: a hand scroll that unfolds laterally

mon: a crest or coat of arms

musume: a young maiden

nengō: the name of a period or era

Nō: classical masked dance drama

samisen: a 3-stringed guitar-like instrument

shita-e: a preparatory sketch for a color print; underdrawing

sumi: black or India ink

surimono: a print for special purposes, often issued by verse clubs at the New Year and usually ornately printed on fine paper

Toba-e: manneristic caricatures in the style of Toba Sōjō

uchiwa: non-folding fans

ukiyo-e: genre paintings and prints of the "Floating World"

yamato-e: color paintings in the Yamato, or Japanese, tradition

Literature Cited in Abbreviated Form

Addiss	Stephen Addiss. *Zenga and Nanga Painting by Japanese Monks and Scholars.* Catalogue of an exhibition at the New Orleans Museum of Art, 1976.
Binyon	Laurence Binyon. *A Catalogue of Japanese and Chinese Woodcuts . . . in the British Museum.* London, 1916.
de Bruijn	R. de Bruijn. *Tekeningen van Utagawa Kuniyoshi.* Catalogue of an exhibition at Gemeentemuseum van 's-Gravenhage, 1955.
Bowie, 1964	Theodore Bowie. *The Drawings of Hokusai.* Bloomington, Indiana, 1964.
Bowie, 1975	_____. *Japanese Drawings.* Bloomington, 1975.
Chaikin	Nathan Chaikin. *Dessins et Livres Japonais des XVIIIe et XIXe Siècles.* Geneva, 1972.
Focillon	Henri Focillon. *Hokousai.* Paris, 1914.
de Goncourt	Edmond de Goncourt. *Hokousai.* Paris, 1896.
Gonse	Louis Gonse. *L'Art Japonais* (2 vols). Paris, 1883.
Hillier, 1955	Jack Ronald Hillier. *Hokusai: Paintings, Drawings and Woodcuts.* London, 1955.
Hillier, 1965	_____. *Japanese Drawings from the 17th Century to the End of the 19th Century.* Plainview, New York, 1965.
Hillier, 1966	_____. *Hokusai Drawings.* Londo,, 1966.
Harari Coll.	_____. *The Harari Collection of Japanese Paintings and Drawings* (3 vols.). London, 1970-1973.
Harari Exhib.	_____. *The Harari Collection of Japanese Paintings and Drawings.* Catalogue of an exhibition at the Victoria & Albert Museum, London, 1970.
Hillier, 1974	_____. *The Uninhibited Brush.* London, 1974.
Vever	_____. *Japanese Prints and Drawings from the Vever Collection* (3 vols.). London, 1976.
Hirano	Chie Hirano. *Kiyonaga: A Study of His Life and Works.* Boston, 1939.
Japanske Handtegninger	*Japanske Handtegninger.* Catalogue of an Exhibition at Artes Galleri, Oslo, December 1977-January 1978.
Ostier	Janette Ostier. *Hanabusa Itcho 1652-1724. Dessins.* Catalogue of an Exhibition at Galerie Janette Ostier, Paris, 1964.
Ouwehand	C. Ouwehand. *Japanse Penseel-tekeningen.* Catalogue of an exhibition at the Rijksmuseum voor Volkenkunde, Leiden, n.d., c.1954.
Poet-Painters	Calvin French and others. *The Poet-Painters: Buson and His Followers.* Catalogue of an exhibition at the University of Michigan Museum of Art, Ann Arbor, and elsewhere, 1974.
Robinson	Basil W. Robinson. *Summary Catalogue of Drawings by Utagawa Kuniyoshi in the Collection of Ferd. Lieftinck.* Groningen, 1953.
Schack	Gerhard Schack. *Japanische Handzeichnunge.* Catalogue of an exhibition in Bielefeld. Hamburg, 1975.
Tikotin	*Felix Tikotin zum siebzigsten Geburtstag,* Basle, 1963.

Index of Artists *(By catalogue number)*

The Best
Older Sister

The Best Older Sister

By Sook Nyul Choi

illustrated by

Cornelius Van Wright and Ying-Hwa Hu

A Yearling First Choice Chapter Book

For my daughter Kathleen.

My sincere thanks to Kathy for her inspiration,
to Audrey for her critique,
and to Ingrid van der Leeden
for her enthusiasm and interest in my work.
—S.N.C.

To En-wei
and his best older sister,
En-szu.
— *C.V.W. and Y.H.H.*

Published by
Bantam Doubleday Dell Publishing Group, Inc.
1540 Broadway
New York, New York 10036
Text copyright © 1997 by Sook Nyul Choi
Illustrations copyright © 1997 by Cornelius Van Wright and Ying-Hwa Hu
All rights reserved.

Library of Congress Cataloging-in-Publication Data

Choi, Sook Nyul.
The best older sister / by Sook Nyul Choi;
illustrated by Cornelius Van Wright and Ying-Hwa Hu.
p. cm.
"A Yearling first choice chapter book."
Summary: Sunhi is unsettled by the family's focus on her baby brother, but with the help of her wise grandmother she learns to appreciate her new role of big sister.
ISBN 0-385-32208-9 (hc : alk. paper). —ISBN 0-440-41149-1 (pb : alk. paper)
[1. Brothers and sisters—Fiction. 2. Grandmothers—Fiction.
3. Korean Americans—Fiction.]
I. Van Wright, Cornelius, ill. II. Hu, Ying-Hwa, ill. III. Title.
PZ7.C44626 Be 1996
[Fic]–dc20 95-53286 CIP AC

The trademark Delacorte Press® is registered in the U.S. Patent and Trademark Office and in other countries.
The trademark Yearling® is registered in the U.S. Patent and Trademark Office and in other countries.
The text of this book is set in 17-point Baskerville.
Manufactured in the United States of America
February 1997
10 9 8 7 6 5 4 3 2 1

Contents

1.
No Time for Sunhi

Sunhi dragged her feet
as she walked home from school.
Her grandmother, Halmoni,
had always waited for Sunhi
outside the schoolyard
with a delicious snack.
Together they would walk home.
Sunhi would tell Halmoni
all about her day at school.

7

But everything changed for Sunhi
when her little brother, Kiju, was born.
Halmoni no longer had time
to play with Sunhi.

Now Halmoni was busy
taking care of Kiju all day
while Sunhi's parents were at work.
Halmoni fed him, bathed him,
and changed his diapers.
That little baby made such a mess
and needed so much attention.

When Sunhi came home,
she saw Halmoni sitting on the sofa,
bouncing Kiju on her knee.
Halmoni was waving Sunhi's
little brown teddy bear
in front of Kiju.

He smiled and drooled with delight.
Mrs. Lee and Mrs. Stone,
their neighbors, were visiting.
They were making silly noises
as they admired the baby.

They hardly noticed Sunhi.

"Oh, hello, Sunhi," said Mrs. Lee,
looking up finally.
"We just stopped by to see Kiju.

How adorable your little brother is!
I can hardly believe he will be
a year old next week."
"Halmoni told us that
it is a Korean custom
to have a big party
on a baby's first birthday,"
said Mrs. Stone.
"You must be so excited."
Sunhi managed a polite smile.
"It is so wonderful to have
a boy in the family," said Mrs. Lee.

Sunhi was tired of all the fuss
everyone made over this baby.

She did not think he was so interesting.
She wished one of these visitors
would adopt him and take him away.

Sunhi glared at the two presents
on the coffee table.
"Sunhi, please put those presents
in your parents' room," said Halmoni.
Sunhi grabbed them and
ran to her parents' room.

She threw them on the bed.
Then she saw three more beautifully
wrapped presents lying in the corner.

"Huh! More presents
for that little boy," said Sunhi.
She could not stand it anymore.

She marched out to the living room
and over to Halmoni.
"Can I have my bear back?
That is still mine, isn't it?"

Sunhi snatched it
and ran back to her room.
Halmoni's eyes opened wide.
She stared after Sunhi.

Sunhi knew she was being rude.
She was ashamed of her behavior
in front of Halmoni and their guests.
But she could not help it.
Tears ran down her cheeks.
She threw herself onto her bed
and sobbed.

Everything was different
with Kiju around.
Even her room
was not her own anymore.
It was full of baby diapers
and baby toys.
It smelled like baby powder.

"How happy you must be to
have a little brother!"
everyone said to Sunhi.
"Isn't it wonderful to be a
big sister now?" they asked.
But it did not seem
so wonderful to Sunhi.
Now her parents had even
less time to talk to her and
play with her in the evenings.
Most of all, Sunhi missed
spending time with Halmoni.
When Halmoni wasn't with Kiju,
she was busy doing things for him.
Just yesterday Sunhi had caught
Halmoni sewing secretly in her room.

20

Sunhi saw the beautiful blue silk.
She knew that Halmoni must be
making something for Kiju
to wear on his birthday.
"What is so special about this
little baby, anyway?"
Sunhi wondered.
"Why is it so important
to have a boy?
Wasn't I good enough?"
Sunhi sobbed.

2.
A Surprise for Sunhi

There was a gentle knock on the door.

Halmoni entered.

She quietly sat beside Sunhi.

Halmoni wiped Sunhi's tears and stroked her hair.

Halmoni said,

"I have a surprise for you.

I was going to save it

until next week.

But I think I will give it to you now."

"What is it, Halmoni?" Sunhi said.

She swallowed her tears and

brushed away Halmoni's hand.

"It is in your parents' room.

Three big presents," said Halmoni.

"What? Those are all Kiju's!" said Sunhi.

Halmoni carried the three

big boxes into Sunhi's room.

"Come on, Sunhi. Sit up.

Open this one first," she said.

In the box was a royal blue
silk Korean dress.
It had rainbow-colored sleeves and
butterflies embroidered on the front.
Sunhi loved it.
"This is for you to wear
on Kiju's birthday," said Halmoni.
"I was afraid you saw it last night
when you came to say good night.
These other two are for your
best friends, Jenny and Robin.
Open them and see if you think
they will like them."
Jenny's was peach-colored with
white rosebuds embroidered
on the front.

Robin's was yellow with tiny blue birds
embroidered on the sleeves.
Sunhi knew that her friends
would love these.
"Halmoni, these are so pretty.
It must have taken you a very
long time to make them!"
said Sunhi.

"Well, luckily Kiju is a good baby.
He sleeps a lot.
I am sorry I haven't taken you
to school and picked you up.
I have missed that.
You are special to me.
It is just that babies are
so helpless and need a lot of care.
Just like you when you were
a baby," said Halmoni.
"Did people come and visit and
make such a big fuss over me?"
asked Sunhi.
"Oh, even more!" said Halmoni.
"What a fuss we all made!

Don't you remember the pictures
of your first birthday?
I was in Korea, but your parents
sent me a big batch of pictures
of you every week.
For your birthday, I made you an outfit
and mailed it to your mother."

"I remember those pictures," said Sunhi.

"Now that you are a big sister,"
said Halmoni, "I thought you
could host Kiju's birthday party.

You, Jenny, and Robin can decorate
the birthday table and host together.
Why don't you invite them over?
We can give them their presents,"
said Halmoni.
Sunhi nodded.
"Okay, I'll ask them to come home
with me tomorrow," she said.
"Where is Kiju?"
Halmoni smiled.
"I think he is sleeping.
Let's go see."

3.
A Bad Older Sister

Halmoni and Sunhi walked to
Sunhi's parents' room.
They peered into Kiju's crib.
Kiju was wide awake and playing
happily with his feet.
He was a peaceful, handsome baby.
"Kiju is lucky to have
a big sister like you," said Halmoni.
"Soon he will be walking and talking.
He will follow you all around.
You will have to teach him
to be smart and kind just like you."
Sunhi's face turned red.

"Halmoni, I was stupid and mean.
Sometimes I wanted
to be an only child again.

I have been a bad older sister,"
said Sunhi.

"Sunhi, that is all right," said Halmoni.

"It is hard to get used to
having a baby in the house.
Sometimes we wish
things had not changed.
But that doesn't mean we are bad.
I know that you love Kiju very much.
I know you are going to be
the best older sister."
Sunhi watched Kiju.

She promised herself
that she would give him the best
first birthday party ever.

"What is Kiju's
birthday outfit like?" asked Sunhi.

"It is just a silk outfit much like
the one you wore," said Sunhi's mother,
walking into the room.

"He is not wearing
an extra-special outfit?
He isn't more special
and important because
he is a boy?" asked Sunhi.

"Of course not!
You are both equally special,"
said Sunhi's mother.

She hugged Sunhi.
Halmoni took Sunhi's hand
in her own. She said,
"Is your right eye more special and
important than your left eye?"
Halmoni had lots of funny sayings
like this, but Sunhi understood.

The next day Jenny and Robin
came over. All three girls
tried on their outfits.
"Ooooh, thank you, Halmoni," Jenny said.
Robin said, "Oh, how pretty! Thank you."
Halmoni beamed with joy.

Then they looked at pictures
of Sunhi's first birthday.
They all laughed at the funny faces
Sunhi made in the pictures.
They laughed and laughed and
rolled on the floor.

4.
The Best
First Birthday Party

On the morning of Kiju's birthday
Jenny and Robin came over very early.
Sunhi's father unfolded
the embroidered silk screen.
Sunhi's mother spread out
a beautiful silk tablecloth.
Halmoni brought out rice cakes.
Halmoni started placing
one green rice cake on top of another.
"See, you stack them just like you stack
pebbles at the beach," she said.

Sunhi began stacking the white
rice cakes. She mixed them
with green rice cakes
to make a pretty design.

Robin stacked the bright red apples.
Jenny stacked brown rice cakes
into a tall tower.
Finally the big table was all set.

The girls helped Halmoni dress Kiju.
They put silk trousers, a silk shirt,
and a green silk jacket on him.
A big, pointy black hat
went on his head.

All their friends and relatives arrived. The girls placed Kiju in his high chair at the table. Kiju cooed and reached for the colorful goodies.

Jenny, Robin, and Sunhi made
funny faces to get Kiju to smile
and look at the camera.
Sunhi's father hurried to take
as many pictures as he could.

"Take lots of pictures of the
beautiful table the girls decorated,"
said Sunhi's mother.
Then, Jenny, Robin, and Sunhi
saw the sign at the front of the table.

"Decorated by Jenny, Robin, and Sunhi,"
it said in Sunhi's mother's printing.
Sunhi smiled at her mother,
and her mother smiled back.
All three girls gazed at the table proudly.

Decorated
by
Jenny
Robin and
Sunhi

"Don't move.

I want a picture of all of you,"
said Sunhi's father.

"Wait!" Sunhi dragged
Jenny and Robin
behind the table.

Then she picked up Kiju and
gave him a big squeeze.

She held him up to pose
for the camera.

Sunhi's father quickly took
a picture of them.

Then Kiju started to squirm
and struggle to be free.

Sunhi put him down.

He tore off his birthday hat
and scrambled toward his
shiny rattle on the floor.
Everyone laughed.

Sunhi's mother lifted Kiju up high.

Kiju said, "Woooh, woooh."

He looked at everyone with a big smile.

"He is lots of fun," said Robin.

"Is he hard to take care of?"

asked Jenny.

"Oh, no, he is not so bad," Sunhi said.

She looked at Kiju proudly.

Halmoni watched Sunhi and smiled.

About the Author

Sook Nyul Choi was born and raised in Korea. After immigrating to the United States, she graduated from Manhattanville College, then worked as a teacher for almost twenty years while raising her two daughters. She is the author of four previous children's books, including the award-winning novel *Year of Impossible Goodbyes*. Ms. Choi lives in Cambridge, Massachusetts.

About the Illustrators

Cornelius Van Wright and **Ying-Hwa Hu** are a husband-and-wife team who live in New York City with their two children. Mr. Van Wright was born in New York and studied at the School of Art and Design and the School of Visual Arts. Ms. Hu, born in Taipei, Taiwan, studied at Shi Chen College and St. Cloud State University. The couple have illustrated numerous children's books both together and individually.